How Video Works

How Video Works raises the curtain on how video is created, scanned, transmitted, stored, compressed, encoded, delivered, and streamed to its multitude of destinations. In today's digital world, every content creator—individual as well as network or corporation—must understand the process of how video works in order to deliver not only the best quality video, but a digital video file with the most appropriate specifications for each particular use. This complete guide covers key stages of video development, from image capture, to the final stages of delivery and archiving, as well as workflows and new technologies, including Ultra High Definition, metadata, signal monitoring, streaming, and managing video files—all presented in an easy to understand way. If you want to own your space in the world of video, either as a professional or as a content creator, this book has the information you need to succeed. The updated third edition contains:

- New sections on image capture as well as streaming and video workflows
- A hands-on approach to using digital scopes and monitoring the video signal
- Thorough explanations of managing video files, including codecs and wrappers
- In-depth coverage of compression, encoding, and metadata

- A complete explanation of video and audio standards, including Ultra HD
- An overview of video recording and storage formats
- A complete glossary of terms for video, audio, and broadcast

Additional links and materials can be found at www.focalpress.com/cw/weynand

Diana Weynand is an award-winning Producer, Director, Editor, and the co-founder of Rev Up Tech (www.revuptech.com), a leader in training and consulting for emerging technologies. Diana was Supervising Editor for the *Barbara Walters Specials*, Director and Producer of the Emmy-nominated PBS series *Cinematic Eye*, and the PBS documentary *Endangered Species: The San Francisco Cable Cars*, and Online Editor for the Olympics and *Real World*. She authored Apple's certified Final Cut Pro books, and has written extensively on video.

Vance Piccin is a freelance Video Editor specializing in Sports, Corporate, Talk Shows, and News Magazines. As Editor and Edit Supervisor, he has covered the NBC Olympics for over ten years, and has garnered seven Emmys in Outstanding Achievement in areas including Graphic Designer, Outstanding Team Studio, and Outstanding Technical Team Remote.

Marcus Weise has operated in both production and post production in the television industry. He has been an Associate Director, Online Editor, and Technical Consultant. His many credits include being an Online Editor for *CSI*.

How Video Works

From Broadcast to the Cloud

Third Edition
Diana Weynand and Vance Piccin
with Marcus Weise

Focal Press
Taylor & Francis Group

NEW YORK AND LONDON

Third edition published 2016
by Focal Press
711 Third Avenue, New York, NY 10017

and by Focal Press
2 Park Square, Milton Park, Abingdon, Oxon OX14 4RN

Focal Press is an imprint of the Taylor & Francis Group, an informa business

First edition published by Focal Press 2004
Second edition published by Focal Press 2007

Library of Congress Cataloging-in-Publication Data
A catalog record for this book has been requested

ISBN: 978-1-138-93340-8 (hbk)
ISBN: 978-1-138-78601-1 (pbk)
ISBN: 978-1-315-76689-8 (ebk)

Typeset in Bookman
By Apex CoVantage, LLC

This book is dedicated to all video content creators—
young and old—who care about the quality
of what they're producing.

Contents

Contents

Acknowledgments

Diana Weynand would like to thank:

Vance Piccin, for being the light throughout the tunnel on this project. His willingness to share his vast experience fueled the energy for us to create a truly relevant book.

Marcus Weise, who co-authored the first two versions of *How Video Works*. Some of his work remains in this edition. Marcus has our deepest appreciation for his generous support of this project over its very long life.

Len Barish, Associate Professor of Electronic Media at Kutztown University, for providing a keen eye as he reviewed this book for technical accuracy and for offering other valuable input and feedback that would benefit his students and a broad audience of readers.

Shirley Craig and Rev Up Tech (www.revuptech.com) for supporting this book's progress over the past several years. And to Diane Wright for contributing new information on streaming media.

Describing technical concepts is hard to do without images. Thanks to the companies who provided photos for our use. Photos are reprinted with permission and courtesy of: Tektronix, Inc., Flanders Scientific, Inc., XeusMedia Technology, Leader Instruments Corp., Panasonic, Matrix, Paul Kulak, and 2ndSide.com. All rights reserved. Thanks also to Moses Zuasola for creating many of the original graphics.

To Focal Press, especially Emily McCloskey, Elliana Arons, and Abigail Stanley, for guiding this book along its path.

Introduction

Since the development of broadcast cameras and television sets in the early 1940s, video has slowly become more and more a part of everyday life. In the early 1950s, it was a treat simply to have a television set in one's own home. In the 1960s, television brought the world live coverage of an astronaut walking on the moon. With the 1970s, the immediacy of television brought the events of the Vietnam War into living rooms. In the 21st century, with additional modes of delivery such as satellite, cable and the Internet, video has developed into the primary source of world communication.

However, while the television set itself provided a cool fire around which many families in the 20th century sat, today many people choose to watch their favorite TV shows and movies on their computers and mobile devices. Without the anchor of the older delivery medium, video content has become king and websites such as YouTube and Vimeo, and subscriber-based services such as Netflix, Hulu and Amazon, have become a major part of the video fabric of our on-the-go lives.

Video Evolution

Just as the use of this medium has changed over the years, so has its physical nature evolved. The video signal started as analog and has developed into digital with different types of digital formats. When television was first created, cameras and television sets required a great deal of room to house the original tube technology of the analog world. In today's digital society, camera size and media files continue to get smaller as the quality continues to improve.

For example, when this book was first published, High Definition was becoming the format of choice. Now the industry is creating programming in *Ultra* High Definition (4K), which has over twice the resolution of High Definition. This expansion in resolution and ease of use has caused many producers to choose the digital route over shooting on film for their projects.

Although the equipment has changed, some of the processes involved in the origination of the video signal have remained the same. This makes the progression of video from analog to digital not only interesting to study, but helpful in providing a foundation of knowledge upon which the current digital video world operates. So much of today's digital technology is the way it is because it evolved from analog.

Analog and Digital

Let's consider the analog and digital realms. All information from the physical world is analog. A cloud floating by, an ocean wave, and the sounds of a marching band all exist within a spectrum of frequencies that comprise human experience. This spectrum of frequencies can be captured by any number of digital cameras and

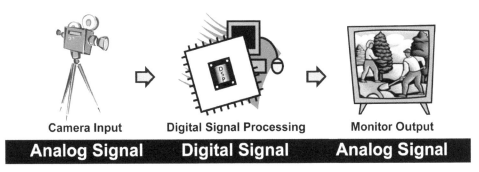

Figure 1.1 From Analog to Digital to Analog

recording equipment and then translated to any number of digital file types made up of digital data, or zeros and ones, representing the image or sound.

Human beings, however, do not process the zeros and ones of digital data. Eventually that data must be converted back to an analog form so we humans can see and hear it. Even with a digital home receiver and other viewing or listening devices, the zeros and ones of a digital signal must eventually be reproduced as analog for humans to experience it with their sight and sound senses (Figure 1.1).

Signal Reproduction

In the early days of television, video was recorded and reproduced as an analog signal on a videotape machine, which was based on mechanical concepts. The videotape machine moved the videotape along guides and through magnetic heads that recorded or played back the signal. As a result of the videotape moving through a mechanical system, the information could only be recorded or reproduced in the order in which it was created. This made post production of videotape, or the editing and manipulating of content after it was shot, a linear process with no instant access.

Figure 1.2 Analog Videotape Recording vs Digital Video Production

With the advent of digital, the primary system for signal reproduction has become solid-state electronics, incorporating computers, servers and digital cards. This change has created a computer file-based system, rather than the taped-based mechanical system of the analog era. File-based systems allow random, or non-linear, access to information without respect to the order in which it was produced or its placement within the storage medium (Figure 1.2).

While most cable companies, broadcast stations, Internet companies, and production or post production facilities create, edit and transmit video signals using a digital file-based system, some facilities still have older videotape machines for inclusion of legacy (analog) content.

About This Book

To create a complete picture of the video process—and answer the question "How does video work?"—this book begins by examining the analog video signal. Digital video technology is a direct evolution from the analog system. Having the knowledge of the analog system provides a firm foundation before moving into a discussion

of digital, and how video works today in the new age of digital distribution.

While this book is designed to cover the process of creating a video signal, storing it, and transmitting it in a professional environment, the same information and concepts apply to any video tool, including consumer equipment.

Creating a Video Image

Video starts with a camera, as does all picture taking. In still and motion-picture film photography, there is a mechanical system that controls the amount of light falling on a strip of film. Light is then converted into a pattern of varying chemical densities on the film. In digital photography, the light from an object goes through a lens, as it does in film photography. On the other side of the video camera lens, however, light is converted to an image by an electronic process as opposed to a mechanical or chemical process. The medium for this conversion has changed over the years. It began with tube cameras and has progressed to completely electronic components.

Tube Cameras

While the tube pickup has been replaced with digital technologies, the process of scanning the image that the tube used has implications for current systems.

In a video tube camera, the lens focuses the image on the face of a *pickup tube* inside the camera. The face of the pickup tube is known as the *target* (Figure 2.1). The target is light-sensitive, like a

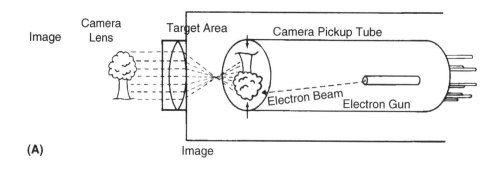

(A)

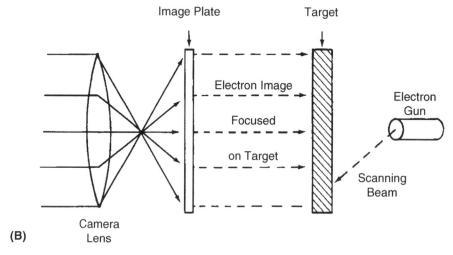

(B)

Figure 2.1 **(A)** Camera Focusing on Image and **(B)** Tube Camera Target Area

piece of film. When light shines on the face of the target, it conducts electricity in proportion to the amount of light that is striking its surface. Without light on the face of the target, the target resists the flow of electricity.

A stream of electrons, called the *beam*, comes from the back end of the tube and scans back and forth across the face of the target on the inside of the pickup tube. The electrical current generated is either allowed to pass from the target to the camera output or not, depending on the amount of resistance at the face of the target.

The amount of resistance varies depending on how much light is shining on the target. The electrical signal that flows from the target is, in effect, the electronic re-creation of the light coming from the scene at which the camera is aimed.

Scanning the Image

When a camera *sees* an object, it begins scanning the image. The beam of electrons sweeps back and forth across the inside face of the target. Where the electron beam strikes the face of the target, it illuminates an area the same size as the electron beam (Figure 2.2). The resulting electrical signal is a continuous flow of varying voltages representing the light that struck the target. Without some information about where the scanning dot was positioned there would be no way for the receiver to know where to start and end the picture. In a later chapter we will see how that is accomplished.

NOTE In a digital video signal, these picture elements are called *pixels*, short for picture elements (Figure 2.3).

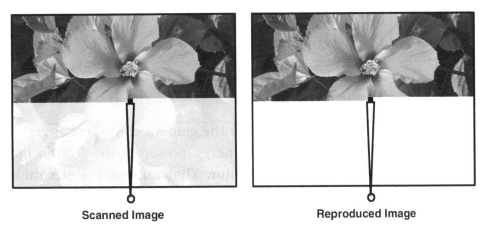

Scanned Image Reproduced Image

Figure 2.2 Scanning and Reproducing an Image

Figure 2.3 Magnified Picture Elements

In the television system that was used in the United States, the electron beam would scan back and forth across the target 525 times in each television frame. Thus each frame in the television signal was composed of 525 *scan lines*. It did not matter what size the camera was or what size the pickup tube or monitor was. The total number of lines scanned from the top of the frame to the bottom of the frame would always be 525.

The image created in the video camera had now been turned into an electronic signal of varying voltages. As an electronic signal, the television image can be carried by cables, recorded, or even transmitted through the air.

Displaying the Image

The varying voltages generated by the camera could be converted back into light. This electrical energy powered an *electron gun* in the television receiver or monitor. That gun sent a stream of electrons to the face of the picture tube in the receiver. Changing voltages in the video signal caused chemical phosphors on the inside face of the receiver tube to glow with intensity in direct

proportion to the amount of voltage. The image that originated in the tube camera is thus recreated, line by line. Motion and detail were all reproduced.

Camera Chips

Over the years, the pickup tubes and the scanning yokes needed to drive the tube cameras have been eliminated and replaced by light-sensitive chips (Figure 2.4). There are two technologies commonly used for chip camera pickups, CCD and CMOS. CCD is a *charge-coupled device.* CMOS is short for *complementary metal–oxide–semiconductor.* First found in still cameras, this technology is now also common in video cameras as well.

A CCD is a chip that contains an area, or site, covered with millions of tiny capacitors or condensers (devices for storing electrical energy). There are millions of individual sites on image sensor chips. Often a chip is rated by the number of "megapixels" or millions of pixels it contains. This chip came out of the technology that was developed for EPROM (Erasable Programmable Read-Only Memory) chips. They are used for computer software where updates or changes can occur. When the information is burned onto an

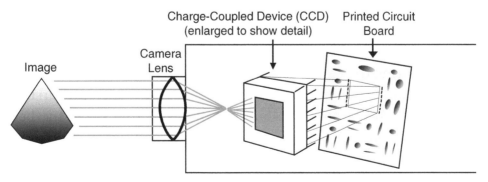

Figure 2.4 CCD Camera Focused on Image

EPROM, it is meant to be semi-permanent. It is erasable only under high-intensity ultraviolet light.

In a CCD camera, the light information that is converted to electrical energy is deposited on sites on the chip. Unlike an EPROM, however, it is easily removed or changed. The sites are tiny condensers that hold an electrical charge and are separated from each other by insulating material. This prevents the charge from leaking off. The chip is very efficient and can hold the information for extended periods of time. When the sites are done being exposed, the charges they collected are moved to adjacent holding cells ready to be passed onto off-chip processing.

CMOS chips are similar to CCDs but have amplification and scanning circuits built directly into the image capture chip. Combining some of the circuits makes it possible to produce less expensive cameras. However, as they transfer the image as it is being photographed, an artifact known as "rolling shutter" may occur. For this reason, high-end cameras still use frame transfer CCD chips.

Types of Chip Cameras

Chip cameras can be found in many forms, from the tiny camera in phones to the largest studio cameras in film and television production. Inside the chip camera, light coming through the lens is focused on a chip. In the case of cameras that use multiple chips, light entering the camera goes through a *beam splitter* and is then focused onto the chips, rather than passing through a pickup tube or tubes. A beam splitter is an optical device that takes the light coming in through the lens and divides or splits it. It directs the light through filters that filter out all but one color for each of the chips. One chip sees only red light, one only blue, and one only

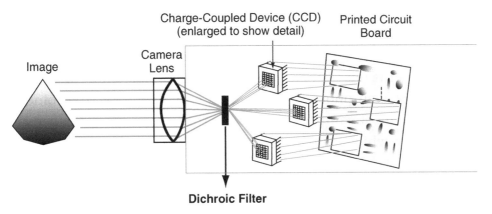

Figure 2.5 Three-Chip CCD

green. The filters are called *dichroic* because they filter out two of the three colors. These chips are photosensitive, integrated circuits (Figure 2.5).

When light strikes the chip, it charges the chip's sites with electrical energy in proportion to the amount of light that strikes the chip. In other words, the image that is focused on the chip is captured by the photosensitive surface as an electrical charge. This electrical charge is then read off the chip. The technology behind these chips allows them to shoot bright light without overloading. However, if the light is bright enough, the charge can spill over from one site to the next. This can cause the edges of an object within an image to *smear* or *lag*.

To prevent this, an optical grid or black screen is laid over the face of the chip so that between the light-sensitive sites there is both insulation and light-absorbing material. To capture the information stored on the chip, the chip is scanned from site to site, and the energy is discharged as this happens. A numerical value is assigned as each site is scanned, according to the amount of electrical energy

present. This is part of the digitizing process, as the numerical value is converted to computer data for storage and transmission.

Many cameras use a single-chip design. The single-chip camera has filters over each photo site that pass only one color; red, blue or green. The most common method for this uses a format called the Bayer filter, which is an arrangement of the colors in a pattern that features twice as many green pixels as red or blue. This accounts for human vision, which is more sensitive to the green region of the color spectrum. In a single-chip camera, there is no need for three chips and a beam splitter.

Typically, the larger the size of the chip in the camera, the better the image quality. For example, a camera with a ⅔ inch chip will capture a better quality image than a camera with a ½ inch chip.

NOTE During the digitizing process, certain artifacts can occur in the video that can be a problem. Through image processing in the camera, these artifacts can be blended to make them less noticeable. These problems can sometimes be overcome by changing a camera angle or altering the lighting.

Video Scanning

When looking at a picture, such as a photograph or a drawing, the human eye takes the scene in all at once. The eye can move from spot to spot to examine details, but in essence, the entire picture is seen at one time. Likewise, when watching a film, the eye sees moving images go by on the screen. The illusion of motion is created by projecting many pictures or frames of film each second. The eye perceives motion, even though the film is made up of thousands of individual still pictures. Video is different from film in that a complete frame of video is broken up into component parts when it is created.

Video Lines

In a tube camera, the electron beam transforms a light image into an electronic signal. Then, an electron beam within a CRT video receiver or monitor causes chemicals called phosphors to glow so they transform the electrical signal back into light.

The specifications for this process were standardized by the National Television System Committee, or NTSC, when the television system was originally conceived in the late 1930s. The NTSC standard was used in North America and parts of Asia and Latin America. As

other countries developed their own television systems, other video standards were created. Eastern and Western Europe used a system called PAL (Phase Alternate Line). France and the countries of the former Soviet Union used a system known as SECAM (Séquential Colour Avec Mémoire, or Sequential Color with Memory). Most developed countries have switched to transmission of television using digital standards, making these analog formats obsolete. However, there are still places in the world where analog broadcasts remain.

> **NOTE** The United States switched to digital broadcasting in 2009, but the NTSC standard lives on in many consumer video products. Cable boxes, TV receivers, disk players and games often include an output simply labeled "video." This is the same signal discussed here.

For each NTSC video frame, the electron beam scanned a total of 525 lines. There were 30 frames scanned each second, which means that a total of 15,750 lines (black and white video) were scanned each second (30 frames x 525 lines per frame). This rate was called the *line frequency*. Scanning 15,750 lines per second is so fast that the eye never notices the traveling beam. The video image is constantly refreshed as the electron beam scans the 525 lines in each frame. As soon as one frame is completely displayed, scanning begins on the next frame, so the whole process appears seamless to the viewer.

The NTSC line frequency and frame rate changed with the addition of color. Both PAL and SECAM used 625 lines per frame at 25 frames per second. These two systems were developed after the introduction of color television and consequently did not require any additional changes. There are variations and combinations that attempt to combine the best elements of all of these standards.

Blanking

An electron beam scanning a picture tube is like an old typewriter. It works in only one direction. When it reaches the end of a line of video, it must *retrace* or go back to the other side of the screen to start the next line. Likewise, when it reaches the bottom of the image, it must retrace or go back to the top of the image to begin scanning the next frame (Figure 3.1).

The period of time during which the electron beam retraces to begin scanning or tracing the next line is part of a larger time interval called *horizontal blanking*. The period of time that the electron gun is retracing to the top of the image to begin scanning another frame is called *vertical blanking*. During horizontal or vertical blanking, the beam of electrons is blanked out or turned off, so as not to cause any voltage to flow. This way the retrace is not visible.

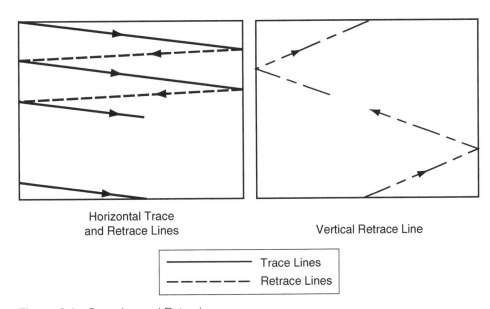

Horizontal Trace
and Retrace Lines

Vertical Retrace Line

———————— Trace Lines
– – – – – – Retrace Lines

Figure 3.1 Scanning and Retracing

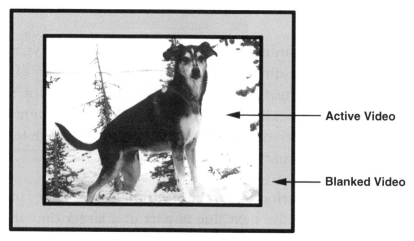

Figure 3.2 Video Frame

The horizontal blanking interval is the separation between consecutive lines. The vertical blanking interval is the separation between consecutive frames. As the video image is integrated with other images, using equipment such as video editing systems or video switchers, the change from source to source occurs during the vertical blanking interval after a complete image has been drawn. This can be compared to splicing on the frame line of a film frame.

Horizontal blanking actually occurs slightly before the beginning of each line of video information. Vertical blanking occurs after each frame. The video picture itself is referred to as *active video* (Figure 3.2). In the NTSC system, active video uses 480 out of the 525 lines contained in one frame. PAL and SECAM use 580 active lines out of the 625 total lines. Blanking functions as the picture frame around the active video. It is a necessary component of the TV signal, even though the electron beam is shut off.

Persistence of Vision

Film is shot at 24 frames per second. However, if it were projected at that rate, a flickering quality to the moving image would be

noticeable. The flickering is a result of the phenomenon that lets us perceive motion in a movie in the first place. That phenomenon is called *persistence of vision.*

Persistence of vision means that the retina, the light-sensitive portion of the human eye, retains the image exposed to it for a certain period of time. This image then fades as the eye waits to receive the next image. The threshold of retention is $\frac{1}{30}$ to $\frac{1}{32}$ of a second. If the images change on the retina at a rate slower than that, the eye sees the light and then the dark that follows. If the images change at a faster rate, the eye sees the images as continuous motion and not as individual images. This concept was the basis of a device developed in the 19th century called the Zoetrope (Figure 3.3). By

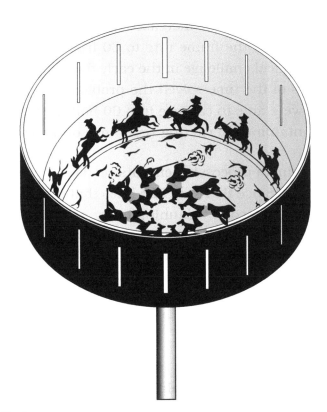

Figure 3.3 Zoetrope

viewing a series of still images through a small slit in a spinning wheel, the characters in the images appeared to move.

In film, this concept is exploited by simply showing each frame twice. The picture in the gate of the film projector is held, and the shutter opens twice. Then the film moves to the next frame and the shutter again reveals the picture twice. In this way, 48 frames per second are shown while the projector runs at 24 frames per second, and the eye perceives smooth, continuous motion.

Fields

The 30-frames-per-second frame rate of video could potentially allow the flicker of the changing frames to be noticeable. Therefore, the frame rate needed to be increased. The simplest way to do this would be to double the frame rate to 60 frames per second. This was a technological challenge in the early days of tube electronics. The engineers of the time solved the problem by breaking the 30 frames they were able to capture into 60 half frames called *fields*, each field containing alternating scan lines of the frame.

The pickup camera processing circuits read out every other line of the video frame. Since there are 525 lines that make up a complete frame, or $\frac{1}{30}$ of a second, scanning every other line yields $262\frac{1}{2}$ lines scanned per field, or $\frac{1}{60}$ of a second (Figure 3.4). Two fields of $262\frac{1}{2}$ lines each combine to make 525 lines, or one complete frame (Figure 3.5). The process was the same in PAL and SECAM, taking into consideration their line and frame rates.

Interlace Scanning

The process of this field-by-field scanning is known as *interlace scanning* because the lines in each field interlace with the alternate

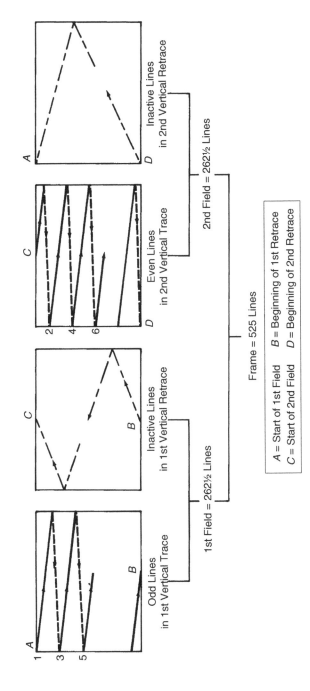

Figure 3.4 Interlace Scanning

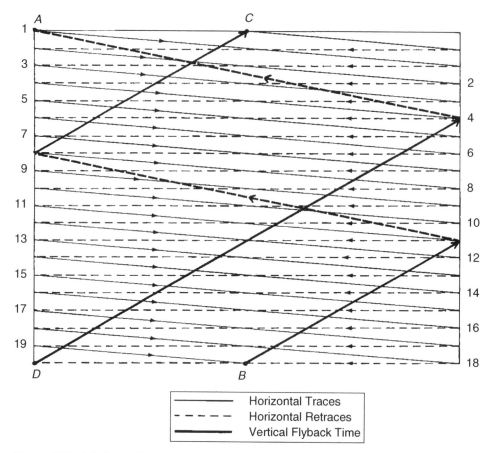

Figure 3.5 Interlaced Frame

lines of the other field. There are two fields for each frame. Because the images are appearing at the rate of ⅟₆₀ of a second, the eye does not see the interval between the two fields. Therefore, the eye perceives continuous motion.

Try This

An interesting experiment that illustrates the concept of interlace scanning is to have your eyes follow a similar scanning pattern as the electron beam would on a frame of video. Look at the paragraph below

and first read just the boldfaced, odd lines. Then go back to the top of the paragraph and read the non-boldfaced, even lines. Notice the way the eyes retrace from the end of a line back to the left margin to begin scanning the next odd line. At the end of the paragraph, the eyes retrace from the last line back to the top again to read or scan the even lines. This is what the electron beam does during its blanking periods.

A television image is created through Interlace scanning. Interlace scanning **is the process of scanning every other** line from top to bottom. The beam **first scans the odd lines top to bottom,** and then it scans the even lines top to bottom. **Each scan from top to bottom** is a field. It is the combination of the **two successive fields that make up an** entire frame of a video image.

This ingenious solution to a problem from 80 years ago now presents a challenge to today's content creators. While some broadcast standards still specify interlaced scanning, many image display devices no longer require alternating lines. These formats are called "progressive" as each line is scanned, one after the other, without interlacing. When interlaced material is presented on progressive displays, it can lead to a distracting artifact called *combing*. This leaves fine lines extending from areas of fast motion similar to the teeth of a comb (Figure 3.6).

Current digital systems scan at a number of different frame rates, depending on world standards and image content, which is discussed in Chapter 12. In the U.S., some broadcasters use frame rates at about 30 frames per second, based on the 60 Hz power standard. Other countries might use 60 Hz or 50 Hz electricity, the

Figure 3.6 Combing Artifact

European standard. Those that use 50Hz power often broadcast 25 frames per second. Many dramatic productions use 24 frames per second to match the look of the film frame rate standard. Sports production drives some networks to use 60 frames per second for sharper motion on fast moving material.

Synchronizing Signals

Video images are generated from a source, such as a camera or computer, and viewed on a device, such as a monitor. In order for the viewed image to be seen in exactly the same way and the same time frame as the generated or original image, there has to be a method for synchronizing the elements of the image. Synchronizing an image is a critical part of the video process.

Synchronizing Signals

As video moves from source to monitor, it is a series of electrical impulses. Whether analog or digital, by wire, fiber optic or through the air, the pulses that make up the picture follow each other one after the other. If you could freeze time then look at individual points along the signal path, you could measure individual voltages or find the bits to make pixels. The transmission medium then is a single dimension. It has only length, but not depth or width.

On the other hand, a single frame of video has both width and height. You can find a specific pixel from the signal path at some point between the left and right of the screen. It also is a measurable distance from the top and bottom. So a frame is a two-dimensional

image. Motion pictures are made of the two-dimensional frames being shown one after the other. You can think of this as a third dimension.

Synchronizing signals provide the information to drive the scanning that changes the three dimensional images to a serial form for transmission and storage. The same signals can then be used to rebuild the pictures so they can be viewed.

When multiple sources are used in the same system, like the cameras in a TV studio, each must start their scan at the same exact moment. While most of video process has transitioned to digital signals, analog sync is still commonly used throughout studio and remote production. Although digital devices process sync in a different manner, the same sync signals described below are still used to co-ordinate the process.

Synchronizing Generators

A *synchronizing generator*, or *sync generator* as it is called, was the heart of the analog video system. Sync generators created a number of different pulses for driving the scanning of early analog equipment. As electronics transitioned from tubes to solid state, many cameras, recorders and processing devices began to incorporate their own sync generator circuits. The master *house sync* generator also provides a signal to devices that have their own sync generators. Devices that slave to that master signal are considered to be *genlocked*.

The heart of the sync generator is an oscillator that put out a signal called the *color subcarrier*, which is the reference signal that carries the color information portion of the signal (discussed in more detail later in this chapter). The frequency of the color subcarrier

Figure 4.1 Sync Generator

is 3,579,545 cycles per second, rounded off and more commonly referred to as simply 3.58. Starting with this basic signal, the sync generator, through a process of electronic multiplication and division, outputs other frequencies in order to create the other pulses that are necessary for driving video equipment. These pulses included horizontal and vertical synchronizing pulses, horizontal and vertical drive pulses, horizontal and vertical blanking pulses, and equalizing pulses (Figure 4.1).

These pulses are often combined so that one signal will contain multiple synchronizing components. Combination signals are referred to as *composite signals*. Terms such as *composite blanking* and *composite video* refer to such signals.

NOTE It is the composite sync signal that remains important today.

Synchronizing Pulses

For older analog systems, the sync generator put out both *horizontal* and *vertical synchronizing pulses*. These synchronizing pulses ensured that all of the equipment within the system was in time or synchronized. Horizontal and vertical synchronizing pulses are part of the composite signal, so they can be easily fed to any piece of equipment that requires a sync reference signal.

Horizontal synchronizing pulses appeared at the beginning of each line of analog video. They assured that monitors and receivers were in synchronization on a line-by-line basis with the information that the camera was creating. Vertical synchronizing pulses appeared during the vertical interval. These pulses assured that the retrace was taking place properly, so that the gun was in its proper position for painting the beginning of the next field.

The composite sync signal ensures that each piece of equipment is operating within the system on a line-by-line, field-by-field basis. If equipment is not synchronized, switching between images can cause the image in the monitor to lose stability. For example, dissolves and special effects can change color or shift position. Character generators or computer-generated images might appear in a different position in the image from where they were originally placed.

Color Subcarrier

As mentioned above, with the advent of color television, the color subcarrier signal was created to carry the color information. This signal became the most important signal of the sync generator. In the digital world, color subcarrier is no longer part of the video signal. However it is still used as the base frequency that a sync generator uses to create composite sync.

The frequency of the color subcarrier is 3,579,545 cycles per second. This frequency must be maintained within plus or minus 10 cycles per second. If this frequency changes, the rate of change cannot be greater than one cycle per second every second. The exactness of this specification has to do with the sensitivity of the human eye to changes in color. As this color subcarrier signal

was the reference for color information, any change in the frequency would cause a shift in the color balance. The color subcarrier is also used as the main reference signal for the entire video signal. If the color subcarrier is incorrect, then all the signals in the television system will be affected.

Cross Pulse Display

On a professional video monitor, the image can be shifted horizontally to make the horizontal blanking period visible. The image can also be shifted vertically to make the vertical blanking interval visible (Figure 4.2 (A)). When the image is shifted both horizontally and vertically at the same time, the display is known as a *cross pulse* or *pulse cross* display. A cross pulse display is a visual image of what is represented electronically on a waveform monitor. This display shows several of the signals created in the sync generator (Figure 4.2 (B)).

Other Signal Outputs

Sync generators often provide test signals, such as black burst and color subcarrier outputs. Some of these outputs may appear on the front of their face plates for ease of access. Those same signals are available at the back of the unit as well. Additional test signals are discussed later in the book.

Vertical Interval Signals

The NTSC analog video image was 525 lines, 480 of which represent picture information, referred to as active video. The remaining lines in the vertical interval were used for synchronizing information. Test signals were inserted in the vertical interval as well. While not

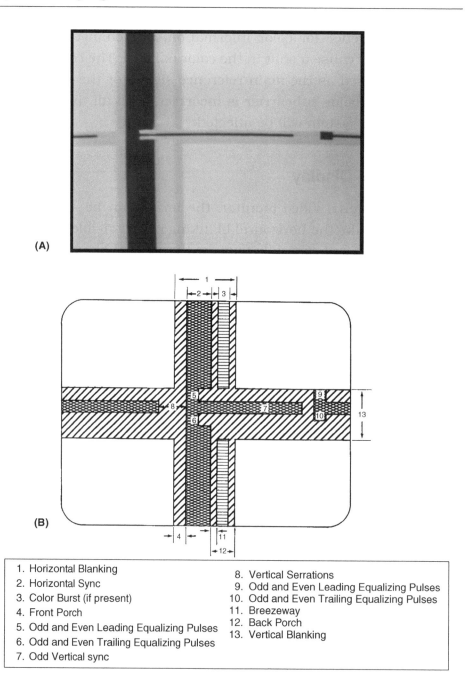

Figure 4.2 **A** and **B**, Cross Pulse Display of an Analog Signal

1. Horizontal Blanking
2. Horizontal Sync
3. Color Burst (if present)
4. Front Porch
5. Odd and Even Leading Equalizing Pulses
6. Odd and Even Trailing Equalizing Pulses
7. Odd Vertical sync
8. Vertical Serrations
9. Odd and Even Leading Equalizing Pulses
10. Odd and Even Trailing Equalizing Pulses
11. Breezeway
12. Back Porch
13. Vertical Blanking

part of the active video, they were a valuable part of the composite signal.

These signals were usually created by devices connected to one or more of the outputs of a sync generator. These extra signals could then be inserted in the vertical interval. These signals included vertical interval test signals, vertical interval reference signals, closed captioning, teletext, commercial insertion data, and satellite data.

In the case of the *vertical interval test signals (VITS)*, a test signal generator could create one-line representations of several test signals. These one-line test signals were inserted in one of the unused video lines in the vertical interval. The VITS could be displayed on an oscilloscope. This test signal provided a constant reference with respect to the active video contained within the frame.

The *vertical interval reference signal (VIRS)* was developed to maintain color fidelity. Small differences in color synchronization can occur when signals are switched between pieces of equipment. The VIRS provided a constant color reference for the monitor or receiver. Without the VIRS, the color balance of the image might change.

Closed captioning was originally developed so the hearing impaired could watch a program and understand the dialogue. In closed captioning, the receiver took the information from the vertical interval and decoded it into subtitles in the active video. Closed captioning could also be used in environments where the audio may not be appropriate or desired. Technically, since closed captioning appeared on line 21, which is active video, the data was not truly in the vertical interval.

Commercial insertion data can be used to automatically initiate the playback of a commercial. This can eliminate the possibility of

operator error. The data are designed to trigger the playback of the required material at the appropriate time, as well as for verification that the commercial was broadcast as ordered.

Satellite data contains information about the satellite being used, the specific channel or transponder on the satellite, and the frequencies used for the audio signals.

Digital Data Bursts

Digital signals do not require blanking, vertical and horizontal sync signals. Instead each line has two short data bursts called the Start of Active Video (SAV) and End of Active Video (EAV) (Figure 4.3, Plate 1). This leaves the time in the signal flow used by analog sync signals available for other uses. It is during this time that audio information (up to 16 channels) and other ancillary data information is

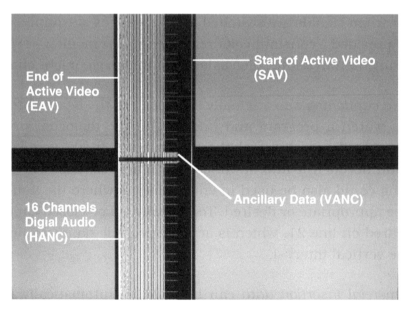

Figure 4.3 (Plate 1) Digital Data Bursts in a Cross Pulse Display

inserted. If you examine the cross pulse display of a digital signal, you can see the audio information forming in the area between each line. This is called the horizontal ancillary data area, or HANC. The types of signals once inserted in the vertical interval of analog signals are now carried in the vertical ancillary data area (VANC) of the digital signal.

Tri-Level Sync

While the SAV and EAV data bursts work inside the digital signal to control scanning and framing, there still needs to be a signal that can be used to synchronize devices that must work as a system.

As HDTV was developed, a matching analog sync signal was created to drive the scanning of the now obsolete analog version of HD. This signal is called tri-level sync. It is a modification of traditional sync, which is now often call bi-level snyc to differentiate it from the newer form. Most digital HD equipment will work with either type of sync, and most TV facilities still use the bi-level form for most purposes. Some HD equipment may not accept bi-level, so you will find tri-level sync outputs on sync generators as well as traditional sync outputs.

In summary, the blanking portions of the video signal, both horizontal and vertical, carry critical information. In addition to synchronizing, the blanking periods are used to carry other data that enhance the quality and usefulness of the video signal.

The Transmitted Signal

Television transmission is the process of sending the video, audio, and synchronizing signals from a transmitting facility to a receiver. In trying to get a package from one city to another, one would arrange for a truck, train, or airplane to be the carrier of that package to its destination. What happens in radio and television is similar, in that specific frequencies are designated as the carriers for radio and television signals. The signal that carries the information is directed out into the air or through a cable so that receivers tuned to the frequency of the carrier can pick up the signal. Once it picks up the signal, the receiver can extract the information from the carrier. Today, most people receive a television signal on a traditional television set through either an aerial on their roof, via cable using cable providers such as Time Warner and Comcast, or via satellite using companies such as DIRECTV or Dish.

Modulating the Signal

To put this information on the carrier, a process called *modulation* is used. To modulate means to make a change. In music, changing key is referred to as modulating to a different key. The melody and harmony of the song sound the same, but the key or pitch is

lower or higher. In broadcasting, making this change to the carrier is called *modulating* the carrier.

There are many ways to modulate a carrier. In analog transmission one way is to change the height or amplitude of signals that are imposed on the carrier. Another way is to impose signals on the carrier that vary in speed or frequency. Think of the carrier wave as being the ride to the destination and the modulation of the carrier as the passenger. The *amplitude change* or *modulation* is referred to as AM, and the *frequency modulation* is referred to as FM (Figure 5.1). In analog television broadcasting, the video image

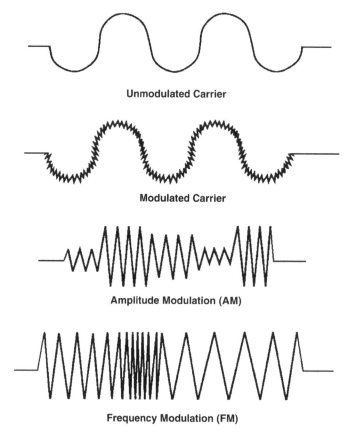

Unmodulated Carrier

Modulated Carrier

Amplitude Modulation (AM)

Frequency Modulation (FM)

Figure 5.1 Carriers and Frequencies

was transmitted by amplitude modulation of the carrier. The audio portion of the signal was transmitted by frequency modulation of the carrier.

At the beginning of the video capture chain, light is converted into varying voltages in the camera. These voltage variations are then used to make changes in amplitude on the carrier wave. These changes in amplitude were proportional to the original picture voltage which came from the light on the face of the target.

For a monitor or receiver to show the original image, it must first receive the carrier. When a receiver is tuned to a specific channel, it becomes sensitive to the frequency of that carrier wave. The receiver, through the process of *demodulation*, takes the varying amplitude changes off the carrier and converts that information back to varying voltages proportional to the amplitude changes on the carrier.

In the TV's receiver, the process is reversed. The varying voltage levels are converted to light by the monitor. This brings the process full circle back to the varying light levels that originally made up the picture in the camera.

In addition to the main video carrier, there were two other carriers that sent out information about the audio and the color portion of the signal. These three modulated carriers—one for video, one for color subcarrier, and one for audio—made up the total composite signal.

Frequency Spectrum

In nature, the spectrum of frequencies ranges from zero to infinity. The spectrum is referred to in terms of *cycles per second*, or *hertz (Hz)*, named in honor of the scientist Heinrich Hertz, who did many early experiments with magnetism and electricity.

Three of the five senses human beings experience—hearing, seeing, and touch—are sensitive to the frequency spectrum. For example, the ear is capable of hearing between 20 and 20,000 Hz, or 20 kHz (kilohertz). Human beings are generally unable to hear sounds above 20 kHz. At extremely high frequencies, our eyes become sensitive to a certain portion of the spectrum and are able to see light and color. Light with frequencies between 432 trillion hertz and 732 trillion hertz becomes visible. Frequencies below 432 trillion hertz are called *infrared*. Infrared frequencies can be felt as heat, but cannot be seen by the human eye. Frequencies above 732 trillion hertz are called *ultraviolet*. Skin exposed to ultraviolet light can become damaged, as can one's eyesight. Only a small portion of the total spectrum is directly perceptible to human sensation without the aid of tools (Figure 5.2, Plate 2).

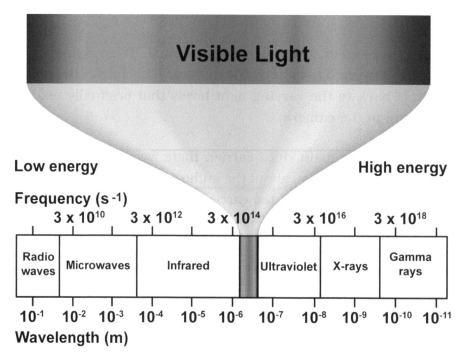

Figure 5.2 (Plate 2) Light Spectrum

Analog and Digital Broadcasting

In the United States, on June 12, 2009, all major television stations shut off their analog transmitters. From that day on, the FCC mandated digital transmission of television signals. Some low power stations were allowed to remain on the air for a few years. The plan was to have them shut down in 2015.

The frequency spectrum is divided into sections, some of which have been given names, including low frequency (LF), intermediate frequency (IF), radio frequency (RF), very high frequency (VHF), and ultra high frequency (UHF). Portions of the VHF and UHF spectrum space have been allocated for use in analog television broadcasting. Television channels between 1 and 13 are in the VHF range. Channels 14 through channel 59 are in the UHF range. Channel 1 is not used, only channels 2 through 59 (Figure 5.3).

Certain analog television channels had a greater separation in the spectrum between them than others. For example, in a city where there is a channel 2, there could not be a channel 3, because the separation between these two channels was too narrow and the signals would interfere with each other. However, in a city where there is a channel 4, there can also be a channel 5. This is because the separation in the spectrum between these two channels allowed enough room for each to transmit without interference from the other.

This additional separation is because all the TV channels are not on continuous frequencies. Instead other services appear between some TV channels. For example, between channels 4 and 5 are allocations for aviation navigation systems, a band for radio astronomy and other services for fixed position and mobile radio services.

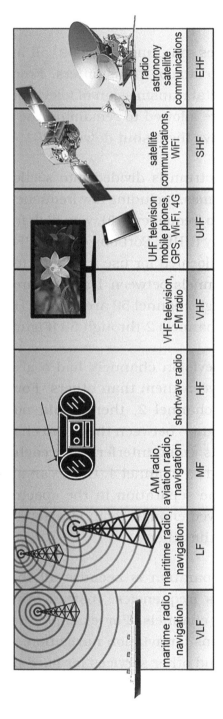

VLF	LF	MF	HF	VHF	UHF	SHF	EHF
maritime radio, navigation	maritime radio, navigation	AM radio, aviation radio, navigation	shortwave radio	VHF television, FM radio	UHF television mobile phones, GPS, Wi-Fi, 4G	satellite communications, WiFi	radio astronomy satellite communications

Figure 5.3 Frequency spectrum

In the conversion from analog to digital broadcasting, new spectrum allocations were made for the digital channels. Digital signals on adjacent channels do not interfere with each other the way analog signals did. As a result, TV channels can be next to each other, so less spectrum space is needed in each city. The FCC reassigned channels to pack them closer together and free blocks of spectrum for other uses. The digital channel assignments are focused on the original frequencies for channels 7–13, 15–19, 21–36, and 38–51. In some of the more crowded television markets, additional frequencies are being used where available.

Compacting the channels in this manner meant that most stations would no longer have the same channel number as their assigned frequency would change with digital broadcasting. Station owners were very concerned that their viewers, who for generations knew to look for their programs on a specific channel number, would not be able to find the new channel.

To create less confusion for consumers, *virtual* channels were developed. A virtual channel is a channel designation that differs from the actual assigned channel frequency. So consumers who want what they know as channel 7 can tune their TV to that virtual number, but the TV is actually set to a different frequency occupied by the analog channel 7.

NOTE In the new television standards, virtual channels are mapped out and are part of the Program and System Information Protocol, or PSIP.

Because digital signals can be compressed to fit more information into the spectrum space than analog, multiple signals can be carried simultaneously in the same bandwith through what are called

sub-channels. If a station chooses to carry multiple programs in their channel, each program stream is assigned a number with a decimal point. So if there are three programs on channel 7, as you tune up the channels you will see 7.1, 7.2 and 7.3. Note that these numbers only appear in the over the air broadcast. Cable and satellite operators that carry the local channel will assign different numbers in their channel map to the additional programs.

Cable systems can carry many more channels than can be broadcast because the cable signal does not take up broadcast spectrum space. The frequencies can overlap those used by other broadcast services, such as radio, aviation, military and public service as long as the cable itself is properly shielded so that no interference with these other services occurs.

Bandwidth

When the television system was originally created, a carrier frequency was assigned for each channel. It was also decided that 6 MHz of *bandwidth* or spectrum space would be made available for the transmission of television signals on the carrier for each particular station. A signal has an upper and a lower half, referred to as the upper and lower side bands. The 6 MHz of bandwidth in television broadcasting uses the upper side band only for transmission. If both upper and lower side bands were used, they would take up 12 MHz of space. The lower side band is not used and is filtered off before transmission. All the information necessary for the re-creation of the television signal is contained in the upper side band.

This limitation of 6 MHz of bandwidth for a television signal is one of the reasons the field process, or interlaced scanning process, was developed. To transmit all 525 lines of information at once would

take far more bandwidth than the 6 MHz allocated for each television station. Consequently it was decided, not only to minimize flicker, but also for the conservation of spectrum space, to transmit only one field at a time.

For example, channel 2 was given between 54 and 60 MHz as the 6 MHz bandwidth spread allowed for transmission. In analog television, the visual carrier was placed 1¼ MHz above the low end of the allowable spectrum. Thus channel 2's assigned carrier was 55.25 MHz.

The *audio carrier*, which was separate from the video, was always 4½ MHz above the assigned carrier frequency for video. For channel 2, this means the audio carrier was 59.75 MHz, allowing ¼ MHz of room between the audio carrier and the upper end of the allowed spectrum space. The third carrier in the television signal was the *color subcarrier*, which was discussed in Chapter 4. When a broadcast channel is selected on a television set, the receiver becomes sensitive to the particular carrier frequency in the spectrum that is assigned to that channel. The television set then receives that carrier and the information that is on it. It strips off the carrier frequency as unnecessary and demodulates the information that was contained on the carrier, and thus recreates the original television image.

In the U.S., digital television transmission uses a modulation scheme called 8-VSB. The 8 refers to the number of symbols that can be produced by a 3 bit digital system. VSB is *vestigial sideband modulation*. Like the analog counterpart, one sideband is filtered away, leaving only a small fraction, or vestigial sideband. The audio and video are combined and modulate a pilot frequency that is .31 MHz above the lower end of the 6 MHz channel.

There are other ways to modulate a digital broadcast signal, for example CODFM and QAM. CODFM is used in place of 8-VSB in Europe. QAM is a standard often employed in one of several forms by digital cable systems.

> **NOTE** The United States government mandated that all analog television transmitters must be shut down by September 1, 2015.

Satellites

Television signals are referred to as *line of sight signals* because they do not bend with the curve of the earth. They penetrate through the atmosphere and continue into space. Because of this, getting television reception beyond 80 miles or so from its transmission source becomes difficult, if not impossible. Since height plays such a major factor in sending and receiving television signals, mountaintops and tall antennas are used to provide as much range as possible from the earth. It was impractical to get any greater range until the development of satellite communications.

Satellites operate on the principle of rebound, bouncing a signal from one place to another. The concept is similar to the game of pool, where a ball is purposely banked off of one side of the table to go into a hole on the other. Satellites launched from the earth are put into orbit around the equator at an altitude of about 25,000 miles. This gives them a very high point from which to bounce signals to the earth. It allows greater geographic coverage and overcomes the problem of the *curve of the horizon*. At about 25,000 miles, the time it takes to orbit the earth matches the speed that the planet spins. These factors make the satellite *geosynchronous*, or stationary, above the earth.

A satellite will appear to stay in a fixed position in the sky for the duration of its lifespan, which is typically about ten years. At this point, solar cells begin to show their age, and satellites run out of the fuel necessary to make orbital adjustments during their lifetime.

Satellites are placed into orbit at specific degree points around the equator. The orbital space along the equatorial arc is assigned by international agreement, similar to the spectrum space in broadcast frequencies. The North American continent, including the U.S., Canada, and Mexico, has from approximately 67° to 143° west longitude. The early satellites were placed 4° apart around the equator, and each satellite had as many as 12 *transponders*, or channels of communication available. With improvements in the technology of both the antennas and the electronics, spacing has been reduced to less than 1° in the equatorial arc. Each new generation of satellite increases the number of transponders available. Currently there can be more than 50. Also, digital compression allows each transponder to carry more than one signal. Depending on the bandwidth purchased from the satellite vendor, about 10 different video signals can be handled by each transponder.

Uplink and Downlink

The area of the earth that the satellite signal covers is known as the *footprint*. The size of the footprint can be as large or as confined as the operator of the satellite wishes. For general television purposes in the continental United States, the footprint covers the entire country. In Europe, footprints can be confined to a single country or allowed to cover the entire continent (Figure 5.4).

On occasion, when long-distance transmission is required, two satellites may be used in what is called a *double hop*. For example, in

Figure 5.4 Satellite Footprint

a double hop from Los Angeles to Paris, the signal would be transmitted to a satellite over North America and received at a downlink facility in, for instance, New York City or Montreal. This facility would then uplink the signal to a satellite over the Atlantic Ocean. The signal would then be received at a downlink facility in Paris.

In setting the antenna of a satellite dish for either an uplink or downlink, there are three positions to align. The first is the elevation or angle above the earth at which the antenna is set. The second is the degree or compass heading toward which the antenna is pointing. The third is the polarity, or horizontal or vertical alignment, of the antenna. These three specifications allow the antenna to be pointed at an exact place in the sky to find the signal. The exactness of these alignments is critical.

If any of these measurements are incorrect, it is possible that the signal will be received by a satellite or transponder assigned to a different uplink facility. The result is two images superimposed on each other at the downlink facilities assigned to receive the images. This is referred to as *double illumination*. Two signals received by

the same transponder on the same satellite at the same time renders both images useless. If the satellite dish is misaligned for the downlink or reception, the quality of the image that is received will be compromised.

The size of the parabolic dish that receives or transmits a signal to a satellite also plays a factor in the ability to discriminate between the various satellites and transponders. For transmission purposes, the law requires a minimum dish size. This requirement is to assure the transmitted signal reaches its specific target, or satellite. The receiver dish can be any size, but the larger the dish, the better the reception.

Satellite signals travel at the speed of light. The actual distance traveled is almost 45,000 miles round-trip. Because of this distance, there is a delay of about a quarter of a second from transmission to reception.

Fiber Optics

Using light to transmit information is a very old form of communication going back thousands of years. Lantern light or signal fires were the original forms. Alexander Graham Bell, the inventor of the original telephone, was one of the early modern developers who used light to transmit human speech. He invented a device he called the "photophone." Bell used sunlight reflected against a membrane that vibrated from the sound of a human voice. The reflected sunlight pulses were received by a parabolic dish located some distance away. The light pulses generated electrical fluctuations in a selenium cell placed in the middle of the dish on the receiving end. This cell was attached to earphones and a battery. The cell created electrical current fluctuations that vibrated the membrane in the earphones and recreated the voice.

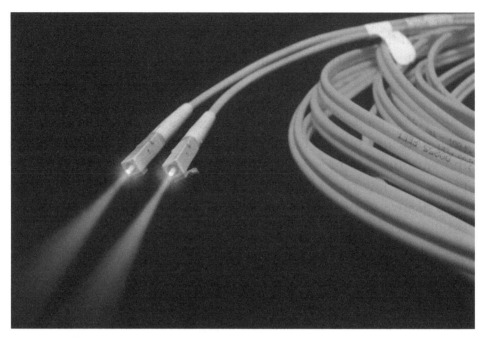

Figure 5.5 (Plate 3) Fiber Optic Cable

The use of glass fiber for light transmission was developed in 1934 with a system that used light to transmit the human voice over an optical cable network. Recent developments in fiber optics now allow the transmission of very large quantities of data at very high rates of speed. The speed and quantity of the data that can now be transmitted are a function of the development of optically pure glass, LEDs (light-emitting diodes), and the LASER (Light Amplification through Stimulated Emission of Radiation) (Figure 5.5, Plate 3).

Optically pure glass is necessary to minimize the loss of signal strength when the light moves through the glass fiber. Optically pure glass is so clear that if more than a mile of it were stacked up, you could see through to the bottom clearly.

There are advantages and disadvantages to the use of lasers and LEDs in generating the light pulses used in a fiber optic network.

The laser is more powerful and emits light at the frequencies that are optimal for use in a fiber network. The specific frequencies needed are dictated by three things: (1) the types of data being transmitted, (2) the need to minimize light loss when going through the fiber, and (3) the distance needed to transmit the data. However, lasers are expensive, require maintenance, are environmentally sensitive, and age more rapidly than LEDs. They also require periodic rebuilding or replacement.

LEDs are simpler and cheaper to manufacture, last longer than lasers, and are not as environmentally sensitive as lasers. However, they are lower in power than lasers and do not transmit well over long distances. Therefore, lasers tend to be used for long-distance transmission such as cross-country or intercontinental use; LEDs typically are used for shorter distances such as in local area network (LAN) or Fiber-Distributed Data Interface (FDDI) applications, such as within or between closely situated buildings or facilities.

As digital data consists of zeros and ones, converting the data to light pulses is not difficult. The *ones* are represented by pulses of light and *zeros* are represented by the absence of a light pulse. This is similar to CD and DVD recordings that also use a laser. However, the laser in those instances is used to burn pits, valleys, or flat areas on the recording surface of the disk. With a fiber optic transmission system, the data is sent from one end to the other but not stored in the fiber lines. The fiber is only a means of sending and receiving data, a light guide.

How Fiber Optic Transmission Works

Fiber optic transmission functions by converting electrical energy to pulses of light. These light pulses are sent through the glass fiber. On the receiving end, the light pulses are converted to electrical

pulses by a device called an *optical detector*. There are several varieties of optical detectors such as photodiodes, PIN diodes, and avalanche photodiodes. The choice of which one to use is dictated by the transmitting system and the network construction itself. The detector converts the light pulses to electrical energy, which is then used to recreate the data in an electronic device.

There are three modes of fiber optics: *single-mode fibers, multimode fibers*, and *plastic optical fiber* (POF).

Single-mode fiber optic cable uses only one mode of light to transmit the data through the fiber optic cable. In this instance the word mode refers to the way the light passes or prorogates inside the fiber. With single mode all the light behaves the same way.

Multiple streams of serial digital data can be grouped together and transmitted simultaneously through the single-mode fiber. This process is known as *multiplexing*. Multiplexing exploits the spaces that occur between packets of data to insert additional data. In this way, many data streams can be interwoven and sent simultaneously.

A single strand of single-mode fiber measures between eight and ten microns in diameter. A micron is one-millionth of a meter. Many strands of fiber may be bundled together to increase the data capacity of an installed system.

Multimode fiber optic cable uses multiple modes of propagation light to carry data (Figure 5.6). Because the core of multimode fiber is much thicker than single mode, as the light is reflected internally some part of the light takes a longer path to the other end. As the light spreads out the waves break into multiple "modes" of propagation. Multimode fibers are capable of carrying more data than single-mode fibers. Multimode fiber strands measure between fifty

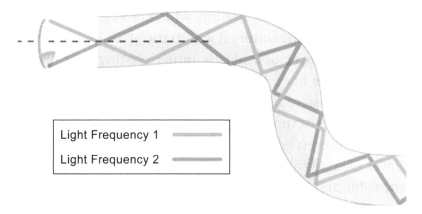

Figure 5.6 Multimode Fiber Optics

and one hundred microns in diameter. These can also be bundled together to increase the capacity of the network.

Plastic optical fiber is a less expensive form of fiber optic cable. You may be familiar with this plastic cable as it is used in consumer audio applications under the name TOSLINK. With fiber connections, a single cable can carry multiple channels of audio as you might find with surround sound systems. Because the light is attenuated more rapidly in plastic cable than in glass, these cables are limited to a few meters in length.

Single-mode fiber is capable of carrying digital data up to 5 kilometers, or about 3 miles, before the light pulses need to be reamplified to continue transmission. Multimode fiber is capable of carrying digital data up to 3 kilometers, or approximately 1.8 miles, before the light pulses must be reamplified. This range is considerably greater than the equivalent in copper wire and therefore less expensive in the overall cost of constructing a data network.

The fiber optic cable itself is made of several layers of material. The core of the cable is the glass fiber measured in microns. The glass

fiber is then coated with a cladding, which is a light reflective material that keeps the light confined within the glass fiber. Surrounding the cladding is a layer of a plastic buffer coating that protects the cladding and glass fiber, helps to absorb physical shocks, and protects against excessive bending. Surrounding the plastic coating are strengthening fibers that can be fabric (such as Kevlar or Aramid), wire strands, or even gel-filled sleeves. Surrounding all of this is the outer layer of, generally, PVC plastic that every cable has that protects the cable and has the manufacturer's information printed on it.

Fiber optic cable has many advantages over copper: It will carry considerably more data over much longer distances; the data carried is immune to electro-magnetic interference; and the cable is much lighter in weight than conventional copper cables. These are strong considerations in network and facility construction.

Fiber optics also has certain disadvantages, cost being one of them. The initial cost of a fiber network is more than using conventional copper cables. Glass fiber is also more fragile; it can be broken easily. Though fiber has great tensile strength, and so installation can be accomplished by pulling the fiber cable in the same manner as copper lines, it has very strict limitations on bends and crushing forces that can destroy the glass fiber. Splicing and connecting fiber cables is very exact, and the equipment needed to install connectors and make splices is expensive and more critical in its precision than the equivalent copper installation equipment.

Currently, fiber optic cables are primarily used by companies such as television facilities and telephone companies that require heavy data transmission. However, there is a move to install fiber to consumers in what is called Fiber To The Home (FTTH). As this is expensive and the limits of the existing system have not been reached or exceeded, FTTH is an on-going enterprise.

Color Video

6

Color, like sound, is based on frequencies. Each color has its own specific frequency in the visible spectrum and its own specific wavelength. Each color is defined scientifically by its frequency or its wavelength. Wavelength is related to frequency in that the higher the frequency, the shorter the physical length of the wave. Color frequencies are extremely high in the spectrum, and therefore are easier to notate by wavelength rather than frequency (cycles per second or hertz). Wavelengths of light are measured in nanometers, or billionths of a meter.

Additive and Subtractive

There are two ways that color is perceived. One way is by adding the frequencies of light together, which is referred to as the *additive color system*. Any light-emitting system, such as a television monitor, is additive. In an additive environment, the combination of all the primary colors yields white light. Sunlight, which is a combination of all the colors, is additive.

Conversely, solid objects, including print media, do not emit light and are perceived through a *subtractive process*. That is, the objects absorb every color frequency that the object is *not*. All colors are subtracted except the ones seen, which are reflected. Therefore, the color of a solid object is the light reflected by it. In a subtractive color system, all of the colors added together yield black. This is because all the frequencies are absorbed by the object and none are reflected.

Primary and Secondary Colors

In any color system, certain colors are referred to as *primary*. The definition of a primary color is that it cannot be created through a combination of any of the other primary colors. For example, in a red, green, and blue (RGB) color system, red cannot be created by combining blue and green, green cannot be created by combining red and blue, and blue cannot be created by combining red and green. When defining a color system, any set of colors can be used as the primaries. A primary color system can include more than three primary colors. Again, the only rule that must be adhered to is that the combination of any two of the primary colors cannot create one of the other primaries.

The basic color system in television is a three primary color additive system. The primary colors in television are red, green, and blue (RGB). Combining two primary colors creates a secondary color. Combining secondary colors creates a tertiary color. In the color television system, there are three secondary colors—yellow, cyan, and magenta—which are each combinations of two primary colors. Yellow is the combination of red and green, cyan is the combination of green and blue, and magenta is a combination of red and blue (Figure 6.1, Plate 4).

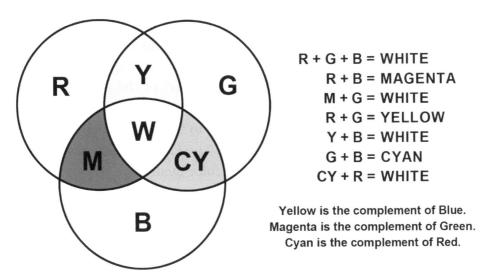

R + G + B = WHITE
R + B = MAGENTA
M + G = WHITE
R + G = YELLOW
Y + B = WHITE
G + B = CYAN
CY + R = WHITE

**Yellow is the complement of Blue.
Magenta is the complement of Green.
Cyan is the complement of Red.**

Figure 6.1 (Plate 4) Primary and Secondary Colors

The Color System

In the early 1950s, the NTSC (National Television System Committee), as well as other groups and individuals, worked toward the goal of adding color to the television signal. The first NTSC television systems that were developed were black and white, or monochrome. NTSC television transmission was created around 6 MHz of spectrum space for transmission of the black and white picture and audio signal.

The development of NTSC color posed a problem because the monochrome television system was already in place. Adding color information to the monochrome signal would have been an easy enough solution, but doing that would have taken up twice the amount of spectrum space. This wasn't possible given the system in place at the time. Also, this color system would not have been compatible with the existing black and white system. The trick to adding color

onto the existing black and white carrier was to add it within the 6 MHz of bandwidth, thus maintaining compatibility.

As with many challenges in television, part of the solution was a game of numbers. By simply working with the mathematics and altering some of the numbers, changes in the system could be made without changing its basic structure. The PAL and SECAM systems were developed following the NTSC color system.

All three systems—NTSC, PAL and SECAM—are analog methods of *encoding color* so that color signals could be broadcast. Digital systems, however, do not need to create a composite signal yet they still use some of the steps that follow to make digital color signals. These systems often honor some of the techniques that affect frame rate to provide compatibility with the vast libraries of shows recorded in analog form.

Harmonics

Harmonics and octaves play an important role in the process of creating analog color video. An *octave* is a doubling of a frequency. For example, in music, the tuning note "A" lies at 440 hertz. To hear another "A" an octave above this, the frequency would be doubled to 880 hertz. An octave above 1,000 hertz would be 2,000 hertz. An octave above 2,000 would be 4,000; an octave above 4,000 would be 8,000; and so on.

Harmonics, on the other hand, are frequencies that change by adding the initial frequency or fundamental tone to itself again, rather than doubling the frequency. For example, if the first harmonic or fundamental tone is 1,000 hertz, the second harmonic would be 2,000 hertz, the third harmonic 3,000, the fourth harmonic 4,000, and so on.

The NTSC monochrome television *line frequency* was 15,750 hertz. Harmonics of that number can be found by adding 15,750 hertz to itself. The second harmonic would be 31,500 hertz, the third 47,250 hertz, and so on. What was discovered in television was that the video information modulated on the carrier frequency seemed to be grouping itself around the harmonics of the line frequency. That left places on the carrier where little or no information was being carried.

These spaces in the carrier were discovered to be mathematically at the odd harmonics of half of the line frequency (Figure 6.2). Half of the line frequency was 7,875 lines per second. If that is the first harmonic, then the third harmonic would be 3 times 7,875, or 23,625. The fifth harmonic would be 5 times 7,875, or 39,375, and so on up the scale into the megahertz range.

An examination of the carrier revealed that space was available at these frequencies. Other video information could be inserted in these spaces without causing any interference with the existing information being broadcast. Using these spaces for color information meant that the existing black and white system and the new color system could be compatible.

NTSC Color Transmission

In order to transmit the color portion of the NTSC signal, an additional carrier frequency was needed. The idea was to make that new carrier frequency as high as possible, because higher frequency signals cause less interference and would result in fewer problems in the existing black and white system. So the 455th harmonic of half the line frequency was set as the *color subcarrier frequency*. It is called a subcarrier because it is an additional carrier of information within the main carrier.

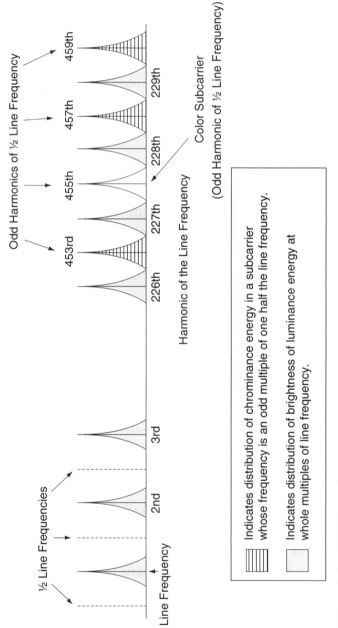

Figure 6.2 Odd Harmonics

This in itself caused another problem. All audio carriers were set at 4.5 MHz above the video carrier for all television stations. Whatever the frequency of the video carrier, television sets were made so that they would detect the audio carrier at 4.5 MHz above that. It was discovered that the new color subcarrier caused a *beat frequency*, or interference, to occur with the audio carrier somewhere in the area of 900 kilohertz. This was visible as wavy black and white lines going through the picture. The problem then became how to eliminate that beat frequency and its visible interference.

Since all television sets looked for the audio carrier at 4.5 MHz above the visual carrier, the audio carrier could not be changed. At the same time, the color subcarrier was derived mathematically from an already existing line frequency and could not be changed arbitrarily.

It was discovered that by slowing the existing line frequency of 15,750 lines per second to approximately 15,734 lines per second, the 455th harmonic of half of that would be a color subcarrier frequency that would not interfere with the audio carrier in a way that was visible. This color subcarrier fits properly in one of the spaces created by harmonics of the line frequency.

At the same time, this new line frequency, which was essentially 16 lines slower than the existing black and white system, was still compatible with existing television sets. Television equipment was designed to work within a range of approximately 1% variation in line frequency. One percent of 15,750 is approximately 157 lines. As the new line frequency was only slowed down by approximately 16 lines, it was within $\frac{1}{10}$ of 1% of the existing line frequency.

NTSC Color Frame Rate

Black and white television sets of that time could handle this change and not display any interference. The slightly slower line frequency produced a new frame rate of 29.97 frames per second. This means that it took slightly longer than one second to complete scanning a full 30 frames. With color television, the 29.97 frame rate—or 59.94 field rate—does not lock with 60 cycle current, or AC (alternating current). Consequently, synchronizing references needed to change. Therefore, analog television systems were referenced to the color subcarrier.

When digital television was developed, this non-integer frame rate was retained to make it easy to integrate legacy material in current productions. So this fix for a 1950's analog problem lives on today in the frame rates used in the United States for broadcasting. If you anticipate broadcasting your projects, it is a good practice to use the 29.97 frame rate.

Encoding the Color Signal

Unfortunately, the information needed for all three colors (the red, green, and blue signals) would not fit in the available spaces on the carrier. So a system of *encoding* was needed in order to compress all of this information onto the color subcarrier signal.

The process of encoding the red, green, and blue information is based on mathematics and, in this case, plane geometry. In plane geometry, the Pythagorean theorem states that the sum of the squares of the sides of a right triangle is equal to the square of the third side. That means that if the measurements of two sides of a right triangle are known, the third side can be calculated. Using the Pythagorean

theorem, if the strength of two of the colors is known, the third can be calculated. Red and blue became the measured signals, and green the derived or calculated value.

Vectors

Color video can be represented as vectors. A *vector* is a mathematical representation of a force in a particular direction. The length of a vector represents the amount of force, and the direction of the vector is where the vector is pointed with respect to a fixed reference, rather like a compass. The piece of equipment used to view and measure these vectors is called a *vectorscope* (Figure 6.3). Like

Figure 6.3 Color Bars on Vectorscope

the waveform monitor, the vectorscope displays an electronic representation of the visual image. (The vectorscope is discussed in more detail in Chapter 8.) In television, the direction of the vector dictates a specific color, and the length represents the amount of that color.

In a three-chip color video camera, there is one chip for each of the three primary colors. The voltage output from each of these chips is the length of the vector. The direction of the vector is specified as the number of degrees away from a reference point. In color television, the reference point is along the horizontal axis that points to the left, or nine o'clock, on a vectorscope. This reference point is defined as zero degrees.

Everything goes around the circle from that point, and from there the various colors are defined. For example, red is defined as being 76.5° clockwise from that reference point. Blue is 192° clockwise, and green is just a little less than 300° (Figure 6.3).

Color Burst

The reference point mentioned above was the part of the video signal known as *color burst*. Color burst is a burst or portion of just the *color subcarrier*. It is not modulated and does not contain any of the other color information.

The burst appears on the analog waveform monitor as a series of cycles during the back porch or the horizontal blanking period. It appears on the analog vectorscope as the line going toward the left, or toward nine o'clock, from the center of the circle (Figure 6.3). It also appears on the video monitor in the pulse cross display as a

yellow-green bar going down the screen in the horizontal blanking period (see Figure 4.2).

Note that the burst, which is made up of 8 to 11 cycles of the subcarrier, has an amplitude and direction and thus actually has a color. The burst was used as the reference for a receiver to decode the color information that is contained in each line of the incoming video signal.

Chrominance and Luminance

Color can be defined by three measurements: (1) *chrominance*, the amount of color information; (2) *luminance*, the amount of white light that is mixed with the color information; and (3) *hue*, the particular color pigment.

The combination of color and light, or chrominance and luminance, produces *saturation*. Saturation is the ratio between how much color and how much light there is in the signal (Figure 6.4, Plate 5). If more white light is added to a color, it becomes desaturated. If the white light is removed, the color becomes more saturated. Consider the difference between red and pink. Pink is the same hue as red, except it has more white light in it, which desaturates it. The method used to add more color in an additive system is to add proportionate amounts of the other two primaries, as the combination of all three is white.

In color television, the length of the vector represents the saturation, and the direction of that vector represents the hue. To be able to replicate colors correctly in a television system, there has to be an exact definition of the chrominance-to-luminance ratio for each color, as well as the direction of the vector in relation to the reference color burst. The colors are described in degrees. The

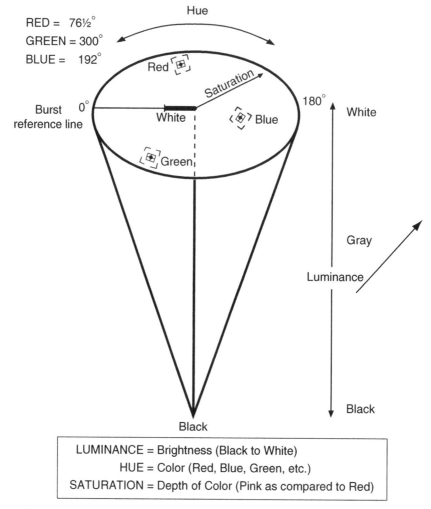

Figure 6.4 (Plate 5) Color Vector Cone

saturation or chrominance-to-luminance ratio in television is given in percentages. Those approximate percentages and ratios in the analog NTSC system are as follows:

Red = 30% luminance: 70% chrominance
Green = 59% luminance: 41% chrominance
Blue = 11% luminance: 89% chrominance

As each camera chip or pickup tube receives light, the voltage output is divided according to these chrominance and luminance percentages. For example, if the output from red is 1 full volt of video, then ³⁄₁₀ of a volt would be the amount of luminance and ⁷⁄₁₀ of a volt would be the amount of chrominance that the chip is seeing. The combination of the three television primaries in the above proportions will give white.

To separate the luminance information from the chrominance, the other side of the mathematical calculation above is used. Red is defined as 30% luminance and 70% chrominance. Therefore, 30% of whatever voltage is detected at the output of the red chip represents the luminance information. White is the sum of 30% of the output of the red chip, 59% of the green, and 11% of the blue. This signal is transmitted as the black and white information on the main picture carrier frequency. The symbol to represent luminance in video is the letter Y. Black and white receivers use only this information and do not decode the color information that is inter-woven in the main carrier.

NOTE These percentages were changed a bit when high definition video was defined. The approximate percentages for HD signals are Red = 21%, Green = 72%, and Blue = 8%.

Color Difference Signals

The calculations used to create the luminance signal are also used to create the chroma or chrominance information. The color information minus the luminance information is known as the *color difference signal*. Mathematically, this would be shown as Red-Y (Red minus luminance), Green-Y, and Blue-Y, or R-Y, G-Y, and B-Y. Based on the Pythagorean theorem, only two signals are needed to

calculate the color information. R-Y and B-Y were chosen because they contain the least amount of luminance information and therefore conserve bandwidth.

The designations R-Y and B-Y were later changed to Pr and Pb for analog signals and Cr and Cb for digital signals. Thus, Y, R-Y, B-Y would be designated either as Y, Pb, Pr or as Y, Cb, Cr. As analog video is replaced by digital, the Pb and Pr designations are no longer in common use and are being replaced by the Cb, Cr designations.

> **NOTE** It is not uncommon to see these signals also represented as YUV. Here the color difference signals are noted as U and V. This is not strictly correct, as that designation is specific to analog signals only.

The color difference signals for transmission are created by measuring the output of the red and blue chips and the luminance signal. This results in vectors which appear 90° apart from each other, creating two sides of a right triangle—on a vectorscope, the R-Y axis goes straight north and the B-Y axis goes straight east (Figure 6.5).

Once the color information from the red and blue outputs has been measured, simple arithmetic dictates what the green output is without actually having the information on the received signal. This process is known as encoding and *decoding* color.

At any given instant, knowing the vector length and angle, circuits in the receiver can reconstruct the original strengths of the R-Y and B-Y signals that produced it. From these two signals and Y, the G-Y signal can be calculated. The color television picture is then produced by combining each of the color difference signals, according

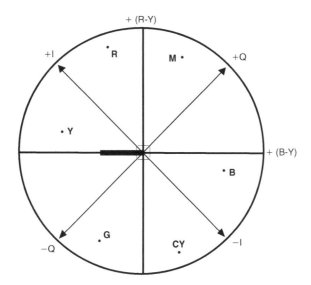

Figure 6.5 Vector Display

to the defined percentages, with the luminance information that was on the video carrier.

While the color difference signals were originally designed to allow the extraction of a black and white signal for compatibility with monochrome receivers, they live on in the digital world. The human visual system is very sensitive to luminance information, but less so to chrominance. By using the color difference matrix math to produce separate luma and chroma difference signals of the red, green and blue from the camera, different amounts of compression can be applied to the color part of the signal, leaving more data for the luminance information. Compression will be discussed in detail in Chapter 14.

Other Color Standards

Like NTSC, PAL and SECAM are ways to make an analog color video signal. PAL and SECAM share the same line frequency and frame

rate, which is different than NTSC. PAL and SECAM are different from each other, and from NTSC, in the way they process color. In the PAL system, the color difference signals are encoded on two separate subcarriers. This differs from NTSC, which encodes both color difference signals on one subcarrier. By using two subcarriers 90° apart in time from each other, color phase errors, which appear in NTSC as a change in hue, appear in PAL as a slight desaturation of the color image. There is no adjustment in the PAL color system for saturation. That aspect of the signal is fixed. Because of this encoding process, color in the PAL system is truer and more consistent than it is in NTSC.

In SECAM, color difference signals are encoded one at a time in sequence on one color subcarrier signal. The receiver stores the first color difference signal, awaits the second, combines both, and creates the color image. Because each of the color difference signals is handled separately, a greater quantity of information can be encoded. As both color signals are stored within the receiver and then decoded, the color achieved is the best of all three standards.

Monitoring the Image

In order to ensure a video signal looks its best on the receiving end, it must be set up and monitored on the sending side. There are two general aspects that are important when preparing a video to broadcast or export: monitoring the image and measuring the signal. The video signal can be viewed and measured on a variety of test equipment such as scopes, which will be addressed in the following chapters. The actual video image, however, is viewed on a monitor. The monitor is part of the group of test equipment used to judge the quality of a video image. Adjustments made to a monitor do not affect the video signal itself.

Types of Monitors

Monitors are available in a number of quality grades and a broad range of prices. At the low end, for a few hundred dollars, are sets sold as consumer television displays. While these can produce a very good image, they do not have the tools necessary that are part of a professional monitor. Their color is often set to be pleasing rather than accurate to make them more appealing for purchase.

In the middle range are professional monitors that have better color rendition and control. They can cost several times what a consumer set does, primarily as there are no efficiencies in mass production to help defray the cost of the additional features. These monitors are good for most general television production applications. They may be stand-alone single displays, or they may be multi-image processors that can display several small images on a single large monitor. This type of display is often seen in control rooms where many images must be viewable at the same time.

Finally, there are top quality monitors used for critical color judgments. These are often found in finishing editing suites and in color correction applications. Called "Grade 1" or "Reference" monitors, it is not uncommon to see these units costing thousands of dollars each. If you are making the final color judgments on high-end or broadcast productions, these are the units to seek.

Video Displays

The original method of displaying video was through the use of the cathode ray tube (CRT). This type of display is called direct view, with the receiver or monitor being rack-mounted or placed on a stand. The screen size ranges from a few inches up to a fifty-inch picture tube. CRT's are no longer manufactured, replaced by several different flat screen technologies described below.

LCD

The LCD (liquid crystal display) uses a fluorescent backlight or, in newer versions, LEDs (light-emitting diodes) to send light through liquid crystal molecules. On the display screen there are red, green and blue pixels that are connected by an array of wires. By applying

voltage to the pixels, backlight can either be allowed or prevented passage, thereby illuminating the screen. As most of the light generated by the backlights is blocked at any given time, these displays draw quite a bit of power. LCDs are not perfect in blocking all the light when they should be black, which makes getting truly deep black images a challenge.

NOTE A new monitor technology called Quantum Dots is emerging as of the writing of this book. The future of monitors seems to be moving in the direction of being able to show a fuller spectrum of color, closer to what the human eye can see.

OLED

Organic light-emitting diode uses a film of organic compound that lights up when an electric current is passed though it. The film is between layers of electrodes that can be switched on and off independently. Red, green and blue elements placed either side by side or one in front of the other in layers provide the color. One big advantage of OLED technology is that it does not require a backlight. Each pixel lights independently. This greatly reduces the power necessary to operate the display when compared to LCD and LED displays.

Plasma

A plasma is an ionized gas in which some of the electrons have been disassociated from some of the atoms or molecules in a substance. These free electrons make the plasma electrically conductive so that it responds to electromagnetic fields. The plasma video display uses the ionized gas or plasma created by an electrical charge passing through it. In the plasma video display, argon, neon, and xenon are used to

produce the colors and luminance. The video screen is composed of an array of red, green, and blue phosphors that are located between two sheets of glass. Each group of three phosphors composes one pixel. An electrical pulse is used to excite the phosphors causing the creation of plasma. The plasma emits ultraviolet (UV) light that causes the phosphors to glow. While plasma displays produce great pictures, their high cost and the commercial success of LCD and LED systems caused manufactures to abandon them in 2014.

Projection Systems

Projection systems are available as front-projection and rear-projection types. In a front-projection system, a video projector is used to illuminate a screen in much the same manner as film is displayed. The screen size can be as large as one hundred inches measured diagonally. Rear-projection systems generally have an internal projector and a mirror to reflect the image on to the viewing screen and are viewed in much the same manner as a direct-view CRT. The viewing screen is generally forty to eighty inches in size, measured diagonally. In the older type of projection systems, both front and rear systems used three CRTs—one red, one blue and one green—that are aligned to create a single image on the viewing screen.

The newer types of displays include Digital Light processing (DLP), liquid crystal display (LCD), liquid crystal on silicon (LCoS) and plasma.

DLP

The DLP uses an optical semiconductor called a Digital Micromirror Device developed by Texas Instruments. The device is composed of millions of microscopic mirrors arranged in a rectangular array

Microscopic Mirror

Microscopic Mirror

Silicon Chip

Figure 7.1 DLP Microscopic Mirrors Technology

on a silicon chip that rotate or move thousands of times a second (Figure 7.1). They direct light toward or away from specific pixel spaces. DLP projectors can use three individual chips, one for each primary color.

There is also a single-chip version that works by focusing a high-intensity lamp through a condensing lens. The condensed light then passes though a six-panel color wheel that filters the light into red, green and blue. Each color appears twice on the filter wheel. The light then passes through a shaping lens. This shaped light source focuses on the chip, is reflected by the microscopic mirrors, and then passes through a projection lens onto a screen. The movement and position of the mirrors creates the color image on the screen.

LCoS

The LCoS display is also a projection technique, used primarily for commercial projection systems. It is similar to the LCD except that it uses an extra layer of material. This layer is silicon, a highly reflective surface located behind the liquid crystal layer, and it increases the intensity of the light shining through the crystal layer.

It therefore transmits a greater amount of light than the LCD alone, creating a brighter image.

The Human Eye

The human eye is not an absolute measuring device; it is an averaging device. Eyes, like noses, get desensitized when exposed for too long to the same stimulus. As a result of looking at one or more colors for a long period of time, mistakes can easily be made when trying to color balance a video image. During setup, it can be helpful to look away periodically for a few seconds so the eyes don't become desensitized. In the case of a long setup procedure, it might be best to walk away for a few minutes into a different room with different light. It is imperative to always apply setup procedures to the monitor in the same light conditions that will be used when viewing the video image.

Color Bars

The test signal traditionally used to set up a video monitor is *color bars*. It is the international professional reference used to ensure that the color of the images that follow look the same on any monitor as they did when they were created. The color bar signal contains everything needed to set up a CRT type color monitor and the signal itself, which will be discussed in the following chapter (Figure 7.2, Plate 6).

There are several varieties of color bar displays approved by the International Organization for Standardization (ISO), the agency that sets international standards. Different color bars have different elements. Although the elements may differ, all color bar signals have the same basic chrominance and luminance references.

(A)

EIA Split Field Bars

(B)

Full Field Bars

Figure 7.2 (Plate 6) Color Bar Displays

Figure 7.3 Stair Step (Gray Scale) Test Pattern

Gray Scale

Color bars do not have a reference to set the contrast or bright part of the picture. For that a test pattern called a stair step or gray scale is very useful (Figure 7.3). This pattern can be made by a test generator or may be found on video calibration disks.

Setting up Monitors

Because analog CRT type monitors were subject to drift in their setup, users were encouraged to check the settings of their monitors at least once per work shift. While current displays hold their setting quite well, differences in room lighting may require adjusting monitors to produce the best picture. While not an issue in control rooms or edit bays, monitors used for field work should be checked when there is a significant change in the amount of light in the environment where the monitor is being used.

If you are using a consumer product as your monitor, it is important to do a complete setup when you first get the monitor. Consumer

equipment is most often set to give the brightest picture possible in a brightly lit room like a store. As you are unlikely to be working in that bright of a space, setting the monitor for the light level you are working in is critical.

Computer monitors are used by many video makers as their main method to view their work. Computers are not designed for just video work, and may not present an accurate display of your material. In addition to the settings for your monitor, you will need to make adjustments to your computer's video hardware. Find the software control panel for your video card and follow the calibration instructions, paying special attention to the gamma setting.

Gamma Curve

Gamma is the property of displays that deals with the relationship of the amount of light produced for the amount of voltage applied to the display. Older tube type displays were non-linear, meaning that it took different amounts of change voltage to see a difference in the dark part of the picture than in the lighter parts. This takes the form of a curve as in Figure 7.4.

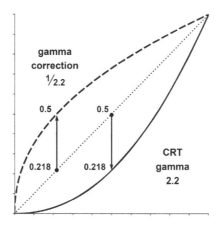

Figure 7.4 Gamma Curve

Early broadcasts fixed this problem in the camera, applying an opposite curve. By building this circuit into the camera rather then each TV, sets could be priced more inexpensively. Now a larger range of display types are used, each with different gamma characteristics. Our video, however, still carries the correction factor for CRT's. So the displays must now be adjusted to suit the video gamma, which is normally set at 2.2 when you are calibrating your computer's video card.

How to Set Up a Monitor

Monitors designed for video evaluation are designed to be as neutral as possible, so that they can be used to judge the video signal they are displaying. Consumer equipment, however, is configured to produce the most "pleasing" possible picture. Should you choose to use one of these devices in a professional situation, you will need to make some initial settings.

First, check and set the color temperature. As anyone who has forgotten to white balance a camera can tell you, light can vary from a warm yellow to a cool blue. Flat screen TV type monitors often have controls to set them to be warm or cool. Often called "picture mode" or something similar, you need to find the control that adjusts color temperature and choose the most neutral setting. This is easiest when looking at a black and white picture. If your monitor offers color temperature options labeled with actual values, the proper one is 6500K or D65. This is the approximate color of daylight.

Next find the detail or sharpness control. The purpose of this function is to make images look sharper. This is done by adding a thin white border around high frequency or detailed information in the picture. While this often produces a seemingly crisper image, it will

be a problem if you are trying to evaluate a shot for focus or depth of field. Turn this down to a very low setting, if not off completely.

Then switch off the dynamic contrast. This function of consumer monitors is to try and increase the contrast range of the monitor. By dynamically changing the brightness of the backlighting system to match overall scene brightness, manufacturers can claim better contrast ratios for their displays. However, if you are using a monitor to judge the quality of your work, this function may mask problems in your shot.

Finally, set the overall backlight intensity of the monitor for light level in your room. If you are working in a dark room, you do not need the full light output of the monitor. Setting the proper amount of backlighting will allow you to get proper setting for brightness and contrast and ease eyestrain. There is not an exact value for this, but you should set a level of backlight that allows you to examine the highlights in your material and lets the blackest parts be as dark as possible.

Setting the Brightness and Contrast

The most important aspects of changing a monitor for different room lighting are the brightness and contrast settings. The brightness setting primarily affects the dark part of the images, while contrast is the brighter parts. This is best done with a black and white stair step or gray scale pattern as shown in Figure 7.3.

Start with the contrast control and adjust the monitor so that the brightest two chips on the stair step pattern are just different. It is often easiest to do this by turning the control way up and then slowly lowering it, watching for a difference to appear. Next use the brightness control to set the two darkest chips so they are just

different. After you set brightness go back and check the contrast with the white chips again. The controls interact and it could take a few back and forth adjustments to get the setting just right.

Setting the Color

The next step is to set the amount of color and the hue (or tint) of the color. To do this you need to use SMPTE bars and be able to look at just the blue channel output. Professional monitors have a blue-only setting that turns off the red and green channels to the monitor. Consumer equipment and computer monitors most often do not have that setting. To set the color and hue on a consumer monitor, you will need to use a blue filter held over your eye that completely blocks the red and green light. You can experiment with several thicknesses of blue lighting gel or photographic filters until you find a combination that works.

In a SMPTE color bar pattern, there are small chips of color located below four of the color bars. These chips are arranged so they contain the same amount of blue content as the bars above them. Adjust the color control so that the outer bars and chips (the white and blue) are the same shade. Then adjust the hue control so that the inner bars (magenta and cyan) match. Again, you may find a small amount of interaction between these settings.

Color Image Tools

The above procedures will do a good job of getting a decent display. However, for an even better result, there are tools designed to help set up monitors.

The first is a video calibration Blu-Ray disk. These disks have test patterns and instructions designed to help set up home theater

systems. They will also help achieve a non-professional monitor setup. As a bonus, some come with the blue filter you need to set color and hue on monitors without the blue-only function.

For the most accurate setup, however, a device called a Colorimeter should be used to properly balance the RGB values of the display. Colorimeters are a form of light meter that is held against the surface of the display. These devices let you measure and balance the amount of red, green and blue light produced by the display.

Wrap Up

Which display to choose requires a bit of compromise. The obvious answer is to select the best quality picture that a budget allows for each application. The level of quality expected for a critical evaluation unit is entirely different than that for a monitor that is only necessary to verify the presence of a signal.

Signal Monitoring

In the previous chapter you learned that a video monitor is used to judge the quality of an image. To measure the video signal itself, you use electronic measuring tools. Traditionally in analog video this was done with oscilloscopes designed specifically for video signal measurement (Figure 8.1). Today signal measurement takes many forms. Professional video production centers will often have stand-alone instruments, similar to the oscilloscopes they replace. Often many of the functions of those instruments can be found built into video production software tools such as editing software. Professional level video monitors also include many of the tools found in stand-alone instruments. This chapter will start by taking

Figure 8.1 Vectorscope and Waveform Monitors

a look at the older analog devices, as the way they work is the basis for how we measure signals today.

Color Bars

In the previous chapter, you learned that color bars were used to set up a video monitor. The same color bars are used to measure the quality of a video signal path. As the most frequently seen test signal, color bars come in several different presentations, including full field bars, EIA split field bars, and SMPTE. These were developed over time to address different aspects of the video setup process.

The SMPTE bar signal contains a 100% white chip, a 75% white chip, and the three primary and three secondary colors. There is a chip for black, which measures 0% in the digital world or 7.5% in the analog domain. Contained in the black chip are two smaller chips. One is a few units "darker" than black and one is a few units "brighter." These chips make up the PLUGE (Picture Lineup Generating Equipment). This signal is designed to help set the brightness on monitors. Adjusting the brightness so the brighter chip is just visible and the darker merges with the area around it will insure a proper black level setting (Figure 8.2, Plate 7).

True video generally does not reach the levels that are contained in a color bar pattern, because color bars by their intent are designed to indicate the limits of the signal (i.e., the highest luminance level, the highest chrominance level, the lowest luminance, and so on). If the colors were presented in the color bar display at 100% of their true values, the reference signals would be beyond the measuring capabilities of the analog waveform monitor. For example, SMPTE defines yellow as 133 IRE units when fully saturated. The graticule on the analog waveform does not measure beyond 120 IRE units. For this reason, a color bar signal reduced

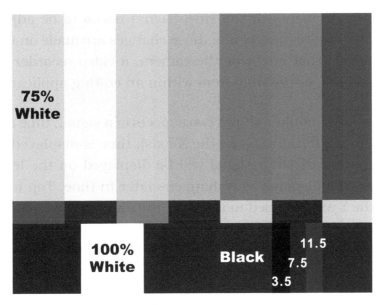

Figure 8.2 (Plate 7) PLUGE Bars Signal

to 75% of true levels was created, and this 75% color bar is the general standard in use. The yellow bar in the 75% color bar display appears as 100 IRE units.

NOTE Some documents refer to this as 75% bars and they mean the traditional bars described above. There is a 100% color bar signal, but it is much less commonly seen.

Analog Waveform Monitors

The waveform monitor is used to make sure the video signal is being recorded or reproduced within broadcast specifications. When analyzing the video signal on a waveform monitor, the view of the signal can be changed and certain parts enlarged in order to take measurements. The video signal is not affected as you take

these measurements. If the video signal needs to be adjusted to meet broadcast requirements, those changes are made on the video source itself. That might be the camera, a video recorder or play-back machine, or possibly from within an editing application.

The waveform monitor shows two aspects of a signal, time and voltage. From left to right (along the X axis), time is displayed. Things that happen early in a signal will be displayed on the left, while the right side displays what happens later in time. Top to bottom (along the Y axis) is used to measure the amount of signal present, or the *voltage* of the signal. Combining the two allows the operator to see how much signal is present at any point in time.

NOTE While analog monitors are not in use much today, learning how they work provides a strong foundation for the process of measuring a video signal in general.

Graticule

Analog waveform monitors have a small CRT (*cathode ray tube*) that displays an electronic representation of the video image. In front of the CRT is a glass or plastic plate known as the CRT *graticule*. The CRT graticule is made up of vertical and horizontal lines used to measure the video signal. The horizontal lines are in IRE *units* of video, measurements that were first developed by the Institute of Radio Engineers (IRE). The IRE scale ranges from –40 to 100 units. The measurement from –40 to 100 IRE is referred to as one volt of video peak-to-peak (Figure 8.3).

The horizontal line at zero units is referred to as the *base line* (Figure 8.3). It is marked with vertical divisions in microseconds

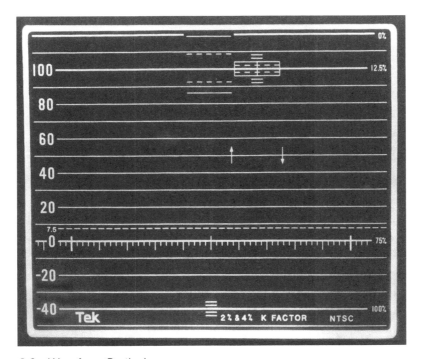

Figure 8.3 Waveform Graticule

and tenths of microseconds. The shortest vertical lines represent $2/10$ of a microsecond, and at every fifth $2/10$ of a microsecond is a slightly taller line that represents a 1-microsecond division, or 1.

Signal Components on Graticule

When reading an analog composite signal on the waveform, the zero-units line of the video signal is always set on the base line of the graticule. The *horizontal sync pulse* should be at the –40 units line beneath the base line. The color burst portion of the signal should reach from –20 IRE units to +20 IRE units, for a total of 40 IRE units (Figure 8.4, Plate 8).

Figure 8.4 (Plate 8) Color Bars on Waveform Monitor

The active video signal, when viewed as luminance only, occupies the range between 7.5 units and 100 units on the monitor. In Figure 8.2, the white portion of the video color bars generates the top part of the waveform display. The horizontal line near the top of the graticule, which should match the pure white square patch of the color bar signal, is equal to 100 units. Analog black, which is also referred to as *setup* or *pedestal*, is the darkest part of the signal and should be on the 7.5 units dotted line, 2.5 units below the 10 unit line. A proper 100% video signal will measure 140 units on the graticule scale from the horizontal sync to the white peaks. Again, horizontal sync takes up the portion between –40 and 0 units, while the active video image extends from 7.5 to 100 units on the scale.

Signal Measurement

Waveform monitors have the ability to change how much time is displayed from the left to the right of the scope. Often, such as in Figure 8.4, this adjustment is called SWEEP. While the default is to show 2 full lines, the time can be changed to show all the lines in both fields simultaneously. In a similar fashion the signal can be expanded, or magnified in either the vertical or horizontal axes for closer examination.

Filters

With the addition of the color subcarrier to the analog video signal, scopes needed the ability to separate the two signals for inspection separately. In the Input section of Figure 8.4, the button marked FILTER selects the content of the display as far as luminance and chrominance are concerned. A FLAT display shows the luminance and chrominance of the signal combined. Low Pass (LPASS) selects the luminance portion of the signal only. Likewise, chrominance

Figure 8.5 Low Pass Display

(CHRM) selects the color portion of the signal alone. Figure 8.5 shows half the scope with the color subcarrier filtered off on the left, and combined with the luminance on the right.

Reference

Waveform monitors needed to know when to start the scanning process in the same way a video monitor did. Reference Sync does just that. The reference button (REF) is used to select either an internal or external reference. In the Internal mode the sync signal that is shown on the display also triggers the start of lines and frames on the scope. External reference (EXT) is used to synchronize the scope with a separate source of sync. Then the signals from devices such as cameras or recorders can be measured in time against that reference. This synchronization process is referred to as video timing. In order to switch cleanly between signals, each

device's sync pulses must perfectly align, and video timing is the process of adjusting each signals arrival at the scope as measured against the external reference.

Viewing an Image

A color bar signal contains precise amounts and durations of chrominance and luminance that appear in an ordered fashion. This signal is used to ensure the video images that follow will fall within the specifications of a specific standard. However, when video images are viewed on a waveform monitor, the scope reflects the chrominance and luminance levels of the video image, which never appear as precise and ordered as color bar signals. Often, there is a wide variety of image elements spread over the peaks and valleys of the entire signal range (Figure 8.6).

Figure 8.6 Image on Waveform

Analog Vectorscopes

The *vectorscope* is another type of oscilloscope used to measure the video signal. Unlike the waveform monitor, which measures the luminance and timing aspects of a video signal, a vectorscope is used to measure the saturation and hue. The name *vector* comes from mathematics. A vector is a geometric form that has magnitude and direction. For video instruments the direction is measured in a circle, much like a clock face, and represents the hue of the color. The magnitude or amount of the color is the saturation, which is measured as the distance from the center of the circle.

Graticule

As with waveform monitors, vectorscopes have a small CRT that displays the signal. The CRT is behind a glass or plastic plate inscribed with a circle that had markings and lines, which is the graticule (Figure 8.7). The markings on the circle itself represent degrees from 0 to 360. The thinner, individual notches or markings represent differences of 2 degrees. The bolder markings represent 10 degrees. The 0 point or mark is at a nine o'clock position on the scope. The degree markings move in a clockwise position from that point.

Axes

There are two perpendicular lines that cut horizontally and vertically through the circle. The line that goes from 0° to 180° is referred to as the *X axis*. The vertical up and down line that goes from 90° to 270° is called the *Y axis*. Analog scopes have a second set of axes, used to measure the subcarrier in a composite signal. This set, called I and Q, are not used with digital signals.

Figure 8.7 *Vectorscope Graticule*

Vector Readings

On the graticule, there are individual boxes that are located within the circle. Starting from the nine o'clock position and moving clockwise, these are yellow (YL), red (R), magenta (MG), blue (B), cyan (CY), and green (G). The three primary colors, red, blue, and green, are each separated by one of the secondary colors. The secondary color is a mixture of the two primary colors on either side of it. The box placement represents the direction or hue of a particular vector. The boxes are also used as an indication of the correct length of a vector, or its saturation.

The proper setup of the chrominance signal for color bars would show the center point of the signal aligned with the center point of the circle scale (Figure 8.8). The burst of the color subcarrier signal, the short line on the X axis, should point directly to the

Figure 8.8 Vectorscope

nine o'clock position. Much like a video image on the waveform, the color bars were designed to fit into specific color boxes in the vectorscope.

Active Video

During active video, the vectorscope does not show straight lines and sharp dots. The display shows a fuzzy blob of energy. This blob represents the variety of colors in the television picture rather than the pure colors that existed in a color bar signal.

Wrap Up

Technology has changed a lot since analog video, but it's important to keep in mind that it was the basis of how we work with and measure video today. The following chapter discusses the software and test equipment used to measure the digital video signal.

Digital Scopes

Just as the change from analog to digital has caused significant changes to the video signal, it has also caused similar changes to the way that we measure the video signal. Scopes have changed from oscilloscopes to computer generated graphic displays of the video signals. Some of these instruments take the same stand-alone form as their predecessors. Others, called *rasterizers*, separate the electronics and display. The advantage of the second format is that a much larger display can be set to show several different displays simultaneously (Figure 9.1).

Figure 9.1 Stand-alone Scope vs Electronics plus Monitor Display

The Digital Signal

While the digital signal, as with analog, is 1 volt peak-to-peak, some of the components and measurements within that 1 volt are displayed and measured differently on a digital scope. One volt is divided into a thousand units, each referred to as a millivolt, expressed as mV (Figure 9.2). On the graticule, 1 volt of digital video is displayed from –.3 volts (or –300 mV) to a peak of .7 volts (or 700 mV) for a total of 1 volt. Active digital video is displayed between the 0 base line on the graticule and .7 volts. This relates to 100% video, or 100 IRE units on an analog waveform monitor.

Since the digital signal is a stream of digital information, it does not require the same synchronization elements that an analog signal did. Sync is now handled by two short data bursts on each line of video called Timing Reference Signal or TRS. This signal consists of 40 bits, or 4 10-bit words, that contain flags that identify the Start of Active Video (SAV) and End of Active Video (EAV).

When a signal is displayed on a digital waveform monitor, there is no horizontal or vertical sync display within the signal (Figure 9.3). On a vectorscope, there is no synchronizing color burst, which used to appear in the nine o'clock position on the vectorscope graticule.

While analog black was displayed at 7.5 IRE units, true black in a digital signal is 0 volts, and is therefore displayed at the baseline on the graticule. Because the analog transmission system was designed to put out peak power at the lower video levels, if the analog black signal were true black, or 0 units, the analog signal could electrically overload the transmitter. Since a digital signal is a stream of data or digital bits, the levels do not vary over time, but instead remain constant. As a result, digital video can utilize the full range between true black and full luminance.

Figure 9.2 Digital Waveform Monitor

Figure 9.3 Digital Signal without Sync

Unlike the older analog waveform monitors marked in IRE units, the scale on the graticule of a digital scope is marked in millivolts (mV) and ranges from –300 mV to +800 mV, with each major division being further subdivided into five minor divisions, each one representing 20 millivolts (Figure 9.3). The horizontal reference line, or base line, is the heavy line at 0 with three large vertical markings between the –.1 and .1 lines. This line is alternately referred to as the 0% line, 0 mV, zero line, blanking level, and black level.

Software Digital Scope Displays

In addition to the waveform and vector displays from classic analog scopes, there are other signal attributes that can be displayed by modern scopes. Some are common to most models of scopes, and others are proprietary displays unique to a specific manufacture or model. Many video content creators have access to scope displays that are built into a software application on their computers.

NOTE The scope displays used in this section are from Apple, Adobe, and Avid applications, but you will find similar displays in many other content creation programs.

Measuring Luminance

In Figure 9.4 (Plate 9), the image, in this case color bars, is displayed on the right side, and the luminance waveform display of the image (color bars) is on the left, as seen in Apple's Final Cut Pro editing application. This display is a digital recreation of the way analog waveform monitors show luminance levels. One advantage of software-based scopes is that they often show the color they are representing in the display, making it easier for the operator to find the part of the display that represents what is in the video image. If you look at this image in color Plate 9, you can see that each color bar is represented by that bar's color in the waveform display.

In Figure 9.5 (Plate 10), a normal video scene is represented on the right side of the monitor and the luminance waveform display of

Figure 9.4 (Plate 9) Color Bars on Software Scope

Figure 9.5 (Plate 10) Normal Video Scene on Software Scope

that image is on the left. In the waveform display, notice the upper luminance levels (appearing almost as horizontal wavy lines), which represent the bright sky. Look closely at that area and you can see where the white clouds start and stop. Notice the sharp vertical V-like dip in the middle of the display. When you look at the image on the right, you see that dip is created from the darkness of the statue, which is much darker than the clouds.

Content creators with a still photography background may recognize the *Histogram* display (Figure 9.6). The Histogram display is the predominant measuring tool used in image editing programs such as Adobe's Photoshop. A Histogram shows the distribution of dark and light areas within the digital image as a pixel density display. The Histogram is displayed within horizontal and vertical axes. The horizontal axis represents levels of brightness from black at the left end of the scale to white at the right end of the scale. Pixel density is read on the vertical axis with the density increases shown from low density at the bottom of the vertical axis, to higher density moving up the vertical axis. For example, the mountain-like clump of dense pixels on the right side of the display in Figure 9.6 would represent the brightest part of the image, in this case the white clouds and bright sky.

At each level of brightness along the horizontal axis, the height of the display line indicates the pixel density at that specific light level. The more pixels at that level of brightness, the taller the display line. Thus, dark areas of the image are concentrated on the Histogram display at the left side and bright areas of the image are shown farther to the right along the horizontal axis. Bright images would skew the Histogram toward the right end of the display and predominantly dark images would skew more toward the left. An evenly lit image would distribute the pixel density display more

Figure 9.6 Histogram Display

evenly across the Histogram screen. In motion images, the Histogram will be constantly changing as the images change.

> **NOTE** Colors may also be displayed as a Histogram. Each of the colors appears on a display, much the same as luminance does, showing the pixel density or concentration of each color.

Many image-processing programs use the Histogram display as part of their user interface for adjusting levels. In Figure 9.7, the Levels filter in Adobe After Effects shows the Histogram with the black levels set to a typical level, then with the blacks crushed. Note the small triangle below the left end of the Histogram display on the left (circled). This acts as the control for the dark parts of the image and indicates how many dark pixels are being clipped to produce the second image. The image on the right shows the small triangle further to the right, producing an overall darker image.

Figure 9.7 Levels Filter Showing a Default Image (left) and with the Image Made Darker (right)

Measuring Color Information

To measure color, you often use a Vectorscope. Like its analog predecessors, the hue of the color is the position around the circle, while the saturation is the distance outward from the center of the display. In Figure 9.8 (Plate 11), you see a digital representation of a vector display of color bars. Like the color bars image in Figure 9.4, the vectors in this display take on the color they are representing.

One very useful marker here is the line from the center of the scope that extends to the upper left, between the yellow and red vectors. This is the skin tone line, which can be helpful when working with certain close up shots of faces. In Figure 9.9 (Plate 12), the gold

Figure 9.8 (Plate 11) Color Bars Displayed on Software Vectorscope

Figure 9.9 (Plate 12) Video Scene Displayed on Software Vectorscope

statue and yellow flowers are causing the vector display to lean toward the skin tone line.

The amount of color, or saturation, in video is also displayed in a Vectorscope display. In Figure 9.10a (Plate 13), the vector display in the Avid Media Composer color correction tool shows an image with normal saturation. In the second version, Figure 9.10b (Plate 14), the saturation for the same image is increased to 200 percent. Notice the red stripe on the taxi in the middle of the image. On the saturated version, the red energy in the Vectorscope reaches out nearly to the box for the red bar in color bars.

Figure 9.10a (Plate 13) Normal Saturation

Figure 9.10b (Plate 14) Increased Saturation

There are other ways to view the color portion of an image in scopes. For example, Figure 9.11a (Plate 15) is a waveform display in what is referred to as *Parade Mode.* In Parade Mode, the individual color channels are shown one after the other with separate representations for red, green and blue. This display is useful to set color balance in a shot. In the video scene (Figure 9.11b, Plate 16), you can see the blue levels are higher than red or green, meaning there is a bit more blue in the image.

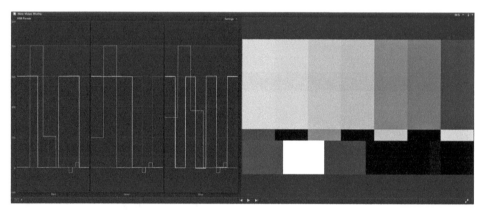

Figure 9.11a (Plate 15) Color Bars in Parade Mode

Figure 9.11b (Plate 16) Video Scene in Parade Mode

Color Gamut

In a video signal, and other areas of color reproduction such as video monitors and computer graphics, there is a range or gamut of allowable values that make up a specific *color space* or *color gamut*. Color space in video is defined as having three attributes. For example, one color space, RGB, uses the three primary colors, red, green and blue. Another color space uses luminance and color difference signals, or Y, Cr, Cb. HSV space defines color by its Hue, Saturation and Value (or brightness). Each of these color spaces contains colors that may not be reproducible in one of the other color spaces. When thinking of 4K/UHD video, many people may first think of its greater image resolution. But it can also produce a much wider range or gamut of colors than say HDTV video (Figure 9.12, Plate 17).

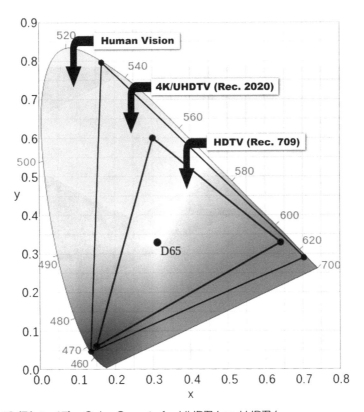

Figure 9.12 (Plate 17) Color Gamuts for UHDTV and HDTV

NOTE The specifications for HDTV color video are outlined in the ITU-R Recommendation BT.709, often referred to simply as Rec.709 or BT.709. The specifications for 4K/UHDTV color video are defined in the ITU-R Recommendation BT.2020.

Diamond Display

The *Diamond display* is a reliable and useful indicator that an image or graphic falls within color gamut. If a signal extends outside the diamond, it is out of gamut. If it stays within the gamut, it is considered to be *legal*. The way the gamut is identified on the Diamond display is by simple vectors that represent colors. Together, these vectors form two diamond shapes (Figure 9.13, Plate 18). Any signal that is outside of these diamonds, or this color

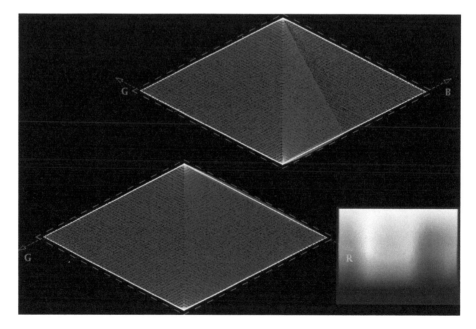

Figure 9.13 (Plate 18) Diamond Display

gamut, is outside the color space limits and may not be reproducible by a color monitor or may not translate properly if the signal is converted to another format. This display is used to ensure that the color portion of the signal is not oversaturated. If the signal is oversaturated, the portions of the image outside the diamond area may be clipped or limited to colors within the gamut.

Making Adjustments Using Scopes

When making adjustments to video signals, you will find that there is an order to adjustment that is most efficient to setting levels. Start by making adjustments first to the luminance part of the image, generally starting with the black adjustment first, followed by the white adjustment. Then, if necessary, progress to the gamma or middle levels. The reason for this order is that the adjustments interact. When you adjust the dark part of the image the brighter sections change as well. Adjustments to the white levels can also influence the dark part of the images, so be sure to recheck the black level before you move on to the gamma.

After adjusting the luminance you can move on to color adjustments. Depending on the device or program you are using, there are several different techniques for this. Which control you start with is not important, but like luminance, there is interaction and overlap so it's important to keep checking back with your earlier color choices as you progress through the tools.

Many image professionals make a distinction between *Color Correction* and *Color Grading*. Generally adjustments made to produce the best possible, technically correct image are considered color correction. When adjustments are used to give a shot a feel

or color treatment to enhance story telling or elicit emotion, the changes are often referred to as the color grade. Think of it as the line between the science of good quality video and the art of color as a creative tool.

Built-In Digital Scope Displays

Monitors built for video production often have scope functions built into their displays that can be switched on and off. This is especially handy for field monitors, as it reduces the amount of gear that a production crew needs to carry. Figure 9.14 shows one manufacturer's monitor and the type of digital displays it makes available.

Figure 9.14 Built-In Digital Scope Display

The Encoded Signal

Video information is constrained by available transmission bandwidth and the limitations of recording media. To overcome this limitation, the video information must first be condensed or compressed so it will fit within the available space. This is done through a process called *encoding*, which involves taking all the parts of the video and audio information and combining or eliminating the redundant material mathematically. It is also the process of converting from one form of information, such as light, to another form, such as electrical or magnetic data, for use in recording and transmitting video and audio signals.

Analog and Digital Encoding

There are four major ways to encode or process video signals. In both the analog and digital domains, there are component outputs and composite signals available. While they are both referred to the same way in each domain, the processing is different for analog than it is for digital, thus yielding four distinct ways to process video signals. They are analog composite, analog component, digital composite, and digital component. Originally, all television

113

broadcasting was analog composite. With the advent of digital processing, broadcasting has become digital. When digital broadcasting became the standard, the majority of signal processing shifted to digital component.

Analog Encoding Process

As mentioned above, there are different ways to encode a signal. The NTSC color process is one form of encoding. As an example, when color was added to the black and white signal, that information was encoded so it would fit within the existing transmission and recording systems. This was done using the Pythagorean theorem (Figure 10.1).

The Pythagorean theorem is an equation in plane geometry that states that if the two sides of a right triangle (a triangle that contains a 90° angle) are known, the length of the third side can be

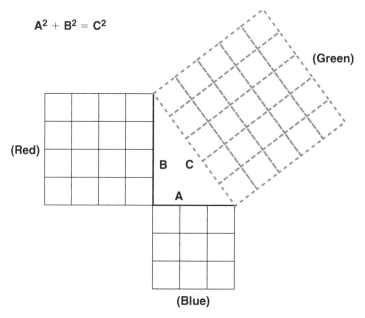

Figure 10.1 Pythagorean Theorem

calculated. The mathematical formula for this is $a^2 + b^2 = c^2$. In the NTSC video signal, green is 59% of the luminance signal, red is 30% luminance, and blue is 11% luminance. When the red and blue signals are combined, they contain less luminance information than green alone. Therefore, if the red and blue signals are timed to appear 90° apart from each other, the third side of the triangle (green) can be mathematically derived, thereby eliminating the green signal (Figure 10.1). The video color information in this encoded signal is thereby reduced or condensed by more than half.

Luminance is encoded by modulating a carrier frequency in both the recording and transmitting process. The light or luminance information is converted to electrical signals that are then used to change or modulate a carrier signal. Light information is also converted to magnetic and optical data for recording purposes, which are additional forms of encoded signals.

Analog Composite Signal

In the analog domain, there are two types of signal processing: composite and component. The composite signal is the combination of all the elements that make up the video signal. This information includes luminance (Y), the color difference signals (R-Y, B-Y), and synchronizing information (H, V, and color). This information is recorded and played back as one signal (Figure 10.2). Composite analog signals were created to reduce the amount of information captured by the camera to allow the color video and sync to fit into the bandwidth of a black and white broadcast signal. The process of combining all the signals both reduces the quality of the image and introduces errors, or artifacts, that can be seen visually. Composite analog video is the lowest quality of the four common encodings. It is often still found on equipment, however, as the familiar yellow connector labeled "video" on many displays, media players and game consoles.

Figure 10.2 Analog Composite Input/Output

Analog Component Signal

In the analog component system, the luminance and chrominance signals are processed separately. Some devices do this with the original red, green and blue channels. Sync may be carried on a fourth wire or path, or it may be part of the green signal. Analog computer monitors use a variation with five signals. Red, green and blue are accompanied by two sync paths, one each for horizontal sync and vertical sync. The computer standard VGA uses this format and it is frequently how signals get to projectors. When you see references to RGB, RGBS, RGBHV, "3 wire," "four wire," or "five wire," you can expect an analog component signal.

A second form of analog component uses the color difference signals from the composite encoding process discussed earlier. However, instead of mixing the three resulting into a single composite, the Y, R-Y and B-Y are carried through the system on three separate wires. In a large-scale facility this is a bit cumbersome to work with, as each device needs three full paths to carry the signal. As a result, patch bays, routing switchers and processing equipment need three times the space and power to operate (Figure 10.3).

116

Figure 10.3 Analog and Digital Component Input/Output

The advantage of keeping the elements separate is that a higher quality of image can be maintained. By recording in this manner, less encoding and decoding is required, thus reducing the loss of fidelity and retaining the original quality.

Digital Encoding Process

Encoding is used in the digital domain to accomplish the same purposes as in analog, i.e., reduce the bandwidth for transmission and recording. Digital encoding is the process of converting analog information to digital data. Using analog to digital conversion, a very large amount of analog information can be reduced to a stream of digital data.

With the advent of digital, the reference to the color difference signals in the digital domain was changed. The analog notation of R-Y, B-Y was changed to PbPr to indicate encoding and transferring of analog signals (Figure 10.4).

The notation used for encoding and transferring the color difference signals within the digital domain is written as CbCr. While the original designations R-Y and B-Y were replaced by the designations Pb

Figure 10.4 Analog Out

Figure 10.5 Component Video Out

and Pr, with the advent of digital video, these were then replaced by Cb and Cr (Figure 10.5). Pb and Pr are still in use when referring to analog component signals.

NOTE Another common, but technically incorrect way these signals may be noted on some equipment or file formats is YUV. This designation has special meaning to color scientists and can cause a bit of confusion for people deeply involved in discussions of color processing. Should you encounter this nomenclature you can assume component video.

Digital Composite Signal

Although no longer a common format, digital composite signals were designed as a transitional format in the 1990's when digital television equipment first started to appear. It allowed existing television facilities to start a transition to digital without the need to completely re-tool. As HDTV does not support this format, it is of historical note only. Digital composite video is very similar to composite analog, with the only difference being that the information is recorded, stored, and transmitted as digital data rather than analog waveforms. A digital composite signal takes the complete

analog video signal, with all of its elements combined, and records or transmits it in a digital form.

Digital Component Signal

This is the most common method of video signal encoding. The majority of cameras and image creation devices process in digital component. Digital component video takes the elements that comprise a video signal (YCbCr) and keeps them separate in recording and transmission. This is similar to analog component in the way these elements are treated.

The inputs and outputs from digital cameras and recording devices can either be RGB or the YCbCr components. Equipment that is capable of creating or reproducing these digital elements will have separate paths for each of these elements. Although the signals are separate, in the digital world they can be combined on a single cable. Digital processing even allows the audio signals to be mixed or multiplexed into the data as well. The data stream can also carry other information such as control signals and *metadata* (metadata will be discussed in Chapter 17). The two most common ways equipment using digital component signals connects is via a coaxial cable labeled SDI or HDSDI and on a consumer connector using HDMI (Figure 10.6, Plate 19).

Transcoding

Because there are several standards and many different video devices, it is necessary at times to translate from one type of encoded video signal to another type of encoded video signal. This process is known as *transcoding*. For example, a digital component signal can be transcoded to an analog composite or component

Figure 10.6 (Plate 19) Digital Component Connections

signal, or vice versa. An RGB video signal, which is generated by a video camera, can be transcoded into an analog or digital component YPbPr or YCbCr video signal for input or output.

The process of transcoding is also used during the editing stage. Media may have been captured and edited in one format, such as HD, but may need to be converted to a different format in order to play well at its destination, such as the web or on a mobile device (formats are discussed in more detail in Chapter 19).

Encoding and Compression

Signal encoding is an aspect of the recording and transmission process. While it allows for some compression of the signals, its main purpose is to facilitate the recording and transmission of these signals. The encoding process contains elements of signal compression, but is not the same as the compression process in the digital domain (compression is discussed in more detail in Chapter 14).

Digital Theory

An analog signal is a sine wave. Like an ocean wave in constant motion, an analog signal continually changes over time. In fact, the term analog is actually derived from the word analogous because of the signal's analogous relationship to the sine wave (Figure 11.1). Digital information, on the other hand, is fixed and absolute and does not change over time. When information is digitized, the data remains as it was originally recorded.

Analog Domain

In the Introduction of this book, we said that sight and hearing are responses to energy waves, which is an analog phenomenon. Video

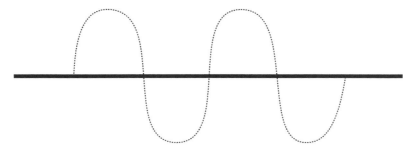

Figure 11.1 Sine Wave

was originally developed as part of the analog world. Because the system was analog, it had the ease and advantages of fitting into the natural physical system. However, it also carried with it all the interference and noise problems. Noise is analog information just as video and audio are. Getting rid of noise and interference in the analog video signal is not easy, as they take the same form as the video and audio signals. Also, manipulating analog information for creative purposes is complex.

To eliminate interference problems and make better creative use of video, a process of digitizing video signals was created. Digitizing refers to converting the analog information to a series of numbers. As digital information, the signals are not subject to real-world analog interference. Real-world physical problems have no effect on the television signal when it is digitized. These compelling benefits drove the move to digital signal processing. However, as humans, we experience the world as inherently analog. Therefore, all digital processing must start by converting from analog and end by going back to analog.

Digital Domain

To create digital video, a digital representation of the analog sine wave had to be created; that is, the analog sine wave had to be *recreated* digitally. To do this, a process was developed to measure the sine wave at different times and assign a numerical value to each measurement. A sine wave curve is constantly changing over time. Therefore, the more frequently this measurement is taken, the more accurate the digital reproduction of the sine wave will be. A doctor measuring a patient's temperature once a day might not get a very accurate picture of the patient's condition. However, taking a reading every hour will give the doctor a much clearer idea of the patient's progress.

Sampling Rate

Another way to think of digitizing is to imagine a connect-the-dots puzzle. The more dots there are to connect, the more closely the curves and outlines will reproduce the picture. The frequency of the dots, or the doctor's temperature readings, are referred to as the *sampling rate.* If the sine wave was measured every 90°, there would be three straight lines instead of a curve. However, if the sampling rate was increased to every 10°, 5°, or even every 1°, the curve of the sine wave would be more accurately represented (Figure 11.2).

There were two factors affecting how the sampling rate for digital video was determined. First, the sampling had to occur frequently enough to accurately reproduce the analog signal. Second, the

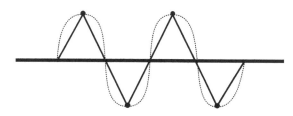

PATTERN DETERMINED FROM FOUR SAMPLES TAKEN

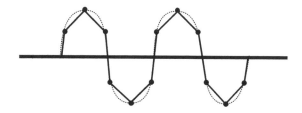

PATTERN DETERMINED FROM TWELVE SAMPLES TAKEN

● = Point Sample Was Taken
⋯⋯⋯ = Sine Wave
─── = Wave of Samples Taken

Figure 11.2 Patterns Determined from Sampling

process had to be simple enough to integrate with the existing analog system. The one element that satisfied both factors was the use of the subcarrier frequency. The subcarrier frequency was used as the basis of the sampling rate because it was the main synchronizing signal for the analog video system.

However, using a sampling rate that equals the subcarrier frequency does not create an accurate representation of the analog information. To accurately reconstruct the analog information from the digital samples, the sampling rate must be more than twice the highest frequency contained in the analog signals, or conversely, the frequencies being sampled must be less than half the sampling frequency.

This conclusion was derived by Harry Nyquist, an engineer at Bell Laboratories (originally AT&T), who in the mid to late 1920s published papers on factors concerning telegraph transmission speed. Other scientists, Karl Küpfmüller and Vladimir Kotelnikov, had come to a similar conclusion as Nyquist. And later, around 1948, an engineer, Claude Shannon, applied Nyquist's work to digital sampling. So while this sampling frequency rule may be known by different names, it's predominantly called either the Nyquest Theorem or the Nyquist-Shannon Sampling Theorem. (The error that is created by working outside this criterion is called *aliasing*, the creation of a false signal based on incorrect data derived from ambiguous samples.)

To accurately represent the analog information in a video signal, it was decided that a multiple of the subcarrier should be used. The sampling rate decided on was four times the subcarrier frequency for the luminance signal and two times the subcarrier frequency for the color components.

Simple mathematics of multiplying 3.58 megahertz (color sub-carrier frequency) times 4 will give a sampling rate of 14.3 megahertz. To accommodate world standards, the actual final sample rate for digital component signals is 13.5 MHz for the luminance channel and 6.75 MHz for each color channel. A value is assigned to each reading, and that number is recorded. What is recorded is not a real-world analog signal, but a series of numbers representing video and audio levels at each instant the signal was sampled.

When video signals became High Definition, higher sample rates were needed to capture the greater detail. In HD, the luminance sample rate is 74.25 MHz and the color components are sampled at half that rate or 37.125 MHz. Each new higher resolution image requires a higher sample rate. 4K systems have twice the amount of information on each line, and twice as many lines. As a result they must sample the analog world 4x faster than HD. 8K image systems must up the rate again by another 4x.

Certain numbers keep coming up when dealing with digital equipment. For example 4:2:2, 4:4:4, and 4:4:4:4. The numbers represent digital sampling standards for video signals. For example, 4:2:2 represents four times the subcarrier frequency as the sampling rate for the luminance portion of the signal, and two times the subcarrier frequency for each of the color difference signals. 4:4:4 represents four times the subcarrier frequency for all three of those signals and 4:4:4:4 adds the key signal, or alpha channel, as part of the digital information. While these numbers are mathematically accurate with Standard Definition signals, they are retained when talking about HD as well. The ratios remain, but there is no longer a direct relationship to the frequency of the subcarrier.

Computer Processing

Early computers functioned using a series of switches that were either on or off, providing either a yes or no option. This could be likened to a questionnaire created to find out someone's name where only yes or no answers can be given, each answer represented by a 0 or 1, respectively. To give a person's name, a letter from the alphabet would be offered and the person would say yes or no to indicate whether that letter is the next letter in his or her name. They would go through the alphabet with the person answering yes or no to each letter, then repeating the process until the full name was spelled correctly. The process would be slow but accurate.

That is essentially what a computer is doing as it goes through its memory. The faster it goes through the yes and no questions, the faster it can process the information. The rate at which this information is processed is measured in megahertz and is one of the specifications that differs from computer to computer. The higher the rate as measured in megahertz (MHz), the faster the computer processor.

Binary System

Each of the yes or no answers referred to above is represented by a zero or one, or combination of zeros and ones. This is called a *binary system* because it is made up of two numbers. The binary system is used for all digitizing processes because it is the language of computers. Each zero and one is a digital or binary *bit*. The number of binary or digital bits the computer can read at once is known as the *word size*. The original computer processors were 8-bit (also referred to as a *byte*), but soon grew to 16-bit, 32-bit, and so on. Computers continue to increase their capability of handling larger

word sizes. The bigger the word size the computer can handle, the faster it can process information. The processing speed of computers continues to increase in megahertz as well. These two factors combined have been responsible for the increase in computer efficiency and speed.

Unlike the binary system, which is based on two numbers, the common mathematical system in use today is the decimal system, which uses values 0 through 9. In this system, the column on the far right represents ones, or individual units, and the next column to the left represents tens of units. The third column to the left represents hundreds of units, the fourth column represents thousands of units, and so on. Each column has a value from 0 to 9. After 9, a new column is started to the left. For example, 198 is represented as an 8 in the ones column, a 9 in the tens column, and a 1 in the hundreds column. After 198 comes 199 and then 200. A 200 means there are 2 hundreds of units, 0 tens of units, and 0 individual units.

In the binary system, a computer does the same type of math but its columns only have values of 0 and 1. The first column

Table 11.1 Binary System Values

Value	128	64	32	16	8	4	2	1		
	0	0	0	0	0	0	0	0	=	0
	0	0	0	0	0	0	0	1	=	1
	0	0	0	0	0	0	1	0	=	2
	0	0	0	0	0	0	1	1	=	3
	0	0	0	0	0	1	0	0	=	4
	0	0	0	0	0	1	0	1	=	5
	0	0	0	0	0	1	1	0	=	6
	0	0	0	0	0	1	1	1	=	7
	0	0	0	0	1	0	0	0	=	8

represents ones or individual units. The second column to the left represents twos of units. The third column represents fours of units. The fourth column to the left represents eights of units, and so on.

Using the table above, if there is a 1 in the second column and a 0 in the first column this indicates there is one unit of twos. The number 3 is represented by a 1 in the first column and a 1 in the second column, indicating 1 unit of twos plus 1 individual unit. The number 4 is a 1 in the third column and a 0 in both the first and second columns, indicating 1 unit of fours and 0 units of twos and ones. Five is represented by 1 unit of fours, 0 units of twos, and 1 individual unit, or 101. A 1 in each of the eight columns, or 11111111, represents the number 255. The number 256 is the start of the ninth column. Thus, the largest word that an 8-bit computer can process at a time is eight bits or one byte.

Sample Size

A second factor in sampling is how much information each sample can carry. If a single bit is used for sampling, that would only indicate if there is a signal present or not, but would in no way represent its analog value. If more bits are used, more accurate analog values can be represented in the sample. For example, with four bits, the analog signal could be any one of 16 different voltages. In video, 8 or 10 bits are typically used for each sample. This creates either 256 (using 8 bits) or 1024 (using 10 bits) different levels at each sample.

Human hearing is more sensitive than vision to errors in the sample size. As a result, audio sample sizes are typically 16 or 24 bits per sample.

Digital Stream

Once data has been digitized, the digital bits that comprise the data can be transmitted. The form of transmission used for digital data is referred to as *serial digital*. The term serial refers to the series of binary bits that are sent out as one continuous stream of digital data, or the *digital stream*. When working with a video signal, this digital stream contains all the information about the image and audio.

The quantity of data in a digital stream dictates the quality or detail of the image. The more detail—or sampled information—from the image, the larger the quantity of data (Figure 11.3). The larger the quantity of data, the greater the amount of bandwidth required to transmit the data. This movement of data is referred to as *throughput*. The larger the bandwidth—or the greater the throughput—the greater the quantity of data that can be carried in the serial digital stream. If the bandwidth used for transmission is too small for the quantity of data being carried in the digital stream, digital bits are dropped or lost. The result is a loss of image quality. In some cases, this can result in a complete loss of the signal.

In order for the digital stream to be received and interpreted correctly, all of the digital bits must be organized. Organizing digital

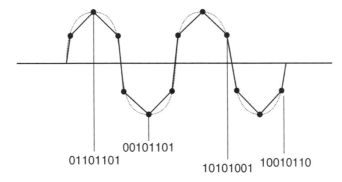

Figure 11.3 Binary Numbers Representing Samples Taken

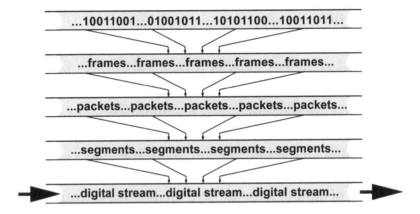

...10011001...01001011...10101100...10011011...

...frames...frames...frames...frames...frames...

...packets...packets...packets...packets...packets...

...segments...segments...segments...segments...

...digital stream...digital stream...digital stream...

Figure 11.4 Digital Stream Data

data is similar to adding punctuation to a group of sentences. Without punctuation, it would be difficult or impossible to read the material and comprehend it. Digital data begins as bits, in the form of zeros and ones, which are grouped into elements called *frames*. Groups of frames are organized into *packets*. Groups of packets are organized into *segments*. The result of a group of segments is the digital stream (Figure 11.4).

Each of these elements in the digital stream is encoded so it can be received and combined in the proper order. If some of the information from the digital stream is lost from any one of these elements, the data, or image, can become unintelligible to the receiving source. In addition to data originating from one source, a serial digital stream may also contain information from several other sources. Just as a single computer is not the only active participant on the Internet, several sources transmitting various types of data may share a single transmission line. It is for this reason that the frame, packet, and segment information is critical. Without this

data, there is no way to decode the serial digital stream to recreate the original data at the intended receiving source.

Serial Digital Interface

The transfer of data from one source to another occurs through an *SDI*, or *serial digital interface*. This interface allows the transfer of data between sources. An SDI is sometimes a stand-alone device and sometimes it is incorporated as an integral part of a piece of equipment. An SDI input/output port can be found on cameras, VCRs, and other production and computer equipment (Figure 11.5).

Along with the video information embedded in the digital stream is all the audio information—up to 16 channels. There are no separate wires for audio. All of the video and audio data is contained in a single serial digital stream and carried through a single SDI cable.

Figure 11.5 Serial Digital Interface (SDI)

HDMI Interface

Another very common interface for carrying digital signals is HDMI. This is the most common interface on consumer cameras, displays and computers. While it is not directly compatible with SDI equipment, inexpensive transcoders allow HDMI devices to be used in a professional environment. Because HDMI signals are limited to about 20 feet, they cannot be easily used in a large studio.

Television Standards

A standard is a set of protocols or rules that define how a system operates. Standards provide a coherent platform from which information can be created, extracted, and exchanged. Without these protocols, there would be no consistency in the handling of information. Television is the conversion of light to electrical energy. The process by which this conversion takes place is referred to as a *television standard* or system. Standards are necessary so that video signals can be created and interpreted by equipment manufactured by different companies throughout the world. For example, video levels, broadcast frequencies, subcarrier frequency, and frame rates are all dictated by a specific standard.

Analog Standards

NTSC analog is one example of a video standard. Other world standards include PAL and SECAM. As you can see in Figure 12.1, each standard is used in many different countries.

In 1941, the first NTSC standard was developed. And in 1953, a new standard with a provision for color television was created. Because there were still so many black and white receivers in use, another

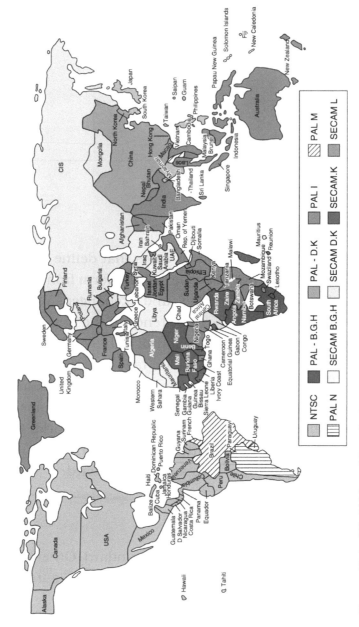

Figure 12.1 World Map of Standards

NTSC standard was adopted in 1953 that allowed for compatibility between those existing receivers and color television broadcasting. NTSC was the first widely adopted broadcast color system and remained dominant until the first decade of the 21st century, when it was replaced with digital standards.

Setting Digital Standards

Like the analog standards NTSC, PAL and SECAM, digital standards are set by international agreement through various worldwide organizations, many of which fall under the auspices of the ISO, the International Organization for Standardization. Established in 1947, this non-government organization, comprised of over 165 member countries, sets technical standards for scientific, technological, and economic activity.

NOTE ISO's official definition of a standard is: A document that provides requirements, specifications, guidelines or characteristics that can be used consistently to ensure that materials, products, processes and services are fit for their purpose.

Some of the video organizations under the auspices of the ISO include SMPTE, NTSC, EBU (European Broadcast Union), and the ATSC (Advanced Television Systems Committee). ATSC is an international non-profit organization formed in 1982 for the purpose of developing voluntary standards for digital television. The ATSC has approximately 140 members representing the broadcast, broadcast equipment, motion picture, consumer electronics, computer, cable, satellite, and semiconductor industries. At a time when manufacturers were researching, developing and vying for the best way to play, record and broadcast digital video, it was imperative to set

a standard that all manufacturers could adhere to. In 1995, the ATSC defined and approved the Digital Television Standards in a document called simply A/53. This included standard definition television (SDTV) and high definition television (HDTV), discussed later in this chapter.

Standards Parameters

Before defining specific standards, an understanding of the basic parameters of a standard is necessary. Analog television standards had specific criteria, while the ATSC's recommended Digital Television Standard allows for a combination of various parameters. Some of the parameters used to define a standard include how many pixels make up the image (image resolution), the shape of the image (aspect ratio), the shape of the pixels that make up the image (pixel aspect ratio), the scanning process used to display the image, the audio frequency, and the number of frames displayed per second (frame rate or fps). A specific combination of these parameters is referred to as a standard *format*.

NOTE The term format may also be used to define a video medium such as VHS, Blu-Ray DVD, HDCam, HDV, and so on. There can be several different formats within a given standard or set of protocols.

Image Resolution

Image resolution is the detail or quality of the video image as it is created or displayed in a camera, video monitor, or other display source. The amount of detail is controlled by the number of *pixels* (picture elements) in a horizontal scan line multiplied by the

number of scan lines in a frame. The combined pixel and line count in an image represents what is known as the *spatial density resolution*, or how many total pixels make up one frame. For standard definition ATSC digital video, the image resolution is 720 pixels per line with 480 active scan lines per frame (720 × 480).

Increasing the number of pixels in an image increases the amount of detail. This corresponds to an increase in the resolution of the image. If the displayed image is kept at the same size, an increase in resolution would increase the detail in the image. Alternatively, a higher-resolution image could be displayed much larger while keeping the same degree of detail as the lower-resolution image.

For example, if a 720 × 480 image is displayed on a 21-inch monitor, and the resolution of that image is increased, the image would have more detail. The same image with increased resolution could be displayed on a larger monitor with no loss of detail.

Aspect Ratios

Video images are generally displayed in a rectangular shape. To describe the particular shape of an image, the width of the image is compared to its height to come up with its *aspect ratio*. This ratio describes the shape of the image independent of its size or resolution. Two common aspect ratios in video are 16 × 9 and 4 × 3. An image with a 16 × 9 aspect ratio would be, for example, 16 units across and 9 units tall. The actual ratio does not depend on any particular unit of measure. If a 16 × 9 image or display were 16 feet wide, it would be 9 feet tall. If it were 16 inches wide, it would be 9 inches tall. A display that is 9 yards tall would be 16 yards wide. Think of a stadium scoreboard at that size. Older standard definition displays were a bit closer to square. A display that is 4 feet wide by 3 feet tall would be referred to as a 4 × 3 ratio.

Another common way to note aspect ratio is to divide the length of the image by the height. In the 16 × 9 example, when the width amount of 16 is divided by the height of 9, the result would be 1.777777 units long. This is often rounded to 1.78 and expressed as 1.78 to 1, or shown as the ratio 1.78:1. For each unit of height we need 1.78 units of width. The older 4 × 3 standard definition image would be 1.33:1. When four is divided by three the result is 1.33333333.

The film world uses a number of different image ratios, but they are almost always expressed as comparisons to 1 unit of height. For example, a theatrical release movie, showing in Cinemascope, has an aspect ratio of 21 × 9, but it is more commonly referred to as 2.35:1. Another common film aspect ratio is 1.85:1, which is closer to the 16 × 9 aspect ratio of HD (Figure 12.2).

Pixel Aspect Ratio

The *pixel aspect ratio* is the size and shape of the pixel itself. In computer displays, pixels are square with an aspect ratio of 1 to 1. NTSC pixels have an aspect ratio of 0.91:1, which makes them tall and thin. When setting the standard for digitizing the NTSC video image, the intent was to digitize the image at the highest practical resolution. While the number of pixels in a horizontal scan line could be set to any amount, the number of scan lines could not be arbitrarily increased since they are part of the NTSC standard. Therefore, the pixels were changed to a narrow, vertical rectangle shape, allowing an increase in the number of pixels per line and added image resolution.

In the digital world, the aspect ratio of the pixels is sometimes changed to take fewer samples on each line. (Remember, the number of pixels in a horizontal scan line can be set to any amount,

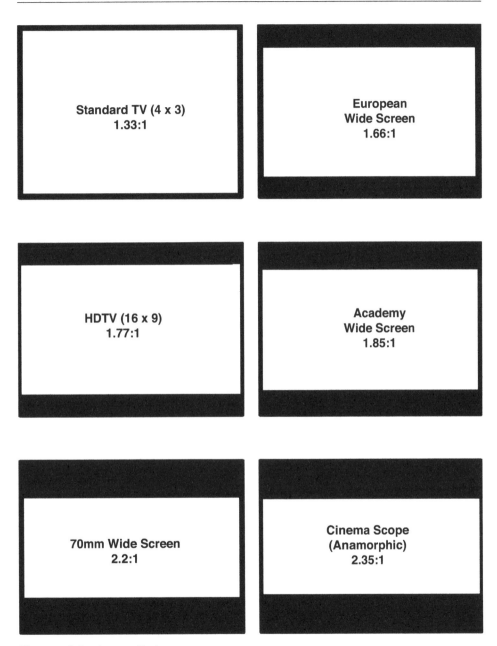

Figure 12.2 Aspect Ratios

but the number of scan lines cannot be arbitrarily increased since they are part of an existing standard.) While expanding the width of each pixel reduces the amount of data being stored and sent, it also reduces horizontal resolution. For example, a camera may have a sensor that is 1920 × 1080 *full raster*, meaning that the sensor itself is full-sized and rectangular—that it is in fact 1920 × 1080, and the pixel aspect ratio is square or 1:1. However, there are recording formats that are not full raster. By expanding the width of each pixel to an aspect ratio of 1.33:1, the HD 1920 × 1080 image can be reproduced at 1440 x 1080. This saves about a third on the amount of data that has to be stored or transmitted. The 1440 × 1080 image is referred to as a *thin raster* format (Figure 12.3).

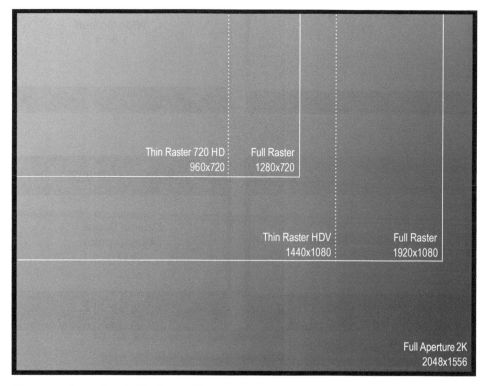

Figure 12.3 Full and Thin Raster Frame Sizes

Interlace and Progressive Scan Modes

Interlace scanning is the process of splitting a frame of video into two fields. One field of video contains the odd lines of information while the other contains the even lines of the scanned image. When played back, the two fields are interlaced together to form one complete frame of video.

Where historically television used an interlace scanning process, the computer uses a non-interlaced or *progressive scanning* technique. Computer image screens can be refreshed as rapidly as 72 times a second. Because this rate is faster than the persistence of vision, the problem of flicker is eliminated. Therefore, there is no need to split the frame into two fields. Instead, the image is scanned from top to bottom, line by line, without using an interlacing process. The complete frame is captured or reproduced with each scan of the image (Figure 12.4).

Progressively scanned images have greater apparent clarity of detail than an equivalent interlaced image. The progressively scanned image holds a complete frame of video, whereas an interlaced frame contains images from two moments in time, each at half the resolution of the full frame.

The computer industry has always insisted on a far more detailed and higher quality image than has been used in the television industry. Computer images usually require very fine detail and often include a great deal of text that would be unreadable on a standard television screen. Traditional television images did not require the same degree of detail as computer information. In a digital environment, the limiting factor is enough bandwidth to transmit the information. Interlace scanning allowed more information to be transmitted in the limited spectrum of space allotted for signal transmission.

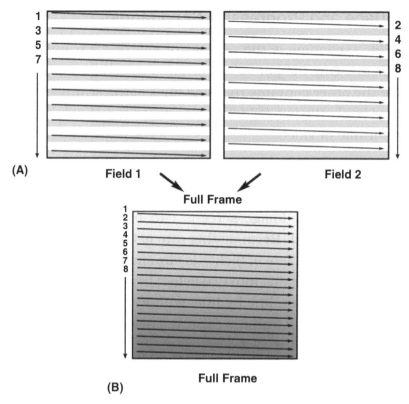

Figure 12.4 (A) Interlaced Scanning and (B) Progressive Scanning

When listing the criteria for a particular standard, the indication of whether the scanning mode is interlaced or progressive appears as an "i" or "p" following the line count, such as 480p, 720p, 1080i, and so on.

Frame Rate

The frame rate, regardless of the pixel or line count, is the number of full frames scanned per second. This rate represents what is known as the *temporal resolution* of the image, or how fast or slow the image is scanned. Frame rates vary depending on the rate at

which the image was captured or created, the needs or capability of the system using the video image, and the capability of the system reproducing the image.

For example, an image may have been captured at 24 frames per second (fps), edited at 29.97 fps, and reproduced at 30 fps. Each change in the frame rate would denote a different format. Different frame rates include 23.98, 24, 25, 29.97, 30, 59.94, and 60 fps. Before color was added to the NTSC signal, black and white video was scanned at 30 frames per second, or 30 fps. When color was added to the signal, the scanning rate had to be slowed down slightly to 29.97 fps to accommodate the additional color information. That legacy rate is still used in countries that once broadcast in NTSC to facilitate incorporation of older previously recorded material. Projects that do not require a broadcast version can use the integer, or non-decimal rate (24, 25, 30, or 60 fps), that is best suited to the source material.

Conventional Definition Television (CDTV)

When digital video standards were created, the ATSC redefined the prior standards that were already in use. The analog standards used throughout the world were placed in a newly defined category called Conventional Definition Television, or CDTV. CDTV refers to all the original analog television standards.

In the NTSC system, the CDTV standard image resolution is 640 pixels by 480 lines of active video. The frame rate is 29.97 frames per second with two interlaced fields, each containing 240 lines of active video. The PAL standard image resolution is 760 pixels by 580 lines. The PAL frame rate is 25 fps with two interlaced fields, each containing 288 lines of active video. SECAM also has

Table 12.1 CDTV Standards

CDTV Standards	Pixels per line	Aspect Ratio	Line Count	Frame Rate	Scan Mode
NTSC	640	4 × 3	480	29.97	Interlace
PAL	760	4 × 3	580	25	Interlace
SECAM	760	4 × 3	580	25	Interlace

760 pixels per line and 580 lines, and shares the same frame rate and scan mode as PAL (Table 12.1).

In the original analog standards, each individual standard contained its own method for processing color information. With the advent of digital video standards, *color encoding* was redefined to a new international standard called CCIR 601, named after the French organization Consultative Committee on International Radio, which first developed the standard. Further refinement of the color encoding process and the merger of the CCIR with other organizations led to a change in name from CCIR 601 to ITU-R 601 named after the International Telecommunications Union.

NOTE You may be familiar with Emmy Awards given to television actors and programs. But the CCIR received a 1982–83 Technology and Engineering Emmy Award for its development of the Rec. 601 standard.

Digital Television Categories (DTV)

The Digital Television category, or DTV, developed from the growth of the digital video domain and encompasses all digital video standards. It has two subcategories: Standard Definition Television

(SDTV) and High Definition Television (HDTV). To further divide the DTV category, there is an *in-between* standard referred to as EDTV, or Enhanced Definition Television.

High Definition Television (HDTV)

The original HDTV standards were analog because at the time there was no digital television system in use. With the advent of digital, HDTV immediately crossed over into the digital domain. In the process, the quality of the image was vastly improved. There are several different formats within the HDTV standard. In addition, many HDTV formats were developed as various manufacturers and various countries began to develop their own broadcasting systems. The differences between HDTV formats include such elements as frame rate, scan lines, and pixel count. Additional information and specifics of the HDTV standard are discussed further in Chapter 13, High Definition Video.

Standard Definition Television (SDTV)

Standard Definition Television, or SDTV, is the digital equivalent of the original analog standards. When a CDTV signal is transferred to the digital domain, it becomes an SDTV signal within the DTV category. It is, therefore, not a high definition image. It has less picture information, a lower pixel and line count, and smaller aspect ratio than HDTV.

Enhanced Definition Television (EDTV)

Enhanced Definition Television, or EDTV, is a term applied to video with a picture quality better than SDTV, but not quite as good as HDTV. While both SDTV and EDTV have 480 lines of information,

SDTV displays the image using interlace scanning, while EDTV displays the image using progressive scanning. In progressive scanning, all 480 lines of the video image are displayed at one time, rather than in two passes as is the case with interlace scanning, giving the progressively scanned image a better quality. Progressive scanning is discussed in more detail in Chapter 13.

Digital Television Standards

As mentioned earlier, in 1995, the ATSC created a set of standards, known as A/53, for digital broadcasting of television signals in the United States. These standards use the MPEG-2 compression method for video compression (see Chapter 15 for more information on MPEG compression). The AC-3 Dolby Digital standard (document A/52), although outside the MPEG-2 standard, has been adopted in the United States as the standard for Digital TV audio (see Chapter 16 for more information on digital audio).

The standards created by the ATSC were adopted by the Federal Communications Commission (FCC) in the United States. However, the table of standards shown below (Table 12.2) was rejected by the FCC because of pressure from the computer industry. The idea, then, was to leave the choice of what standards to use to the marketplace as long as it worked with the MPEG-2 compression scheme. The result has been that all manufacturers and broadcasters have been using the standards included in the ATSC table.

Together, HDTV, SDTV, and EDTV make up 18 different ATSC picture display formats.

The Horizontal Lines column contains the number of lines in the image, while the Horizontal Pixels is the number of pixels across each line. In the Format column, the "i" refers to images scanned

Table 12.2 ATSC Picture Display Formats

	Format	Horizontal Lines	Horizontal Pixels	Aspect Ratio	Scan Mode	Frame Rate (fps)
HDTV	1080p	1080	1920	16 × 9	Progressive	24
	1080p	1080	1920	16 × 9	Progressive	30
	1080i	1080	1920	16 × 9	Interlaced	30
	720p	720	1280	16 × 9	Progressive	24
	720p	720	1280	16 × 9	Progressive	30
	720p	720	1280	16 × 9	Progressive	60
EDTV	480p	480	704	16 × 9	Progressive	24
	480p	480	704	16 × 9	Progressive	30
	480p	480	704	16 × 9	Progressive	60
	480p	480	704	4 × 3	Progressive	24
	480p	480	704	4 × 3	Progressive	30
	480p	480	704	4 × 3	Progressive	60
	480p	480	640	4 × 3	Progressive	24
	480p	480	640	4 × 3	Progressive	30
	480p	480	640	4 × 3	Progressive	60
SDTV	480i	480	704	16 × 9	Interlaced	30
	480i	480	704	4 × 3	Interlaced	30
	480i	480	640	4 × 3	Interlaced	30

using the interlace approach, while the "p" refers to progressively scanned images. 24 fps is also used to refer to 23.976 frames per second and 30 fps is also used to refer to 29.97 frames per second.

Digital Television Transmission

Digital video requires a different form of transmission from analog. In analog, the video was broadcast using AM for the images and FM for the audio. But digital contains all the elements in one data stream. Since digital signals can be compressed to use less

spectrum space than analog, several digital data streams can be transmitted in the same space that contained just the one analog signal. To take advantage of this capability, the ATSC developed new standards for transmitting digital television.

NOTE After nearly 70 years, the majority of over-the-air NTSC transmissions in the United States ended on June 12, 2009, while other countries using NTSC ended within the next two years.

While the U.S. government mandated a change to digital television, it did not order that all television broadcasting must be High Definition, only that it be digital. As High Definition (HD) television is not mandatory and as compressed digital signals can require considerably less spectrum space than analog signals, broadcasters can transmit both a High Definition signal and more than one Standard Definition (SD) or Enhanced Definition (ED) signal in the remaining spectrum space. This is called *multicasting.*

The A/53 standard for transmitting digital television signals is called 8VSB, which stands for *8-level vestigial sideband.* A *vestigial* element is a part of something that has no useful value. Vestigial in this case refers to that part of the carrier frequency that is filtered off as unnecessary. It uses the amplitude modulation (AM) method of modulating a carrier frequency. The A/53 standard using 8VSB can transport 18 different video standards simultaneously and has the capability to expand and change as needed. The 8VSB system of carrier modulation is also very useful for television transmission in that it greatly conserves bandwidth, is a relatively simple method of modulation, and saves cost in receiver design. This capability is also what makes multicasting possible.

The "8" in 8VSB

8VSB modulation treats digital bits a bit differently than the standard On/Off of most digital electronics. Typically a digital bit has either the presence or absence of some known voltage. Five volts is typical, so something close to five volts is a digital 1. Something close to 0 volts is a digital 0.

In order to increase the amount of data that the broadcast signal carries, 8VSB works with groups of three bits. In binary math, three bits can be combined into eight different patterns:

000 001 010 011 100 101 110 111

8VSB then assigns each of those patterns, or *symbols* as they are called, a different voltage. That voltage is what gets transmitted. At the receiver, the voltage is recovered and the three bits it represents are added to the bit stream. So in the same amount of time it takes to send one bit, three are sent.

However, like everything else, there is a price or tradeoff. Because noise is always present in electronics, sometimes the addition and subtraction that it causes makes it hard to see exactly what voltage a signal is for a moment. To overcome this error, correction schemes must be employed to compensate. For 8VSB, this error correction consumes about 40% of the transmitted data.

For transmission, the MPEG-2 program data, the audio data, the ancillary or additional data such as instructions about what is contained in the data stream, closed captioning, and synchronizing information are combined or multiplexed into the data stream. This data stream is what is sent for transmission.

Digital cable, while adhering to the adopted ATSC standards, generally does not use 8VSB for signal modulation. Instead cable

operators use a more complex form of modulation called *quadrature amplitude modulation* (QAM) that is capable of 64 or 256 levels rather than the 8 levels of 8VSB.

Satellite broadcasting uses another form of modulation called *quadrature phase-shift keying* (QPSK). Again, the standards used for satellite broadcasting adhere to the ATSC table but satellite broadcasters use QPSK for modulating the carrier signal.

Moving Forward

Video technology will continue to evolve. And "television" viewers will want to watch their programs in a variety of ways on a growing range of media sources and delivery platforms, including, of course, the Internet. Creating a new DTV system that incorporates these elements must be developed in the future to keep pace with the industry's technological growth and that of the consumers' expectations. The ATSC is already making plans for a 3.0 system that will adapt to future innovations. Moving forward, this new system must address some of the key concepts of the emerging technology, by making it scalable, interoperable, and adaptable.

High Definition Video

<div style="text-align: right">**13**</div>

As noted in Chapter 12, there are two subcategories that fall under the DTV (Digital Television) category of standards: SDTV (Standard Definition Television) and HDTV (High Definition Television). All high definition video, also referred to as high def or HD, falls under the HDTV category of standards. Analog television standards, including NTSC, PAL, SECAM, and variations of these standards, are not compatible with each other and converting images from one standard to another requires a process that can degrade the image quality. HDTV represents an international effort to create more compatibility between world standards.

Setting High Definition Standards

In the early 1990s, another organization, the International Telecommunication Union (ITU), became involved in recommending television standards. The ITU is the United Nations specialized agency for bridging gaps throughout the world in Information and Communication Technologies (referred to as ICTs). There are different sectors of the ITU, and the sector that addresses recommended uses in the television industry is the Radiocommunication sector, or ITU-R. The ITU-R study group that focuses on video is the Broadcasting Service

(Television) study group. And the recommendation that group laid out for high definition standards is the document, ITU-R Recommendation BT.709.5 (parameter values for the HDTV Standards for production and international program exchange).

> **NOTE** The ITU is committed to connecting all the world's people—wherever they live and whatever their means. They allocate global radio spectrum and satellite orbits, develop the technical standards that ensure networks and technologies seamlessly interconnect, and strive to improve access to ICTs to underserved communities worldwide. Through their work, they protect and support everyone's fundamental right to communicate.

To create a unified approach to adopting standards, three of the world's leading international standards organization came together in 2001 to form the World Standards Cooperation (WSC). This organization was established by ISO, ITU, and the International Electrotechnical Commission (IED). The purpose of the WSC moving forward is to strengthen and advance the voluntary consensus-based international standards systems of ISO, IEC, and ITU.

Today, there are several different high def standards, each with its own unique combination of image criteria, including frame rate, pixel count, line count, and scanning mode.

Widescreen Aspect Ratio

CDTV and SDTV standards use an image size with an aspect ratio of 4 × 3. A 4 × 3 image is four units wide by three units high. While rectangular in shape, it is much closer to a square than the widescreen image currently seen in cinemas. The human eye perceives a great deal of motion and depth information from the area *outside* of direct view. This area is known as peripheral vision. Having a

4 x 3 **16 x 9**

Figure 13.1 4 × 3 and 16 × 9 Aspect Ratios

wider video image area takes advantage of this characteristic and improves the sense of reality for the viewer.

As HDTV was developed, this fact was taken into consideration and all HDTV standards were widened to a 16 × 9 aspect ratio, or an image that is nine units high by sixteen units wide (Figure 13.1). Since the HDTV standards all have a 16 × 9 ratio, it is often referred to as the aspect ratio for the standard. A native standard is the basic standard for which the piece of equipment was designed. It may be capable of handling other standards, but its original intent is called the native standard.

Widescreen video can be played back on a 4 × 3 monitor in different ways. To see the entire widescreen image, the image must be reduced in size so the width of the image fits on the 4 × 3 monitor. This creates black above and below the widescreen image, a layout often referred to as letterbox. To make use of the full 4 × 3 image area, the sides of the widescreen image can be cropped to show just the middle portion, or 4 × 3 area. Also, a process of panning, or moving horizontally across an image, can be applied during transfer to reveal a particular portion of the widescreen image. This process is often called *pan and scan* (Figure 13.2).

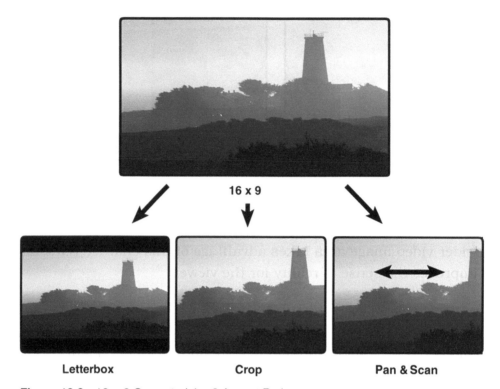

Figure 13.2 16 × 9 Converted 4 × 3 Aspect Ratios

4 × 3 material can also be displayed on a widescreen monitor. The content creator can choose how to deal with the aspect ratio conversion. If the top and bottom of the smaller image is enlarged to touch the top and bottom of the 16 × 9 raster, an empty area will be remain on the left and right of the image. If this is left black it is referred to as *pillar box* presentation. When graphic elements are added on the sides, the term *wings* is sometimes used for the left and right black areas. Finally the image can be enlarged further, matching the left and right edges of both aspect ratios. This will discard a portion of the top and bottom of the original 4 × 3 frame. It also leads to quite visible softening of the image.

HD Image Resolution

With the 16 × 9 aspect ratio, there is a larger image area and there-fore more room for additional pixels. Different high def standards have different pixel and line counts that make up that standard's image area. The greater the number of pixels that make up the image, the greater the image resolution.

For example, one high def format has an image resolution of 1920 × 1080. In this format, there are 1920 pixels across one line and 1080 lines in one frame of the image. The 1920 pixel count is the *horizontal resolution*, and the 1080 line count is the *vertical resolution*. Another high def standard is 1280 × 720, which is 1280 pixels per line by 720 lines. The combined pixel and line count make up the spatial density resolution of the high def image.

Ultra High Definition

Much like the rapid increase in megapixel count for still image cameras, video systems continue to develop higher resolution imag-ing. As technology develops faster processing, better compression algorithms and more precise manufacturing techniques, higher resolution equipment is possible. Images that have a higher reso-lution than the standard HD are referred to as UHD, or Ultra High Definition.

4K

As of this writing, the highest resolution equipment available is called 4K, as the image has approximately 4000 pixels in each scan line. The actual number for a true 4K image is 4096 pixels per line, with 2160 lines in each frame. This size is used for Digital

Cinema photography and projection. The aspect ratio for this format is 1.9:1, just a little wider than the common 1.85:1 used by many feature films.

Television broadcast and home monitors are a slightly different format called UHD or Ultra HD. This format is exactly double the 1920×1080 pixels of standard HD. The UHD frame is 3840 pixels on 2160 lines. This produces an image that is four times the pixels as the largest HD frame.

While the 4K format is in the early stages of adoption, a variety of production equipment and cameras are available to create content in this format. Displays for home use are also available. While development on ways to get the content from the producers to the home is ongoing, at this time there are limited ways to deliver 4K content. Netflix has 4K series available via web delivery and YouTube is playing 4K content. There are also a few movies available on specialty players. Just as HD grew to proliferate the television marketplace, it's expected that 4K will become the television standard by 2017.

One advantage of capturing images in 4K for standard HD delivery is that scenes can be enlarged up to 2x without any softening or reduction of resolution. For example, an image originating as 4K would be perfectly clear on a sports replay when the image freezes and then zooms in to an area of interest in the frame.

8K

If 4K is good, will 8K be better? The broadcaster, NHK, in Japan is developing the next generation of High Resolution technology. Called 8K, this format has 7680 pixels on each of its 4320 lines.

This is almost twice as many pixels and lines as 4K. In addition, frame rates up to 120 fames per second are being considered for this format. To enhance the audio experience, the format specifies surround sound with 22.2 channels. NHK has shown the format in prototype form numerous times in recent years, and hopes to broadcast the format starting with the 2020 Olympic Games in Tokyo. In addition to NHK, Sony and Red Digital Cinema Camera Company are working to bring 8K sensors into their cameras in the coming years.

One advantage of working with 8K is that its super-high resolution allows for more options during the post production process. As mentioned above with 4K shooting a sports replay, with 8K you can shoot an image in wide shot, perhaps a potentially dangerous animal far away, and then digitally zoom and crop or pan and scan the image to use just the desired portion. The zoomed-in portion would still match the smaller resolution of the current industry standard HD televisions. Also, 8K camera sensors create sharper pictures and richer colors than a 4K camera. But the 8K image can be *downsampled* to 4K, creating a better picture with a lower resolution.

Modulation Transfer Function (MTF)

When discussing resolution, it's easy to forget that the digital image sensors are capturing the analog world. While the technology of image capture advances at the rapid rate of computer systems, often the optical technology of the lens and prisms systems struggle to keep up. Optically, image sharpness and contrast are related and measured by something called the *Modulation Transfer Function*, or MTF. The way this is measured is by using imaging test charts that contain pairs of black and white lines (Figure 13.3).

Figure 13.3 USAF 1951 Imaging Test Chart

NOTE This chart was developed by the U.S. Air Force in 1951, which is why you will sometimes see that information on the chart itself.

As the lines get smaller and closer together they become more difficult to reproduce. The edges of the lines become blurred together, mixing to produce soft gray images. The point where the lower

contrast of the lines merge to gray represents the limit of sharpness the optical system can transfer to the image.

Although a cell phone or inexpensive camera may well make a 4K recording, the inexpensive mass-produced lens will not be able to create a high enough resolution to replicate clear line divisions in charts such as in Figure 13.3.

Progressively Segmented Frames

HDTV standards can use either of the two scanning modes, interlace or progressive. When a high def standard uses an interlace mode, the odd fields are transmitted first, followed by the even fields, just as they are in CDTV or SDTV. In progressive scanning, the entire image is scanned as one complete frame. This data may then be transmitted as a complete frame and received as a complete frame. If there is insufficient bandwidth to transmit the complete frame, the data may be segmented and transmitted in two parts.

Because progressively scanned images are complete frames of video, they require more bandwidth to transmit than may be available. To transmit these images within an interlace environment using narrower bandwidths, a process of segmenting progressively scanned frames was developed.

To do this, the image is divided into two fields by scanning every other line as in interlace scanning. The difference is that, in the interlace scanning process, the two fields are from different instances in time. When a progressively scanned image is segmented, the two fields are from the same instance in time. When the separate fields are recombined, the result is a complete progressively scanned frame (Figure 13.4).

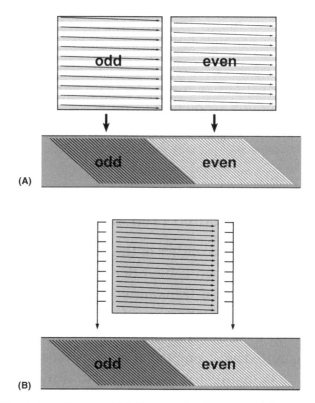

Figure 13.4 **(A)** Interlace Scan and **(B)** Progressive Segmented Frame

This process accommodates the need to segment the data without compromising the quality of the image. Images that are progressively scanned and then transmitted as segmented frames are referred to as PsF, for Progressively Segmented Frames.

Frame Rate

Within the HDTV set of standards, there are numerous frame rates. The frame rates are part of a set of criteria that defines a particular HDTV standard. Each set of criteria was defined because of specific requirements within an existing physical environment. For example, North American electrical systems use 60-cycle alternating

current, while European electrical systems use 50-cycle alternating current.

In addition, one of the major forms of image creation has been film. Film runs at 24 fps in North America and 25 fps in Europe. To minimize the difficulty in incorporating film into HDTV, a set of criteria was developed to accommodate the film frame rate. A different HDTV standard was created with a specific set of criteria based on the ease with which the new standard would interface with an existing system. Therefore, two of the many HDTV standards include 24 fps and 25 fps.

Film-to-Tape Conversion

There are many situations when film is transferred to HDTV, or HDTV to film. Film is often used as an archival medium because the film standard has not changed in generations. When film is used as the originating medium but the delivery requirement is video, film must go through a conversion process. Converting film to an electronic form is often referred to as *telecine*, which can also refer to the machine used in the conversion process. In PAL systems, the existing video frame rate matches the 25 fps film rate, and the conversion process is simply a matter of converting from one medium to the other. However, in the NTSC system, where the video frame rate of 30 fps does not match the film rate of 24 fps, a different conversion process must take place.

Converting Different Frame Rate Sources

Whether the need for conversion is from film to video or video to video, the HDTV 24 fps standard makes video and film more compatible with each other, especially in the United States where film

is shot at 24 fps. However, to create 30 images per second in video from a source producing 24 images per second, additional video fields are added. This is done by duplicating images from the 24 fps source. The process of adding additional fields to create additional frames is known as a 2:3 *pulldown* system or sometimes as a 3:2 *pulldown* system.

The 2:3 or 3:2 pulldown process is used when 24 fps progressive scan video, used in image capture, must be converted to 30 fps for either editing or transmission. It is also used when transferring 24 fps film to 30 fps video. When transferring 24 fps film or video into a 30 fps video system, it is essential to decide which sequence will be used—2:3 or 3:2—and then maintain that sequence.

Using 2:3 and 3:2 Pulldown Sequences

When transferring 24 frames per second in a 2:3 sequence, the system will map four frames from the original source to every five frames, or ten fields, to the transfer source. The first frame that is transferred is referred to as the A frame. It is transferred, or pulled down, to two video fields. The second frame is referred to as the B frame and is transferred to the next three consecutive video fields. The third film frame, the C frame, is transferred to the next two consecutive video frames. And the fourth frame, the D frame, is transferred to the next three consecutive video frames (Figure 13.5).

The resulting transfer process yields five video frames for every four original 24 fps source frames. Video frame 1 and video frame 2 are each derived from two separate film frames, A and B. Video frame 3, however, is a composite of one field from film frame B and one field from film frame C. Video frame 4 is also a composite composed of one field from film frame C and one field from film

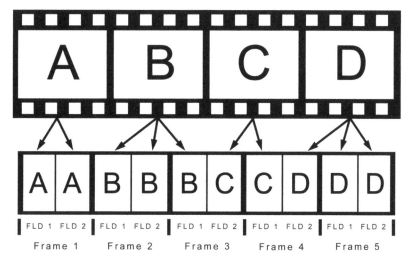

Figure 13.5 2:3 Pulldown Sequence

frame D. Video frame 5 is composed of two fields, both from film frame D.

When scanning through video images that have been transferred using this process, the video frames that contain two different frames will appear as a double image. When these frames are viewed in motion, however, the double image is not discernible. When editing video that has been transferred from film using this pulldown process, the sequence of frames must be maintained. If the sequence of video frames is broken, for example by editing two combination frames consecutively, the resulting conflict of images will be discernible when displayed in motion.

When the pulldown sequence is changed to 3:2, the resulting frames yield a different result. The five video frames would be AA AB BC CC DD (Figure 13.6). Here the second and third frames are composite, rather than the third and fourth. In

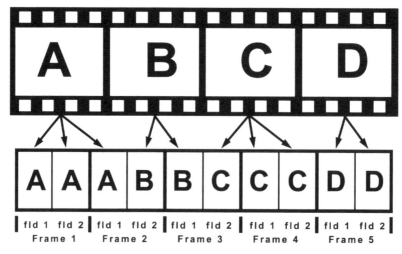

Figure 13.6 3:2 Pulldown Sequence

the 3:2 sequence there is one clean frame followed by two composite frames followed by two clean frames. Therefore, when converting 24 fps to 30 fps, it is essential that one of these processes is applied consistently so the order of clean and composite frames will be maintained.

Maintaining Consistency in Pulldown Sequences

Just as the pulldown sequence must remain constant, so should the transfer process. Once the transfer of a scene or section has begun, it is essential the transfer be completed without stopping. If the transfer is stopped and then restarted in a single scene or sequence, the system will assume the first frame again is an A frame and begin the sequence from there. Later, when attempting to edit this sequence together in video, it is very possible that the frame sequence will have been broken and the edited version will contain overlapped images from incompatible frames. The result could be a stutter or jump in the images.

During the film or video transfer process, as the footage is digitized into the video system, a computer file can be created that will indicate where the associated composite frames are for each section. The added fields can also be seen and identified by scrolling through the video a field at a time. With a correctly compiled computer file, it is possible for a video system to extract and recombine the overlapping fields to create a clean 24 fps sequence from the 30 fps 2:3 or 3:2 pulldown sequence created in the video transfer. The process will discard the redundant fields used to create the 30 fps video from the original 24 fps material. This process is referred to as *inverse telecine*.

Converting an HD Signal

One of the primary differences between HDTV and SDTV is the increase in the amount of information that makes up the HDTV signal. Because of the number of pixels per line, lines per frame, and frames per second, HDTV has a greater spatial and temporal resolution. While the size of the image is larger and the resolution is greater, the recording, storage, and transmission processes remain similar. Because of these similarities, HDTV signals may be converted to other standards.

Converting HDTV to SDTV or CDTV is referred to as *down converting*. In the downconversion process, the number of lines and the number of pixels per line are reduced to fit the targeted standard. For example, a HDTV image that is 1920 × 1080 could be reduced to a 720 × 480 SDTV image. The reduction is achieved by deleting some lines and pixels in the downconversion process. The consequence of this is a reduction in image resolution, though the aspect ratio may remain the same. However, in some situations when a 16 × 9 image is reduced to 4 × 3, the 4 × 3 image may appear as though it had greater detail than the original.

Figure 13.7 Down Converter on HD VCR

Downconversion is used when an HDTV native image needs to be used in an SDTV or CDTV environment. For example, a program can be shot in HDTV, but transmitted or broadcast in SDTV or even CDTV. Also, if the editing process is configured with SDTV or CDTV equipment, a downconversion from HDTV allows the editing to occur within the existing post production environment. Some HD VCRs are even equipped to downconvert a signal internally (Figure 13.7).

CDTV or SDTV can also be converted to an HDTV standard through a process called *upconverting*. The upconversion process increases the number of lines and the number of pixels per line to fit the targeted standard. This involves, in some instances, duplication of information to fill in the additional spatial resolution. This does not increase the detail in the image nor the apparent resolution. It merely increases the pixel and line count.

Upconversion is used when taking a CDTV or SDTV image and enlarging it to fit in an HDTV space. For example, an older television program that originated in CDTV may be upconverted to HDTV or SDTV for current broadcast. Some equipment contains a downconversion/upconversion circuit within the machine itself.

In other cases, the conversion process is accomplished through an outboard or stand-alone device.

HDTV Applications

Because of the different HDTV scanning types and frame rates, HDTV images may look different with each standard. A faster scan rate, or temporal resolution, typical of interlace scanning, gives more frequent image information because it scans an image twice for each frame, once for the odd lines and again for the even lines. The scans are created in different moments in time. This process refreshes the image more frequently than progressive scanning. Therefore, interlace scanning is often used for images that contain a great detail of motion with a lot of action. For example, football games are often shot using 60-field interlace (60i) HDTV. The more frequent scanning of the image fields produces a greater number of images in a given amount of time, creating a smoother transition from field to field and frame to frame.

An HDTV image shot in 24p, or 24 fps progressive scanning, gives a less frequent scanning rate or slower temporal resolution. Shooting in 24p means it takes longer to scan a full frame because successive lines must be scanned. A 24p frame rate creates a softer, film-like look. In 24p, rapid motion is not advisable because the slower temporal resolution cannot capture enough motion detail to track the action clearly.

One of the reasons 24p was developed as a standard was to match 35mm motion picture film, both in terms of temporal and spatial resolution. Certain television programs that originated in SD video are converted to HDTV for archival and sometimes broadcast purposes. However, shows that were created after the advent of HDTV, but during the time HDTV standards were still being

defined, turned to film for production purposes. This allowed the shows to be both archived in film, an established medium, and converted to any video standard at a later date.

Non-Picture Data

Digital video uses a data stream to carry picture information, but there is also non-picture data mixed in with it. Some of this non-picture data contains sync and color information, and some of it contains information about the picture data stream itself. This digital data stream also contains information about which standards are being used.

Vertical Ancillary Data (VANC)

In analog video signals, the vertical blanking interval between fields was used to carry synchronizing information and eventually included test signals, timecode and closed captioning data. In digital video this data has now been incorporated into the data stream and is included under the heading of VANC, or vertical ancillary data. VANC is created and encoded into the data stream through a data encoder that creates and can also retrieve the information. The data to be encoded is programmed in by the operator through a series of menus built into the encoder.

Horizontal Ancillary Data (HANC)

In addition to VANC, there is also HANC or horizontal ancillary data. This is analogous to the data carried in the horizontal blanking interval that relates to line-by-line synchronization and color synchronization.

Compression

<div style="text-align: right">**14**</div>

Compression is the process of reducing data in a digital signal by eliminating redundant information. This process reduces the amount of bandwidth required to transmit the data and the amount of storage space required to store it. Any type of digital data can be compressed. Reducing the required bandwidth permits more data to be transmitted at one time.

Compression can be divided into two categories: *lossless* and *lossy*. In lossless compression, the restored image is an exact duplicate of the original with no loss of data. In lossy compression, the restored image is an approximation, not an exact duplicate, of the original (Figure 14.1).

Lossless Compression

In lossless compression, the original data can be perfectly reconstructed from the compressed data that was contained in the original image. Compressing a document is a form of lossless compression in that the restored document must be exactly the same as the original. It cannot be an approximation. In the visual world,

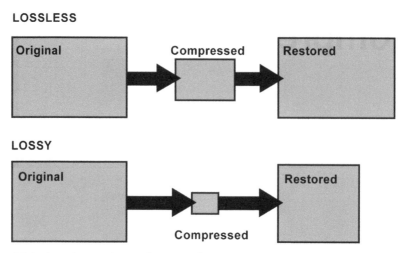

Figure 14.1 Lossless vs Lossy Compression

lossless compression lends itself to images that contain large quantities of repeated information, such as an image that contains a large area of one color, perhaps a blue sky. Computer-generated images or flat colored areas that do not contain much detail—e.g., cartoons, graphics, and 3D animation—also lend themselves to lossless compression.

One type of lossless compression commonly used in graphics and computer-generated images (CGI) is *run-length encoding*. These images tend to have large portions using the same colors or repeated patterns. Every pixel in a digital image is composed of the three component colors—red, green, and blue—and every pixel has a specific value for each color. Therefore, it takes three bytes of information, one byte for each color, to represent a pixel.

Run-length encoding, rather than store the RGB value for each individual pixel, groups each scan line into sections, or run-lengths, of identical pixel values (Figure 14.2). For example, one section of a line of video might consist of a row of 25 black pixels. This section

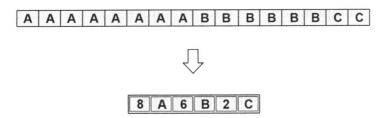

Figure 14.2 Run-length Encoding

would be run-length encoded as 25, 0, 0, 0. This translates as 25 pixels, each composed of R = 0, G = 0, and B = 0, or black. The original image would have required 75 bytes (25 pixels × 3 bytes) to hold this data. When compressed using run-length encoding, the same data can be contained in four bytes.

Lossy Compression

Video images generated by a camera are generally not suited for lossless compression techniques. Rarely are there long enough run lengths of the same pixel value in an image to maximize the efficiency of these techniques. Compression used for active video is usually in the *lossy* category. With lossy compression, the restored image will be an approximation of the original. When a lossy image is reproduced or uncompressed, not all the data left out during compression will be restored exactly as it was.

To minimize the visible loss of data, lossy compression techniques generally compress the data that comprise those parts of the image the human eye is less sensitive to, or that contain less critical image data. The human eye is more sensitive to changes in light levels or luminance than it is to changes in color, both hue and saturation. Within the color gamut, the human eye is more sensitive to the yellow-green-blue range. The human eye is also more sensitive to objects in motion than to still objects.

In lossy compression, the data compressed is the data that does not fall within the human sensitivity range or data that contains a great deal of motion. Two commonly used lossy compression techniques are JPEG and MPEG. These techniques, and variations of them, are described in this and the next chapter.

Data Reduction

Video files generally contain redundancy that can be used to reduce the amount of data to be stored. This can be done by registering the differences within a frame (*intraframe*) and between frames (*interframe*) rather than storing all the information from each frame.

Intraframe Compression

Intraframe compression utilizes *spatial redundancy*, or the repetition of data within the space of the frame, to define the data that can be discarded. This compression is achieved through a technique called *sub-sampling*. In sub-sampling, the number of bits needed to describe an image is reduced by storing only some of the pixels that make up the image. For instance, every second pixel in a row and the entirety of every second row could be ignored. Those pixels that are retained would then be increased in size to compensate for the data that has been left out (Figure 14.3).

Another sub-sampling strategy uses the *average values* for a group of pixels. This average is substituted for the original values for those pixels. Sub-sampling effectively reduces the number of pixels in an image. Alternatively, rather than reduce the number of pixels in an image, the amount of information about each pixel can be reduced. This, however, also reduces the number of gradations of color and grays in the image.

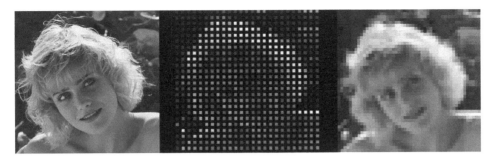

Figure 14.3 Intraframe Compression

Quantization is another method for reducing the amount of data. Quantizing sets a limit on the quantity for the range of values to be stored and the increments between values for the data to be coded, thereby compressing the amount of data needed to be stored.

Transform coding uses a complex conversion process to turn coded blocks of the image into a compressed image or video file for storage or transmission.

Interframe Compression

Interframe compression compares the unchanging portions of successive frames from one frame to the other. Simple movements of objects between one frame and another or changes in light, for example, can be stored as similar commands between frames (Figure 14.4). The commands take up less storage than the actual data required to store the complete frame. Interframe compression utilizes a version of sub-sampling in which not all frames are transmitted. Instead, the commands are stored to recreate the data. Other strategies used in Interframe compression are *difference coding, block-based difference coding,* and *block-based motion compensation.*

In *difference coding,* each frame is compared to the preceding one and only those pixels that are changed are stored.

Figure 14.4 Interframe Compression

Block-based difference coding works in the same fashion but at a block level rather than a pixel level. The frames are divided into blocks of pixels, and it is these blocks that are compared between frames.

Block-based motion compensation is a further refinement of difference coding. The frame is divided into blocks as before. These blocks are then compared to blocks in the preceding frame to find blocks that are similar. If the similar blocks are in different locations, it is this difference of position that is stored rather than the actual information in the block.

A further refinement is *bidirectional motion compensation*, in which the current frame is compared to both the preceding and following frame and the differences stored rather than the content of the frame (intraframe and interframe compression are discussed in more detail in the following chapter).

Data Transmission Limitations

The requirements of the programming source, as well as the transmission and storage devices being used, may limit your choice of compression types. The limitations for transmission are controlled by the quantity of data the transmission and receiving systems can handle in a given time period. The limitations for storage are

obviously limited by the space available. Therefore, another factor to be considered in data compression is the bit rate needed to store, transmit, and reproduce the data accurately.

Bit Rates

The complexity of an image is a result of the combination of the amount of movement or change from frame to frame and the quantity of detail contained in the image. To maintain proper image motion in time, the zeros and ones, or digital bits, that comprise the data must be transmitted and received quickly enough to reproduce the image in the proper time frame. Depending on the complexity of the image and the required level of quality, different data rates, or *bit rates*—that is, the speed at which the data is processed—are used.

If the images are less complex in nature, or if the required level of quality is not high, a fixed or constant data rate or bit rate may be used. Where the images are either more complex or the required level of quality is high, variable bit rates may be used in order to maintain a reduced data rate while not compromising the quality. Because of these differences, constant bit rates can be used to compress images in real time, whereas variable bit rates cannot.

Constant Bit Rates

Fixed or *constant bit rates* (CBR) result in varying levels of picture quality because there is no allowance for image complexity. Broadcast media—such as cable, satellite, and terrestrial broadcasting—require constant bit rates for their transmission equipment. Live broadcasts, satellite linkups, and playback of uncompressed video all require immediate real-time compression while being transmitted.

Variable Bit Rates

Although video runs at a fixed frame rate, the amount of data required to encode each frame can be variable, depending on scene complexity. *Variable bit rates* (VBR) allow for consistent picture quality when the complexity of the image varies. Each part of the image is analyzed and compressed at its optimal compression rate. Less complex portions of the image are compressed at higher rates while more complex portions of the image are compressed at lower rates. In order to achieve variable bit rates, there must be greater analysis of the image content to achieve the best quality with the least amount of data; most encoding software and equipment does *two-pass* variable bit rate encoding, with the first pass over the video devoted to simply analyzing the video. With variable bit rates, the encoding process is more complex and cannot be done in real time. VBR encoding is used for storage in media such as DVDs.

JPEG Compression

JPEG defines the standards for compressing still images, such as graphics and photographs. Similar to video standards groups discussed in previous chapters, JPEG compression was developed by the Joint Photographic Experts Group, a joint working group of the International Standardization Organization (ISO) and the International Electrotechnical Commission (IEC).

In JPEG compression, the image data is converted from RGB into luminance (the Y component) and chrominance information (the color difference signals, the Cb and Cr components). JPEG takes advantage of the human eye's greater sensitivity to changes in luminance than changes in color by sampling the chroma or color information in the image less often than the luminance. This process is known as *downsampling* or *chroma subsampling*.

Downsampling can result in data reduction by a factor of 2 in the horizontal direction only or by a factor of 2 in both the horizontal and vertical directions if both are used. The components are then grouped in blocks of 8 × 8 pixels and converted using a type of transform coding called Discrete Cosine Transform, or DCT. Data can be reduced further by encoding redundant luminance information in the image using intraframe coding methods.

JPEG compression of 10 to 1 results in images that appear to be unchanged from the original. More aggressive compressions of 100 to 1 are possible, but visual degradation is apparent. The levels of compression used are dependent on the end use of the image file.

JPEG 2000

JPEG 2000 was designed to handle higher compression ratios than can JPEG, but without introducing the artifacts that are a by-product of higher compression under the DCT-based JPEG standards. Instead of the Discrete Cosine Transform method of coding, JPEG 2000 uses Discrete Wavelet Transform, or DWT. The DWT approach does not divide the image into blocks but analyzes the whole image and organizes the image data to a more easily compressed form. This reduces the blocking artifacts introduced by DCT.

> **NOTE** JPEG 2000 can handle both lossless and lossy compression. Apart from being designed to deliver higher compression ratios, JPEG 2000 has been designed to detect and conceal errors introduced into the file by transmission, such as over wireless channels.

As with JPEG, the images are transformed from RGB to the luminance and chrominance (Y, Cb, and Cr) information. The image is then tiled into areas that are encoded separately. The results are called *sub-bands*, which are then quantized and further processed into what are called *precincts*, which are approximately related blocks in the image. The precincts are divided into *code blocks* that are of equal sizes, and the encoder codes these blocks (Figure 14.5).

This coding takes place in three stages and the resultant bit stream is then divided into *packets* for transmission. Those packets containing the least significant bits can be discarded. JPEG 2000 is designed for applications such as multimedia devices, video streaming and video servers, HD satellite imagery, and storage of video sequences.

Motion JPEG Compression

Motion JPEG, or *M-JPEG*, while not covered by the JPEG standard, was developed from JPEG as an early attempt to compress moving images by treating each image as a single still picture. M-JPEG compression uses intraframe coding and is used in nonlinear editing systems, some Internet browsers, game consoles, and compressed video disks.

MPEG Compression

MPEG compression was developed by the Motion Picture Experts Group and defines the standards for compressing moving images. MPEG techniques establish the protocols for compressing, encoding, and decoding data, but not the encoding methods themselves. In other words, the rules dictate the order of the data and what the data must contain but not the method by which the data

Figure 14.5 Discrete Wavelet Transform (DWT) Process

181

is derived. This allows for continuous improvement in encoding techniques without having to constantly change existing equipment. The following chapter takes a more in-depth look at MPEG compression.

Other Compression Codecs

Many other compression systems are based on MPEG and JPEG. Some formats, such as HDV and XDCam, use the toolsets of MPEG, but are adapted to specific uses. Other formats, such as H.264 or AVC (Advanced Video Coding), are MPEG formats with names based on other standards groups categories or marketing by equipment manufacturers who developed improved compression formats within the MPEG protocols. The next generation of these codecs, H.265 or HEVC (High Efficiency Video Coding) is able to compress video into smaller files and has the ability to work with the larger frames of 4K and 8K images.

Problems Introduced During Compression

During compression and encoding of digital data, various errors and inaccuracies can be introduced into the image. Some of these problems include *aliasing*, *quantization noise*, *overload*, and *degradation*.

Aliasing occurs when frequencies being digitized are too high for the sampling frequency. Aliasing produces a distortion consisting of vertical lines through the image.

Quantization noise is caused by the quantization process, which forces the frequencies into a limited fixed number of levels or steps, producing coarseness in the final image.

Overload occurs if the amplitude of a signal is too great. All levels exceeding the maximum level that can be correctly digitized are converted to white and produce a bleached final image. In another type of overload caused by low amplitude signals, all levels below a minimum are converted to black causing a darkened final image.

Degradation can occur during the transmission of the compressed images. The nature of the compression process means that a single bit error can have an exaggerated effect on the final image.

Compression Artifacts

The compression and decompression process sometimes introduces small visible errors into the restored image. These errors are called *artifacts*. The type of artifact depends on the type of compression used and the signal content.

Chrominance smear—As a result of low luminance levels or high chroma levels, colors can bleed across sites on a chip. The result is called smearing. The appearance is that of colors blending between areas in the image.

Chrominance crawl—Very fine vertical stripes in a scene can produce high frequency luminance signals that start to be interpreted as chrominance information. This appears as a shimmer of rainbow colors over the striped surface.

Blocking—This is the appearance of small, regular squares that appear to tile an entire still image.

Mosquitoes—This refers to the fuzzy dots that can appear around sharp edges after video compression.

Codec Attributes

There are dozens of different codecs in use in image processing, each having strengths and weaknesses, which make them suitable for different tasks in the stages of video production.

For image capture, a codec that preserves as much image detail as possible is ideal. Compressing too much at this early stage will discard detail that can make post processing—such as color correction and image compositing—more difficult. Very high-end cameras record as much detail as possible by capturing uncompressed data from each of the RGB channels. This leads to the creation of tremendous volumes of data to store and move.

At the other end of the camera spectrum, phones and inexpensive consumer cameras heavily compress the signal using long GOP codecs like H.264. While this creates very manageable file sizes, post production image processing is limited by the lack of color depth and detail that is retained.

Post production editing is best done in an intraframe codec. Codecs that use interframe techniques, such as MPEG and H.264, require decoding the video to find the individual frames to make an edit, then re-encoding the frames on the fly. This process can tax even the most powerful computer edit systems, and make for a slow and frustrating editing experience. Codecs such as DN × HD and ProRes are designed by edit system manufacturers to address this issue.

Video destined for the web needs to be compressed in a codec that is designed for streaming the data over the Internet. The files can be more heavily compressed and long GOP codecs are ideal (GOP codecs are discussed in the following chapter). H.264 is frequently

the best choice, but there is also much content on the web in Windows Media formats and other codecs as well.

From capture to delivery, an image may move from one codec to another, or be transcoded, several times. Keep in mind that as the images go from less compressed to more compressed, detail and color fidelity are reduced. Once parts of the image are discarded in favor of smaller file sizes, they cannot be recovered. Going from a heavily compressed image to a less compressed format does not improve the image.

NOTE You can read more about codecs in Chapter 19.

MPEG Compression 15

The majority of codecs in use today are based on the principles developed for MPEG compression. Remember, MPEG compression was developed by the working group of authorities, Motion Picture Experts Group (MPEG) formed by the ISO and the IEC. It defines the standards for compressing moving images. In fact, MPEG compression is really a set of tools that can be combined in different ways to compress video files. New tools have been regularly added to the standard leading to an ever more efficient compression. This chapter will take an in-depth look at how an MPEG-2 compression works in order to lay a foundation for the MPEG process.

The MPEG Process

The MPEG process starts by analyzing a sequence of video frames known as the video stream. Redundant information is encoded and compressed. The compressed video stream is then encoded into a *bit stream*. The bit stream is then stored or transmitted at the bit rate called for by the playback equipment. The data is decoded and uncompressed when it is to be used and the image restored to its original form.

MPEG compression utilizes a combination of two different compression schemes, *spatial* and *temporal*. Spatial compression reduces the quantity of data contained in each frame of video by eliminating the redundant data within the image. Temporal compression compares the changes between the images over time and stores the data that represents only the changes.

Spatial compression uses the same technique as JPEG compression, described in the previous chapter, to create an *intra picture*, called an *I frame*. Unlike the temporal compression frames, the I frames are complete "stand-alone" images that can be decoded and displayed without reference to any surrounding frames.

The I frames are interspersed within the video stream and act as references for the temporal compression between frames. The arrangement is somewhat like a picket fence, with the I frames representing the relatively few fence posts while the temporal frames are the many pickets. The temporal compression frames, called B and P frames, contain motion information that describes how the different regions of the I frame have changed between the intervening frames. The B and P frames contain far less data than the I frames. They contain only the data about the changes that have occurred between frames. This accounts for the great efficiency of MPEG encoding. Compression rates of 25:1 can be achieved with little or no noticeable degradation in the quality of the uncompressed image. I frames and B and P frames are described in more detail below.

I Frames

An *I frame* (intra picture) is one frame that is a complete image sampled in detail so it can be used as a reference for the frames around it. Each I frame is divided into 8 × 8 pixel blocks which are then placed in groups of 16 × 16 pixel blocks called *macroblocks*

Figure 15.1 (Plate 20) I Frame Macroblocks and Blocks

(Figure 15.1, Plate 20). These macroblocks are then compressed using a variety of compression techniques. I frames are created as often as needed and particularly when there is a substantial change in the image content. In a typical video stream, this occurs approximately two times per second.

P Frames

The frames before and after the I frame, labeled P and B, contain the data representing the changes that occur between themselves and the I frame. *P frames* (predicted pictures) contain descriptions of how the pixel blocks in the previous frame have changed to create the current frame. In addition, the P frames are examined to see if data blocks have moved. Subject or camera movement might cause some image blocks to have the same data in each frame, but in a different location. These descriptions of distance and direction of movement are called *motion vectors*. The decoding process for the current frame looks backward at the previous frame and repositions the pixels based on the P frame motion vectors. The previous frame could be either an I frame or another P frame.

If there is a substantial change in the image, new pixel blocks are created for the portion of the image that has changed. These new blocks are derived from the source video and use the same encoding method as the I frame. P frames cannot stand alone or be directly

accessed, since they are dependent upon the information in the previous frames from which they are derived. P frames contain much less data than I frames and are therefore simpler to encode.

B Frames

B frames (bidirectional pictures) are similar to P frames in that they are made up of motion vectors and picture blocks. The difference is that they look both forward and backward to compare pixel blocks, where the P frames only look backward to the previous frame.

When new elements enter the picture, the pixels in a B frame can be compared forward or backward to pixel blocks in either I or P frames. The data representing the difference between the previous and following frames is used to create the B frame.

Using B frames causes delays in the transmission of the bit stream. As the encoder must wait to see what is contained in future frames, the data is buffered until that data is available. Transmission of the data cannot occur until the B frames are able to be calculated. Because of this potential delay in playback, B frames are not used in all forms of MPEG.

The B and P frames both consist of data that reflects only the changes between the frames and not data about the complete image itself. For this reason, neither B nor P frames can stand alone as single images.

The Group of Pictures (GOP)

I, B, and P frames are grouped together to form a *Group of Pictures*, or GOP. A GOP must start and end with an I frame to permit its use as a reference for the surrounding B and P frames. A GOP can contain just P frames or both B and P frames in between the I frames. The number of B frames or P frames within a GOP can be increased

I B B P B B P B B P B B I B B P B B P B B P B B P B B P B B I

Figure 15.2 Group of Pictures (GOP)

or decreased depending on image content or the application for which the compressed video is intended. For example, a fast-moving action sequence with complex content (lots of detail) would use shorter groups, hence more I frames. Group lengths typically range from 8 to 24 frames. Figure 15.2 shows the typical GOP structure for 30 frames of IBP-encoded video stream.

IP Method

Excellent compression quality can be achieved using just I and P frames, even though the P frames only use backward references in time. The following example shows three frames of the source video material encoded only with I and P frames (Figure 15.3).

IBP Method

The addition of the optional B frame increases the compression quality but lowers the rate of data transmission. The B frame looks both forward and backward in time so the frame with the most helpful information can be used as a reference (Figure 15.4).

The source video material (top row) shows a truck moving left to right over a city background.

The compression process starts with an I frame, which is a JPEG compression of a single frame of video.

In the next step, a P frame is generated that refers backward in the sequence of images to the previous I frame. The P frame contains motion vectors that describe the position of the background and the movement of the truck. When the truck is repositioned, the area of the background that is uncovered leaves a "hole" in the background (black square).

To fill in the missing part of the background, blocks of pixels are copied from the I frame using JPEG compression and combined with the motion vector data contained in the P frame.

The procedure is repeated for subsequent P frames which refer back to the previous P frame, retrieve data from the I frame, and fill in any new "holes."

Figure 15.3 IP Method of Compression

Like the IP method, the IBP method starts with an I frame.

In the next step, the last frame of GOP is generated as a P frame first. The P frame refers back to the I frame with motion vectors to describe the background and the movement of the truck. Again, any "holes" in the background are filled in with pixel blocks from the I frame.

The B frame is then generated by motion vectors for the objects in motion. Like the IP method, the truck's movement uncovers a region of the background leaving a "hole" in the picture.

The B frame is completed by filling in its "holes" with pixel blocks from either the I or P frames by looking both forward and backward in time.

Figure 15.4 IBP Method of Compression

Profiles and Levels

The I, B, and P tools can be combined into progressively more sophisticated compression techniques called *profiles*. Picture quality can improve depending on the profile used. Each profile can be divided into *levels* of quality, depending on the compression tools used and the physical parameters of the compressed video, such as the picture size, resolution, and bit rates. There are four levels that provide a range of picture quality, from limited definition (¼ resolution video) to high definition with 1080 scan lines. Each level has its own specific standard for the input video, such as Standard Definition video or High Definition video.

Main Profile at Main Level

The different profiles and levels can be mixed and matched to create a wide variety of picture sizes, bit rates, and encoding qualities. The most useful combination for Standard Definition images is the *Main Profile at Main Level* (abbreviated as *MP@ML*). Main Profile means that I, B, and P frames can be used for compression, and Main Level means that the picture resolution is 720 × 480 in NTSC. Different storage, delivery and transmission systems have different bit rate constraints. The I, B, P compression tools are flexible enough that MP@ML can adjust the bit rates. Lowering the bit rate reduces the picture quality unless it is compensated for by using more sophisticated encoding tools.

High Definition Profiles and Levels

MPEG-2 has a number of Profile and Level combinations designed for High Definition images as well. Main Profile at High Level is for the two HD formats, 1920 × 1080 and 1280 × 720. ATSC

Table 15.1 Samples of Various Bit Rates for Main Profile at Main Level

Bit rate	Application
1.5 Mbits/sec	YouTube 480p (using H.264)
2.5 Mbits/sec	YouTube 720p (using H.264)
4.5 Mbits/sec	YouTube 1080p (using H.264)
3.5 Mbits/sec	NTSC/PAL broadcast quality
10 Mbits/sec	DVD disk (using MPEG compression)
15 Mbits/sec	Equivalent to DV tape quality
8–15 Mbits/sec	HDTV quality (MPEG-4 AVC compression)
19 Mbits/sec	HDV 720p (using MPEG-2 compression)
24 Mbits/sec	AVCHD (using MPEG-4 AVC Compression)
40 Mbits/sec	1080 Blu-ray DVD

and DVB broadcast formats use MP@HL, however the chroma is heavily subsampled to 4:2:0, which represents the lowest digital color sampling (color subsampling is discussed in the following section).

The least compressed of the MPEG-2 Profiles and Levels is 422 Profile at High Level. This allows for 4:2:2 sampling of images up to 1920 × 1080. Data rates of up to 300 megabits per second are allowed. Several camera and recorder manufacturers use this format. For example, Sony XDCAM @ 50 megabits per second is 422P@HL.

As of the writing of this book, the MPEG-2 standard does not allow frame sizes greater than 1920 x 1080 or frame rates above 60 frames pre second. For 4K and UHD applications, other compression formats must be used. The more recent compression standard, MPEG-4, allows for larger frame sizes. Even the recent development of HEVC (or H.265) makes it the likely successor to MPEG for larger frames.

Color Subsampling

Another aspect of the compression process is color subsampling. As mentioned above, 4:2:0 and 4:2:2 are numbers that represent digital sampling standards. First, the RGB channels are converted into luminance (Y) and two chrominance channels (Cr and Cb). After converting RGB video signals into luminance and chrominance data, the chrominance portion can be compressed with little apparent loss in image quality.

> **NOTE** As mentioned throughout the book, the human eye notices changes to luminance levels, the brightness and contrast of an image, more easily than it does changes to color. This is why reducing the frequency of color sampling can be an effective method of compression.

Let's consider four different digitizing schemes for video: 4:4:4, 4:2:2, 4:1:1 and 4:2:0. In each case, for every set of four pixels on a scan line, there are four digital samples of the luminance channel. The schemes differ, however, in the amount of times the chroma in each line is sampled. In the 4:2:2 scheme, for example, only two samples are taken for each of the two chrominance channels (Figure 15.5, Plate 21). Each chrominance sample is *shared* by two pixels. As a result, the two chrominance channels are digitized at half the resolution of the luminance channel, reducing the amount of data for those two channels by 50%. This reduces the total data required for each frame of video by 33%.

4:2:0 sampling takes the idea of sub-sampling the chrominance channels a step further than 4:2:2. If, for every four pixels, there were four samples of luminance but no samples of chrominance, that would be 4:0:0 sampling. Of course, with no chrominance data you would only have a black and white picture. However, if

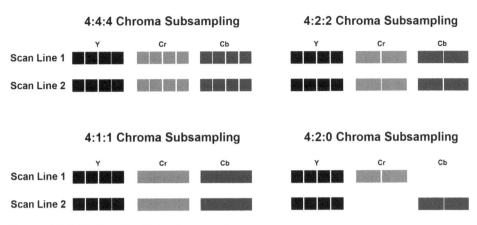

Figure 15.5 (Plate 21) Color Subsampling

every other scan line was digitized at 4:2:2 and the lines in-between were digitized at 4:0:0, the chrominance data from the 4:2:2 scan lines could be shared by the alternating 4:0:0 scan lines, further reducing the amount of data required to describe a frame of video.

Figure 15.5 illustrates how 4:2:0 sampling alternates between 4:2:2 and 4:0:0 sampling on each scan line. Each chrominance sample is therefore shared by two pixels horizontally as well as two scan lines vertically. This means that the chrominance samples cover a 2 × 2 area, or four pixels. As a result, the two chrominance channels each have only 25% of the data that the luminance channel has. Reducing the data requirements for two channels to 25% reduces the total data required for each frame of video by 50%. 4:4:4 represents four times the subcarrier frequency for all three of the signals and 4:4:4:4 adds the key signal, or alpha channel, as part of the digital information.

NOTE While these numbers are mathematically accurate with Standard Definition signals, there is no longer a direct relationship to the frequency of the subcarrier in High Definition. Yet the ratios remain when talking about HD as well.

Alpha Channel

The process of combining or compositing images often requires a channel of transparency information to be part of the image data file. In computer graphics terms, this data is often called the *Alpha Channel*. It is a luminance only channel that is part of some video codecs. In areas where the channel is completely white, the image that contains the alpha channel is opaque. If part of the alpha channel is completely black, the companion image is completely transparent. Shades of gray between the two extremes are a proportional mix of the attached image and the other images in the composite.

In the world of video, this process is often referred to as *keying*. The *key signal*, or alpha channel, can be derived by the color in one of the images to be combined (often called a chroma key or green screen). The key may also use the luminance of one of the images as the alpha. Some devices, notably graphics machines, will provide a separate key signal output.

MPEG Variations

Over time, MPEG variations, such as MPEG-1, MPEG-2, MPEG-4, were developed with different compression schemes. For example, MPEG-2 compression can use a variety of computer algorithms, or mathematical formulas, to compress the images. These different algorithms can be used in combination to provide progressively increased compression without loss of quality. Different MPEG compression techniques or variations lend themselves better to specific applications.

MPEG-1

MPEG-1 comprises the Video CD (VCD) format, the quality of which is analogous to that of the output of a VHS tape. The VCD format

was a popular way of recording video onto CDs before the ready availability of DVD recording. This format uses small pictures sizes, about a quarter of the size of a standard definition frame, and low frame rates to keep the data stream small enough to play back from a CD. MPEG-1 does not support broadcast-quality video and is no longer frequently used. However, as nearly every computer made since the early 1990s can play this format, it is not quite dead yet. Additionally the popular audio format, MP3, is formally called MPEG-1 Audio Layer 3.

MPEG-2

Nearly all digital video broadcast uses the MPEG-2 video compression standard, which is also used to encode audio and video for broadcast satellite and cable TV. MPEG-2 is more complex than its predecessor, MPEG-1, but it is essentially an improved version of MPEG-1. The MPEG-2 standard has a number of parts describing coding and testing of audio and video files, data broadcasting, downloading of files, and interfaces for decoding the files. MPEG-2 Part 1 defines a transport stream for the broadcast of audio and video files and a program stream for storage on media such as DVDs.

One major difference between MPEG-1 and MPEG-2 is that MPEG-2 is designed to support interlaced video as used in broadcasting while MPEG-1 does not. MPEG-2, however, also supports progressive scan video streams.

MPEG-2 organizes pixels into macroblocks (16×16 instead of 8×8). The macroblocks are processed as four blocks of 8×8 blocks. MPEG-2 has a definition for fields within frames. There are two fields in each interlaced frame. The field containing the odd lines is sometimes called the upper field and the lower field contains

the even lines. MPEG-2 uses two types of DCT coding, frame DCT and field DCT. Frame DCT-coded macroblocks are coded from four blocks coming from the same frame of video. Field DCT-coded macroblocks can either be coded with four blocks coming from one field of video or two blocks coming from one field and two blocks coming from another field. Non-interlaced video is coded using frame DCT while interlaced video can be coded using frame DCT or field DCT. Field DCT can only be used with interlaced video.

While other versions of MPEG are more efficient than MPEG-2, there are uncountable set top boxes, TV receivers, DVD Players and computer devices that can decode MPEG-2 streams. As a result it still finds wide use in the industry.

MPEG-4

MPEG-4 is a set of coding standards designed to compress digital audio and video data. It includes many of the features of MPEG-1 and MPEG-2, but adds to them and offers increased resistance to errors and greater compression efficiency. Whereas MPEG-2 is DVD quality video, MPEG-4 delivers the same quality but at lower data rates and in smaller files. This makes MPEG-4 the best choice for streaming video on the Internet (the process of streaming video is discussed in more detail in Chapter 21). MPEG-4 is also used for distributing media over broadcast TV and to handheld media devices, such as cell phones, tablets, and so on, so its flexibility and resistance to errors introduced by transmission are key.

MPEG-4 Compression Process

MPEG-4 is processed in a visual hierarchy rather than as a series of images. Every object is represented by a *video object plane* (VOP) that consists of a sampling of the object over a number of frames.

A *group of video object planes* (GOV) is similar to the GOP organization used in MPEG-1 and MPEG-2. A *video object layer* (VOL) is the next level of organization and consists of a series of VOPs or GOVs. The *video object* (VO) is all of the VOLs associated with an object.

The VOP may be thought of as an MPEG-1 or MPEG-2 video frame and is coded in a similar fashion, with I-VOPs, B-VOPs, and P-VOPs. As MPEG-2 introduced variations on the IBP system of MPEG-1, MPEG-4 has its own new techniques to improve the efficiency of compression.

MPEG-4 also uses *sprites*. A sprite is a video object that is static and persistent. Once the sprite has been transmitted, only perceptual variations need be updated. Sprites, being static objects, are treated and encoded much like a JPEG image.

Webcasts on the Internet are broadcast in MPEG-4, MPEG-4/AVC (Advanced Video Coding), Real Video, WMV (Windows Media Video), QuickTime, RealMedia, and 3 GP (3rd Generation Partnership—cell phone application), all of which include some aspects of MPEG-4 parts (or standards) and profiles. Each part contains a number of profiles. Most of the features are left up to developers as to whether or not to implement them so there are levels and profiles in MPEG-4 implementation, but probably no implementation that includes them all.

Audio for Video

Human perception and learning is 90% visual. And yet people are more critical of what they hear than what they see. Because audio comprises a much smaller percentage of human information gathering, even a small audio discrepancy will translate into a much greater perceptible difference. It has been found through experimentation and research that people will watch poor-quality film and video as long as the audio is good. On the other hand, an audience will not tolerate poor audio, no matter how good the video is, because it is more of a strain to make sense of the content. If audio is out of sync by one or two frames, it is obvious and annoying. Even so, audio is often thought of as less important than video. But this is simply not the case.

Measuring Volume as Decibels

The human ear responds to a remarkable range of sound amplitude, or loudness. The difference between the bare perception of audio, perhaps fingers lightly brushing away hair, and the threshold of pain is on the order of a 10 trillion to 1 ratio. Because this range is so enormous, a measuring system had to be created that reduced this range of information to more manageable numbers.

In mathematics, *logarithms* are often used to simplify large calculations. Logarithms can be used with any numeric system, such as base 10 or base 2. When logarithms use the decimal system, or base 10, to simplify the measurement of sound, that measurement is referred to as *decibels.* All sound is measured in decibels and all measurements are logarithmic functions.

The decibel measurement was developed many years ago by Bell Laboratories, which was then a division of the Bell Telephone company. Decibels are notated as *dB.* One decibel is one tenth of one *bel,* which was named after Alexander Graham Bell. However, this larger unit of measurement, bel, is rarely used.

The decibel is not a specific measurement in the way that an inch or foot is an exact measurement of distance. A decibel is actually the ratio between a measured signal and a 0 dB reference point. (The factor of 10 multiplying the logarithm makes it decibels instead of bels.) It was found that, under laboratory conditions, about one decibel is the *just-noticeable difference* in sound intensity for the normal human ear. On the very low end of the decibel scale, just above 0 dB, is the smallest audible sound referred to as the *threshold of sound.* A sound 10 times more powerful than 0 dB is 10 dB, and a sound 100 times more powerful than 10 dB is 20 dB (Figure 16.1).

Electronic Audio Signals

For acoustics or acoustical engineers, the 0 dB reference point is the threshold of hearing. For electronics, the 0 dB reference point is the maximum allowable power for a transmitted audio signal. Therefore, a 0 dB measurement refers to a very different level of sound in acoustics than it does in electronics, and a different measuring scale is required.

Nearby Jet Taking Off	**140**	
Ambulence Siren	**130**	*Threshold of Pain*
Rock n' Rock Concert	**120**	*Threshold of Discomfort*
Subway Train	**110**	
Bar in Nightclub	**100**	*Very Loud*
Home Theater System	**90**	
Normal Piano Practice	**80**	
Average Conversation	**70**	
Background Noise In Restaurant	**60**	*Moderate*
Quiet Office	**40**	
Quiet Whisper / Library	**30**	*Faint*
Rustling Leaves	**20**	
Human Breathing	**10**	
	0	*Threshold of Hearing*

Figure 16.1 Noise Levels in Decibels

Acoustic engineers use an acoustic measuring system called *decibel sound pressure level* or *dBSPL*. The measurement of acoustic sound is based on air pressure. Electronic audio signals are based on an electrical measuring system. This scale uses a volume unit measurement, or *VU*. The maximum allowable strength for a sustained transmitted audio signal is 0 dBVU. For analog electronic recording, it is permissible to have audio signals that momentarily exceed 0 dBVU by as much as +12 dB (Figure 16.2, Plate 22).

Digital recording is a serial stream of digital data. Because this digital stream represents every aspect of the audio signal, including frequency and amplitude, increases or decreases in dBVU do

Figure 16.2 (Plate 22) Analog VU Meter and Digital Audio Meter

not add to the quality of the signal. Digital audio recordings are generally made to peak around the −12 dB range. In the digital realm, 0 dBFS, (or 0 dB full scale) is when all the bits are set to 1 and represent the maxium signal (Figure 16.2). Unlike analog audio, digital signals that exceed 0 dB level are said to *clip* and will be distorted.

Digital Audio

When recording a video signal, the audio portion is included with the video as part of the serial digital stream. A digital audio signal has several benefits. Because noise is analog information, audio recorded as digital data is immune to analog noise problems. Also, as a serial digital stream, digital audio allows for recording and reproducing with a greater dynamic and frequency range.

Since digital audio is in the stream of signal data, no separate audio connections are required. One connection, referred to as SDI (Serial Digital Interface), carries the serial data that includes audio, video, synchronizing, time code, and so on. The number of audio channels is not limited by the equipment or the physical recording process. The only limitation in the number of digital audio channels is the processing speed and the available bandwidth.

Sampling Rates

Loudness, as measured in dB, is not the only aspect of sound that needs to be understood. Equally important is the frequency of the sounds you hear. Human beings are sensitive to only certain areas of the frequency spectrum. The ear is capable of hearing between 20 and 20,000 Hz, or 20 kHz (kilohertz).

The process of capturing analog sound freqencies as data is called *sampling.* The theorem that describes how frequently we must sample audio is named after Harry Nyquist, the American physicist discussed in Chapter 11. The theorem states that sampling of a sine wave has to be slightly more than twice the highest frequency in order to be successfully reproduced. If the sampling rate is equal to or less than the original frequency, data will be lost at certain points along the wave. The reproduced signal will be incomplete (Figure 16.3).

Based on the Nyquist theorem, the sampling rate for audio had to be slightly more than 40 kHz, or 40,000 samples per second. The original sampling rate for high quality audio was set at 44.1 kHz. In order to have a sample rate that worked equally across international

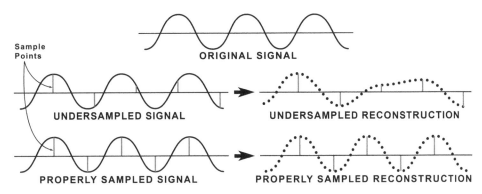

Figure 16.3 Nyquist Theorem

video frame rates, 48 kHz was chosen for professional video equipment. For some applications, the sampling rate can be increased to 96 kHz and as high as 192 kHz. Other, lower quality applications can reduce the audio sampling rate by first filtering away the high frequency component of the analog signal. Sample rates as low as 8 kHz can be used for "phone quality" recordings.

Each sample taken is composed of digital bits. The number of bits contained in the sample can vary. A sample can be composed of 8 bits, 16 bits, 20, 24, or 32 bits, and so on. The more bits in the sample, or the larger the digital word used, the truer the reproduction. Both the frequency of sampling and the number of bits contained in the sample are restricted only by the band-width and the speed of the equipment creating or reproducing the data.

Audio Compression

Sampling is part of the digitizing process. Audio, like video, once it is digitized or sampled, can be compressed. The compression process reduces the quantity of data by reducing redundant information. Within the range of human hearing—20 Hz to 20 kHz—the range of 2 to 5 kHz, which is the range of the human voice, is most sensitive. During the compression process, this range is given a higher proportion of the compressed audio data stream. Frequencies above and below this range are more heavily compressed and are allotted a smaller percentage of the data stream.

Audio is typically compressed by a factor of about ten to one. As with video compression, different audio compression techniques are used depending on the sound quality desired and the band-width and sampling rates available. The MPEG process of compression is common. Within the MPEG compression process, three data rates are used. Each of these data rates is referred to as a *layer*.

Table 16.1 Data Rate Layers

Layer 1	192 kbps	Lowest compression
Layer 2	128 kbps	Medium compression
Layer 3	64 kbps	Highest compression

A layer is a data transfer rate that is based on the number of samples per second and the number of bits contained in that sample. Each of these layers represents a different quality of reproduction. Each layer is compatible with the layer below it. In other words, Layer 1 can reproduce Layer 2 and Layer 3. Layer 2 can reproduce Layer 3, but they are not backward compatible.

Layer 1 is the lowest rate of compression, thereby yielding the best fidelity of the original signal. The bit rate is 192 kilobits per second (kbps), per channel.

Layer 2 is a mid-range rate of compression. The bit rate is 128 kbps per channel. In stereo, the total target rate for both channels combined is 250 kbps per second.

Layer 3 is the highest rate of compression at 64 kbps per channel. Layer 3 uses complex encoding methods for maximum sound quality at minimum bit rate. This is the standard popularly referred to as *MP3*, which represents MPEG-2 Audio Layer 3.

Noise Reduction

Analog recording on tape created an inherent high frequency hiss. This is caused by the movement of the oxide particles across the audio heads while the tape is in motion. The particles rubbing on the audio heads create a hissing sound, some-what like rubbing sandpaper on wood. The noise is created by a physical

phenomenon and is not a recorded signal. It is the nature of the recording medium.

A process of noise reduction in analog recordings was developed by Ray Dolby, an engineer who was also involved in the original creation of videotape recording. Dolby discovered the range of frequencies that comprise this high frequency hiss. He determined that by amplifying the high frequencies in the recorded signal, and then attenuating or reducing those signals to their original levels on playback, the high frequency noise inherent in analog tape recordings could be reduced. If the high frequencies were simply reduced on playback without the first step of amplification, the high frequencies in the signal would be lost. Dolby encoding can be used for any type of analog recording on tape.

Single-Channel, Stereo, and Surround Sound Audio

No matter how sound is recorded, compressed, or reproduced, how it is heard depends on the recording technique that is used. For example, single channel or mono audio, also called monophonic or monaural, consists of a single audio signal without reference to left, right, front, or rear. When played back, mono audio imparts no information as to the direction or depth of the sound.

Other audio recording systems, such as stereo and surround sound, include data that imparts information as to the direction and depth of the sound. Stereo, with discrete left and right channels, more closely resembles the way sound is normally heard. Due to the position of the ears on either side of the head, each ear receives the sound at a slightly different time, allowing the brain to locate the source of the sound. With stereo recordings, the sound is separated so that each ear hears the sound in a natural way, lending a sense of depth and reality.

To enhance this realistic effect, Dolby Labs developed surround sound. Surround sound adds additional channels that appear behind the listener. These are called the surround channels. The term surround sound is a trademark of Dolby Laboratories.

Dolby Digital and Surround Sound

The ATSC adopted a set of standards for the video portion of digital television known as document A/53, introduced in Chapter 12 of this book. The table of standards associated with A/53 does not address audio. Audio standards are set in a document referred to as A/52. Within the A/52 document, the ATSC refers to the Dolby Digital coding system as AC-3. The AC-3 method of coding audio has been accepted by manufacturers as the primary audio coding method to be used for most consumer equipment. Consequently, broadcasters and manufacturers have accepted this standard for production purposes.

Dolby Digital, or AC-3, covers many different variations of audio inputs, outputs and the various channels associated with multi-channel audio systems. As most manufacturers have adopted Dolby Digital as their manufacturing standard, most new consumer equipment contains Dolby Digital decoders. Because of this, professional equipment manufacturers design and build audio equipment to accommodate the Dolby Digital AC-3 audio standard.

As digital data allows for the inclusion of more information than was possible in analog, more channels of audio have been added to further enhance the realism of the audio. The number of channels first was increased to six. This is referred to as 5.1 Dolby Digital, or just 5.1.

The 5.1 system has five discrete, full-range channels and a sixth channel for low frequency bass. The five full channels are left and

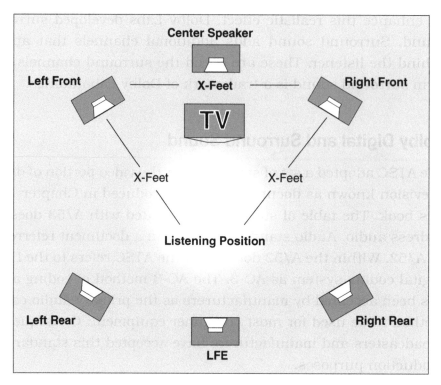

Figure 16.4 Surround Sound Speaker Layout

right front, center, and left and right rear (Figure 16.4). The front left and right channels would be the equivalent of the original stereo channels, the center the equivalent of the original mono channel, and the left and right rear the equivalent of the original surround channel. However, these channels now carry far more audio data that adds to the realism of the audio portion of a program. They are no longer as restricted as the older analog systems were. These channels now contain audio data that create an effect of being within the actual environment.

The sixth channel is referred to as the *LFE* channel, or *Low Frequency Effects* channel. Because low frequency audio is non-directional, the placement of the LFE speaker is not critical. Low

frequency audio, because of its power even at low volume levels, tends to reflect off surfaces and so its direction is not discernible by the human ear. As the LFE channel needs only about one-tenth the bandwidth of the other full audio channels, it has been designated as .1 channel or a tenth of a channel, thereby giving the designation 5.1 channels of audio.

With all these possibilities for creating and recording, the audio channels and their uses must be designated and documented carefully. A video program tape or file may have mono, stereo or multichannel surround. The surround might be discrete channels, or be encoded with either analog or digital encoding. Many programs may have more than one format of audio attached. For example, it is common to have six discrete channels for surround, and two additional channels with a stereo mix.

As part of the drive for more immersive and theatrical viewing experiences, the number of surround channels can be increased. To expand the sound field even further, the 7.1 channel system adds two additional speaker positions to the left and right of the listener.

NOTE NHK in Japan has developed an 8K video system that includes 22.2 channels of surround using layers of speakers above and below screen level.

Out-of-Phase Audio

As with any signal based on sine waves, the waves of audio signals can be out of phase with each other. If the waves are 180° out of phase or, in other words, exactly opposite each other, cancellation will take place. When one wave is at its peak, the other would be at its low point (Figure 16.5). The result would be silence or near

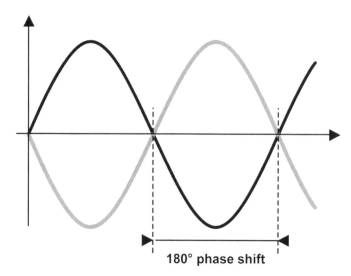

180° phase shift

Figure 16.5 Out-of-Phase Audio

silence. Either side listened to alone would sound fine, as two signals are needed to create an out-of-phase situation. Signals less than 180° out of phase also cause a decrease in volume or amplitude but to a lesser degree.

Out-of-phase situations can be detected by a phase meter, a scope, or sometimes just by listening. Listening to one side, then the other, and then both at once, will sometimes allow the detection of an out-of-phase situation. A drop in amplitude, when the two sides are listened to at once, will be an indication that the signals are out of phase.

The out-of-phase error can occur anywhere along the audio chain, from the microphone placement in the original recording to the final playback. The audio may have been recorded out of phase or the speakers may have been wired incorrectly. Correcting this problem can sometimes be as simple as reversing two wires on one side of the signal path. By reversing one side only, the two

sides would then be in phase with each other. This switch can be made anywhere along the audio path, and the problem will be corrected.

If the audio is recorded out of phase, this can only be corrected by re-recording the audio in the correct phase relationship. It is possible to play back out-of-phase audio and, by phase reversing one side of the signal path, correct the phase for playback purposes.

Some digital scopes have a selection for checking stereo audio. If audio is present in the SDI stream, the signal will appear on the scope. If the audio is stereo and in phase, it will appear as a straight diagonal line. If audio is out of phase, the two lines appear separated by the amount they are out of phase.

Measuring Audio Phase

Some digital scopes have a selection for checking stereo audio using a display called a *lissajous pattern*. If the audio is in phase, it will appear to orient along an axis on the scope marked "in phase" (Figure 16.6, Plate 23). Should the audio be out of phase, it will tend to orient to the axis that is 90° to the in-phase line. The greater the difference between the channels (or the more stereo the content), the more confused the display appears. It is difficult with very different material to be certain if the signal is falling in or out of phase on the scope.

A second feature on the scope in Figure 16.6 shows another useful phase tool. This one helps determine phase with stereo audio that has very different content. The feature is called a *Correlation Meter* and is represented by a diamond. On the display shown in the figure, there are 5 different Correlation Meters (shown as diamonds),

Figure 16.6 (Plate 23) In-Phase Stereo Audio Signal

one below each stereo pair of meters, and one below the lissajous display of the signal. The diamond shaped indicator shows how much the channels in the measured stereo pair are similar, or correlate. If they are exactly the same and in-phase, the diamond will move to the far right of the display. If they are completely different, and therefore have no phase relationship, the diamond will fall in the center of the display.

Properly phased stereo audio will cause the diamond to drift between the center and right side of the meter. Out of phase audio will cause the diamond to begin to move to the left of the center mark, and many scopes will turn the diamond red. The greater the phase error, the further to the left the diamond will move.

Transporting Audio

When working on large scale video productions, there are several common ways to manage and move audio signals both in analog and digital form. Many people, having been in or worked around music performances, may be familiar with the analog method using twisted pair wiring. Each individual audio signal, like microphones or instruments, is carried to mixers and amplifiers on a pair of wires that are twisted together to reduce interference. Often when there are many signals to move around, say between a stage connection box and the mixer, multiple sets of wires are bundled together in "mults."

With the advent of digital signals, several other forms of moving the audio portion of the program became possible. One option is called *embedded* audio. In this system, the uncompressed audio signals are inserted into the digital data stream along with the video signal and other metadata. This is very convenient as a single cable can carry up to 16 channels of digital audio right along with the picture information. (Figure 4.1, Plate 1 shows the digital audio signal in a pulse cross display.)

In large TV productions, however, audio is often handled by different departments and equipment right up to the time it is handed off to the people who will oversee its transmission to air, cable or web. In those cases, it is not efficient or possible to work with the audio that is embedded with the video portion of the program.

Currently the most popular format in these situations is called AES, which is shorthand for the signal format AES 3, or AES/EBU. AES is the Audio Engineering Society, a standards group interested in all things audio. EBU is the European Broadcasting Union, a standards group that deals with broadcasting in the European

Figure 16.7 AES Digital Input

Union (you can read more on standards in Chapter 12). This standard dates back to 1985 and describes a system of encoding digital audio signals in a way that is compatible with the needs of audio and video systems. In 1985, stereo audio was the most prevalent form of listening, so the AES bundled its two channels together into a single stream. As a result, one "channel" of AES contains two signals, both the left and right portions of a stereo pair of analog channels (Figure 16.7).

AES was designed to work with the existing analog system, so it was designed from the outset to be carried on either twisted pair wire, like analog audio, or on the kind of coax that video signals use. This made it easy to transition to digital audio as existing wiring and patch bays could be repurposed to carry the AES signal. It is also possible to carry the signal on fiber optic cable, and on consumer grade cable and connections.

NOTE When used in consumer equipment on copper cable, it is called S/PDIF (Sony/Philips Digital Interface Format). TOSLINK is the consumer name for the fiber optic connection. TOSLINK is shortened from Toshiba Link.

The AES did not stop with just that one format. There is another format that is quite common in large productions known as AES 10

or, more commonly, MADI (Multichannel Audio Digital Interface). As the name implies, this digital standard is designed to carry many more channels than the stereo pair of AES 3. Using MADI, up to 64 channels of audio can be carried on a single cable, either copper coax or fiber optic. This format is used to connect devices that require a lot of audio channels to be connected to each other, such as hooking the studio routing system to the audio mixer. It is also a really handy way to deal with the stage box idea. By putting a MADI breakout box near the source of audio signals, a single coax or fiber cable can be run back to the audio mixer. Imagine the savings in time laying one cable to the floor of the basketball arena from the TV truck instead of five or six mults!

Taking the idea of reduced wiring for multi-channel applications and applying computer networking techniques leads to another interesting way to move audio signals. *Audio over Ethernet* encodes audio signals using the standards and conventions of computer networking. There are several different proprietary formats for this. As of the writing of this book, CobraNet and Dante were very popular.

With these techniques, several hundred individual audio channels may be carried over standard network cabling and distribution equipment. Now distributing and collecting audio from large venues is as simple as connecting a network cable. As most of the infrastructure of television is migrating toward computer based technologies, this will likely become the dominant method for audio connections in the near future.

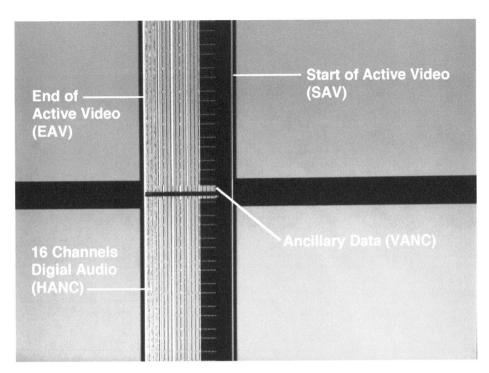

Plate 1 (Figure 4.1) Digital Data Bursts in a Cross Pulse Display

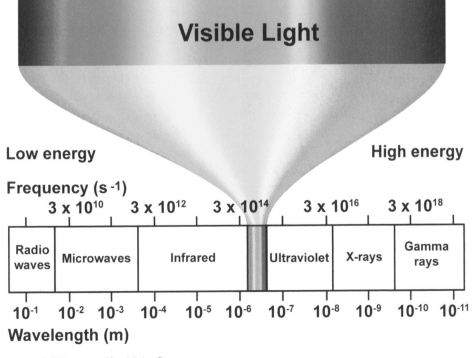

Plate 2 (Figure 5.2) Light Spectrum

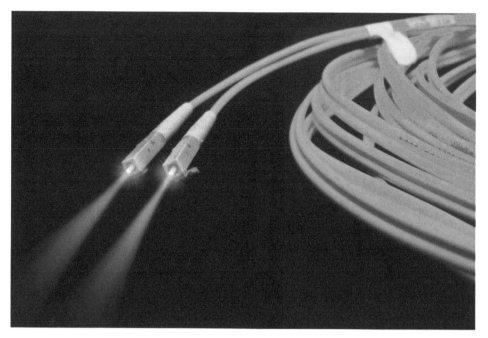

Plate 3 (Figure 5.5) Fiber Optic Cable

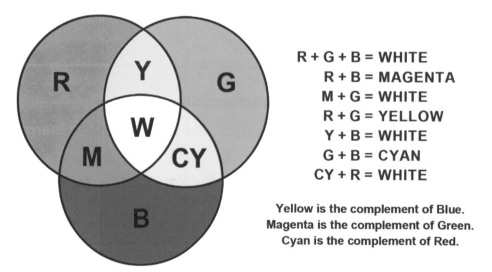

R + G + B = WHITE
R + B = MAGENTA
M + G = WHITE
R + G = YELLOW
Y + B = WHITE
G + B = CYAN
CY + R = WHITE

Yellow is the complement of Blue.
Magenta is the complement of Green.
Cyan is the complement of Red.

Plate 4 (Figure 6.1) Primary and Secondary Colors

LUMINANCE = Brightness (Black to White)
HUE = Color (Red, Blue, Green, etc.)
SATURATION = Depth of Color (e.g. Pink or Red)

Plate 5 (Figure 6.4) Color Vector Cone

(A) EIA Split Field Bars

(B) Full Field Bars

Plate 6 (Figure 7.2) Color Bar Displays

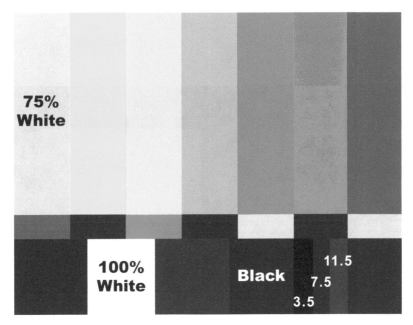

Plate 7 (Figure 8.2) PLUGE Bars Signal

Plate 8 (Figure 8.4) Color Bars on Waveform Monitor

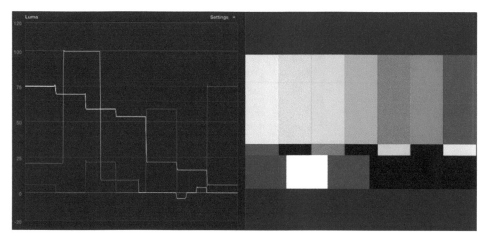

Plate 9 (Figure 9.4) Color Bars on Software Scope

Plate 10 (Figure 9.5) Normal Video Scene on Software Scope

Plate 11 (Figure 9.8) Color Bars Displayed on Software Vectorscope

Plate 12 (Figure 9.9) Video Scene Displayed on Software Vectorscope

Plate 13 (Figure 9.10a) Normal Saturation

Plate 14 (Figure 9.10b) Increased Saturation

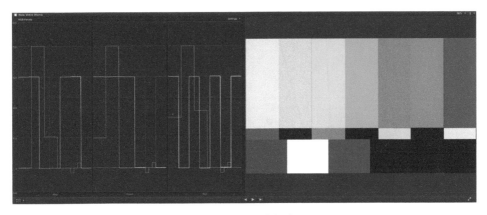

Plate 15 (Figure 9.11a) Color Bars in Parade Mode

Plate 16 (Figure 9.11b) Video Scene in Parade Mode

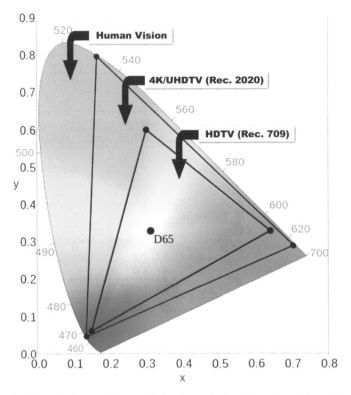

Plate 17 (Figure 9.12) Color Gamuts for UHDTV and HDTV

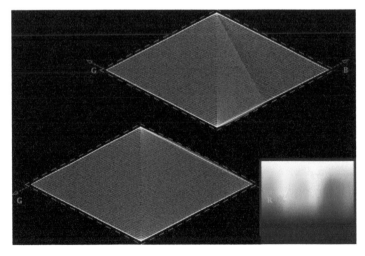

Plate 18 (Figure 9.13) Diamond Display

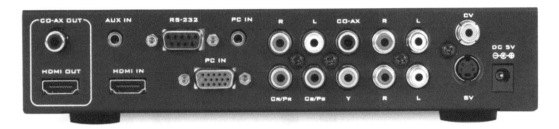

Plate 19 (Figure 10.6) Digital Component Connections

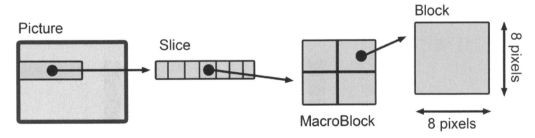

Plate 20 (Figure 15.1) I Frame Macroblocks and Blocks

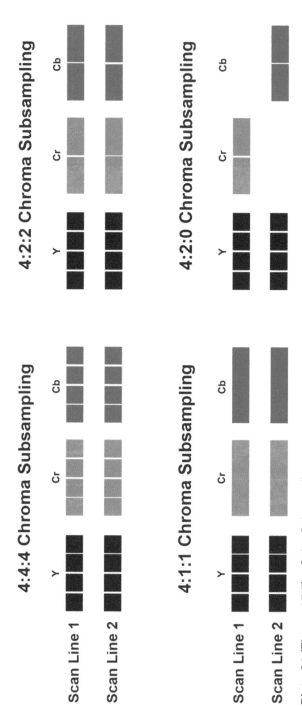

Plate 21 (Figure 15.5) Color Subsampling

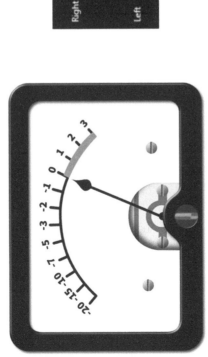

Plate 22 (Figure 16.2) Analog VU Meter and Digital Audio Meter

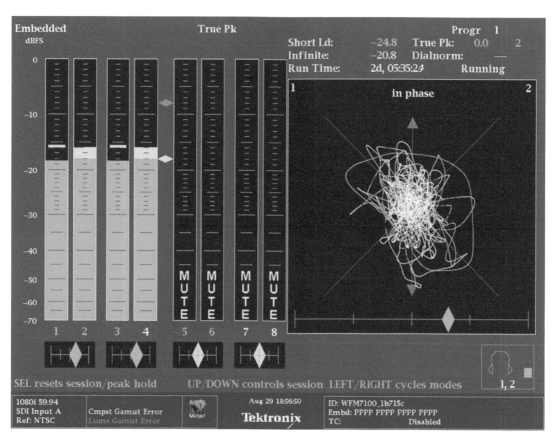

Plate 23 (Figure 16.6) In-Phase Stereo Audio Signal

Plate 24 (Figure 18.2) Automated Playout System (XeusMedia Technology)

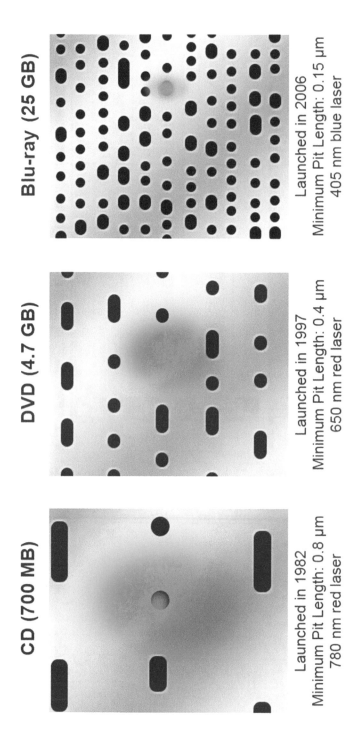

The tighter the pattern of the pits on the disc, the more information the disc can hold. Also, a shorter laser beam can focus on the pits with greater accuracy and precision.

Plate 25 (Figure 20.5) CD, DVD, and Blu-ray Laser Beam coverage

Metadata and Timecode

The term, *metadata*, was first coined in 1968 by an American computer scientist, Philip Bagley, who used the term in his technical report, "Extension of Programming Language Concepts." Since that time, many fields, such as Information Technology, Information Science, Librarianship, and of course the Computer and Video fields, have adopted this term. The prefix, *meta*, is Greek for "among," "after," or "beyond." In English, *meta* is used to indicate a concept, which is an abstraction from another concept. So metadata is data developed about other data. It's often defined simply as "data about data," or "information about information."

Types of Metadata

In general, metadata information describes, explains, locates and makes it easier to retrieve, use, or manage a resource. A book contains information, but there is also information about the book, such as the author's name, book title, subtitle, published date, publisher's name, and call number so you know where to find the book on a library shelf. This extra information outside of the book content is its metadata. Logging this information in a library system

allows a user to search for the book by any of the criteria logged without knowing one word of the book content itself.

The same is true for media such as a movie on a DVD. You can't hold up a DVD to see the movie that's on it, so you have to search for information about it online or read the DVD label or case. While reading that information, you might become aware of the different types of metadata. In fact, there are three basic types of metadata: Structural, Descriptive, and Administrative. Using the DVD as an example, Descriptive metadata often includes the information you might search for first, such as the movie title and main actors, perhaps a byline that further describes the film (Figure 17.1). Structural metadata includes how the movie data is organized, for example what slots of information the metadata will contain. The DVD will also contain Administrative information, often in small print, such as the creator, studio or production company that produced it, the date it was created, perhaps the type, or format, and so on.

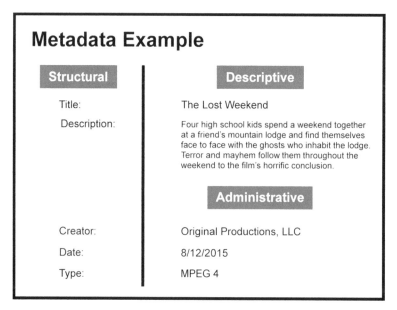

Figure 17.1 Types of Metadata

As you look at this information, it's quite possible you might never give a second thought to the type of metadata you're reviewing. In truth, the type is less important than becoming aware of the different ways metadata can be used.

NOTE The ISO had a hand in standardizing metadata. In its report, ISO/IEC 11179, it specifies the kind and quality of metadata necessary to describe data, and it specifies the management and administration of that metadata in a metadata registry (MDR).

Metadata in Photos

Have you ever looked at an old photograph that's started to yellow with age? If you turned the photo over, it's very likely you saw something written on its back, usually the date and the person in the photo. Before metadata became widely used, this was the "human" or analog way to enter metadata. Someone wrote down what they knew about the person, event or time. In whatever form it took, that information was kept with the photo. Today, we do the same thing but we do it digitally. Using photo programs such as Apple's iPhoto, Windows Live Photo Gallery, and Picasa, we are able to label and rate photos, enter captions, and add key words about a photo. This makes it very easy to organize and retrieve images.

While humans can enter descriptive data about the photos, there is other information, let's call it structural or sometimes administrative metadata, which the camera that captured the photo knows about the image. For example, the moment you snap a picture, the camera embeds information into the image such as the file type (e.g. JPEG, TIFF), image resolution (3264 × 2448), date and time the image was taken, perhaps even the name of the camera and size of the file (Figure 17.2). This metadata can also be used as search criteria alongside the descriptive information you manually entered yourself.

iPhone 6 AWB

iPhone 6 back camera 4.28mm f/2.4

3264 x 2448 2.4 MB JPEG

| ISO 640 | 4.28mm | – | f/2.4 | 1/15 |

IMG_2294 ★ ★ ★ ★ ☆

January 7, 2015 at 9:23:23 PM

Gig #2 on 100 Gig Journey

Figure 17.2 iPhoto Metadata for Image Imported from an iPhone

Metadata in Video

Like the DVD movie example sited previously, metadata is particularly useful in video because its contents aren't directly decipherable by computers. And since video has become a primary form of communication and expression in the 21st Century, the need to organize it and access it quickly and easily is very important. One of the first forms of metadata used in video was timecode. Timecode is a labelling system that provides a way to search and edit individual frames of video. (Timecode is discussed in more detail later in this chapter.)

As video has become digital, metadata has become an essential part of the video data stream. Metadata in the serial digital video stream contains the information about what video standard is being used, the frame rate, line count, the number and type of audio channels, and the compression and encoding system used. Any necessary information to allow the digital data to be correctly interpreted for use and display is contained in the metadata. Incorrect metadata can cause the rest of the data itself to be unusable. Data that is incorrectly

identified cannot be retrieved. For example, if the metadata indicates that the audio is Dolby surround sound when it is actually two channel stereo, the audio will not be reproduced correctly as the system will be trying to recreate a signal that is not there.

As with still images, there are two ways metadata can be attached to a video file: it can be captured automatically or entered manually. If it's automatically generated and captured, it's most likely administrative type of metadata, while the manually entered metadata tends to be more descriptive. Most video metadata is automatically generated in the camera or through the use of software. The information captured is contained within the video file and can easily be accessed in a video editing system (Figure 17.3).

NOTE When working with metadata, you may see a reference to a standard format called Exchangeable Information File Format, or EXIF. This is a standard that makes it possible for different systems to read image and video metadata. Most EXIF data cannot be edited after capture but sometimes the GPS and date/time stamp can be changed.

Logging footage has been a customary stage in the editing process, both film and video. Today, the video editor or producer can go way beyond just naming clips. Editors can add keywords that further identify the clip, such as who is in the clip, what scene the clip is from, who the client is, as well as notes or excerpts from the narration or script (Figure 17.3). Some editing systems can recognize the number of people in a shot and what type of shot it is—wide, medium, close-up, and so on. When this option is selected, the information is entered automatically during the capture process. More and more, editing software is including metadata entry options that increase the amount and variety of information you can add to a video file.

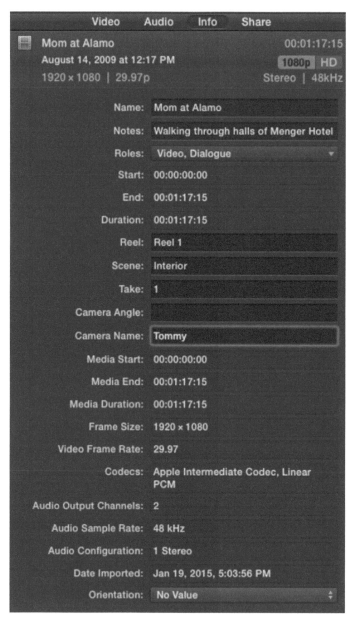

Figure 17.3 Clip Information in Apple's Final Cut Pro X Editing Application.
In this video clip information window, notice that some fields are gray and some are black.
The gray fields contain the camera-recorded data, which has been entered automatically.
Those fields are not editable. The descriptive fields, such as Name, Notes, Reel, Scene,
Take, and so on, are customizable fields where you can enter information manually
within the editing application.

TIP Remember, metadata travels with video files as it does with still images. So include information that will make it easy to find or access that video in other projects or applications.

Metadata in Broadcast and on the Web

If you are the only person looking at your video, and you know where everything is, it may be less important to think about creating a structured metadata system. But when video is being broadcast or uploaded to the Internet, it's very important to think about how the metadata will be used.

For example, a worldwide sports event might be shot by a major broadcaster and archived for future broadcast. But what if the News Department at the broadcast station wanted to air a clip of the winning touchdown? The automatically captured metadata might provide clip names, durations, and running timecode, and other information. But if a logging assistant entered keywords such as *touchdown, great catch,* or *quarterback sack* at the locations they occurred during the game, editors and operators who wanted to access that information later would have no trouble finding what they need.

The same holds true for the Internet. Metadata on the web contains descriptions of the web page contents and keywords that link to the content. This metadata is referred to as *metatags*, which are tags or coding statements in HTML that describe some aspect of the contents of the Web page (Figure 17.4). That information might include the language the site is written in, the tools used to create it, and where to go for more information. Some metatags are only visible to search engines looking for that information. Some sites, such as Wikipedia, encourage the use of metadata by asking editors to add hyperlinks to category names in the articles, and to include information with citations such as title, source and access date.

To define a description of your web page:

```
<meta name="description" content="Services for television training">
```

To define keywords for search engines:

```
<meta name="keywords" content="consulting, training, webinars, books">
```

To define the author of a page:

```
<meta name="author" content="Diana Weynand">
```

Figure 17.4 Website Metatags

Metatags and keywords not only provide ways of organizing and accessing media, but they offer great marketing potential as well. For example, keywords allow YouTube users to easily find specific videos even though 100 hours of video are uploaded every minute (as of this writing). YouTube, along with other video sharing sites, requires metadata for videos being uploaded so the over 3 billion unique users a month can find what they're looking for quickly and learn more about the video they're viewing.

Timecode Metadata

In the early days of television, all programs were broadcast live. The only means of archiving a television program was by using a process called *kinescope*. Kinescoping was the process of focusing a 16mm motion picture camera at a television monitor and photographing the images. Starting in the mid-1950s, when videotape recording was invented, programs were taped live and then played back for broadcast at a different time. These programs were played in real time without the benefit of instant replays or freeze frames. When videotape began to be used for editing purposes, it became critical to identify specific frames of video, access those frames, then cue and edit them to specific locations in an edited master tape. Film frames traditionally could be identified by numbers imprinted along the

FILM FRAMES LABELED WITH EDGE NUMBERS

2:29:35:16	2:29:35:17	2:29:35:18	2:29:35:19

VIDEOTAPE WITH TIMECODE LABELING EACH FRAME

Figure 17.5 Labeling Frames

edge of the film. Unlike film, at the time of manufacture, video had no numbering that could be used to identify individual video frames.

In 1967, EECO—a video equipment manufacturing company—created *timecode*, a system by which videotape could be synchronized, cued, identified, and controlled. This format was adopted by *SMPTE* (the Society of Motion Picture and Television Engineers) as a standard. SMPTE timecode records a unique number on each frame of video (Figure 17.5). Working with timecoded video ensures that a specific video frame can be accessed using the same timecode number over and over again with complete accuracy. This was referred to as frame accuracy, as in having a frame-accurate editing system or making a frame-accurate edit.

Reading Timecode

Timecode is read as a digital display much like a digital clock. However, in addition to the hours, minutes, and seconds of a digital

clock, timecode includes a frame count so the specific video frames can be identified and accessed. A timecode number is displayed with a colon separating each category, constructed as follows:

Table 17.1 Timecode

00:	00:	00:	00:
hours	minutes	seconds	frames

A timecode number of one hour, twenty minutes, and three frames would be written as 01:20:00:03. The zeros preceding the first digit do not affect the number and are often omitted when entering time-code numbers in editing systems or other equipment. However, the minutes, seconds, and frames categories following a number must use zeros, as they hold specific place values.

Here are some examples of how timecode is read and notated:

2:13:11	Two minutes, thirteen seconds, and eleven frames.
23:04	Twenty-three seconds and four frames.
10:02:00	Ten minutes, two seconds, and zero frames. (It is necessary to hold the frames place even though its value is zero. If the last two zeros were left out, the value of this number would change to ten seconds and two frames.)
3:00:00:00	Three hours even.
14:00:12:29	Fourteen hours, twelve seconds, and twenty-nine frames.
15:59:29	Fifteen minutes, fifty-nine seconds, and twenty-nine frames.

Timecode uses military clock time in that it runs from 00:00:00:00 to 23:59:59:29, that is, from midnight to the frame before midnight.

In a 30 fps standard, if one frame is added to this last number, the number turns over to all zeros again, or midnight. The frame count of a 30 fps video is represented by the 30 numbers between 00 and 29. The number 29 would be the highest value of frames in that system. Add one frame to 29, and the frame count goes to zeros while the seconds increase by 1. The frame count of a 24 fps video is represented by the 24 numbers between 00 and 23.

Timecode can be used with any available video standard regardless of that standard's frame rate. The only difference in the timecode numbering process is that the last two digits indicating frames may appear differently. The frames will reflect whatever frame rate was chosen as the recording format. For example, a timecode location in a 24 fps HDTV standard might be 1:03:24:23, which represents the last frame of that second; whereas the last frame of a 30 fps HDTV standard would be 1:03:24:29.

Timecode Formats

Since its development, timecode has had several formats. The original format was *Longitudinal* or *Linear Timecode*, or *LTC*. Longitudinal timecode is a digital signal recorded as an audio signal.

Another timecode format is *Vertical Interval Timecode*, or *VITC*, pronounced *vit-see*. While LTC is an audio signal, VITC is recorded as visual digital information in the vertical interval as part of the analog video signal. VITC must be recorded simultaneously with the video. Once recorded, VITC can be used to identify a frame of video either in still mode or in motion.

In digital recording formats, the timecode is carried as part of the Metadata contained within the digital stream or file structure. In digital video signals such as SDI and HDSDI, this is part of the

HANC (Horizontal Ancillary Data). For file-based recording such as MXF and QuickTime, the timecode is encoded on a virtual track reserved for this purpose.

Non-Drop-Frame and Drop-Frame Timecode

When timecode was created, NTSC video ran at 29.97 frames per second. This was a technical adaptation to allow color broadcasts. In other words, it takes more than 1 second to scan a full 30 frames. In fact, it takes 1.03 seconds to scan 30 frames of color video.

Timecode had to account for this small difference. If every video frame was numbered sequentially with 30 fps timecode, at the end of an hour the timecode would read 59 minutes, 56 seconds, and 12 frames, or 3 seconds and 18 frames short of an hour, even though the program ran a full hour. There are fewer frames per second and thus fewer frames in an hour.

Broadcast programs have to be an exact length of time in order to maintain a universal schedule. In order to allow timecode to be used as a reference to clock time, SMPTE specified a method of timecoding that made up for the 3 seconds and 18 frames, or a 108-frame difference. It was determined that numbers should be dropped from the continuous code by advancing the clock at regular intervals. By doing this, there would be an hour's duration in timecode numbers at the end of an hour's worth of time.

The formula began by advancing the clock by two frames of timecode numbers each minute, *except* every tenth minute (10, 20, 30, and so on). By advancing 2 frames on every minute, a total of 120 frames, or 12 more than the 108 frames needed, would be dropped. But 2 frames dropped from every minute *except* the tens of minutes

would be 54 minutes x 2 frames per minute, which equals 108 frames, accounting for the necessary number of frames to identify a true clock time period. SMPTE named the new alternative method of time coding color video *drop-frame timecode* in reference to its process. Drop-frame timecode is sometimes referred to as *time of day*, or TOD timecode. The original 30 fps continuous code was subsequently termed *non-drop-frame timecode* (Figure 17.6).

In drop-frame timecode, the timecode is always advanced by skipping the first two frame numbers of each minute except every tenth minute. For example, the numbering sequence would go from 1:06:59:29 on one frame to 1:07:00:02 on the very next frame (see Figure 17.6). The two frame numbers that are skipped are 1:07:00:00 and 1:07:00:01. At the tenth minute, no numbers are skipped. The numbering sequence at each tenth minute would go from, for example, 1:29:59:29 on one frame to 1:30:00:00 on the next.

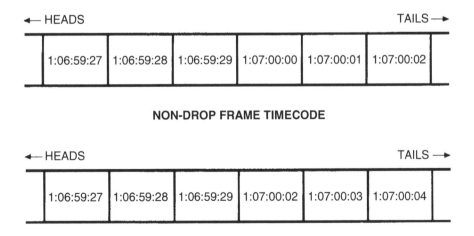

NON-DROP FRAME TIMECODE

DROP FRAME TIMECODE

Figure 17.6 Timecode Formats

Like non-drop-frame timecode, drop-frame timecode leaves no frames of video unlabeled, and no frames of picture information are deleted. The numbers that are skipped do not upset the ascending order that is necessary for some editing systems to read and cue to the timecode. But at the end of an hour's worth of material, there will be an hour's duration reflected in the timecode number.

NOTE A convention is followed when working with timecode numbers that helps to identify whether they represent drop-frame or non-drop-frame timecode. If the punctuation before the frames value is a semi-colon, such as 1:07:00;00, it is drop-frame timecode. If there is a colon dividing the frames, such as 1:07:00:00, it is non-drop-frame timecode.

Timecode at 24 Frames Per Second

While the terms 24 fps and 30 fps are used for convenience, the true frame rates that most systems use are 23.976 fps and 29.97 fps respectively. SMPTE timecode for video runs at the same frame rate the video does, 29.97 fps in drop-frame timecode mode. Timecode used in the 24 fps video system runs at 23.976 fps, also referred to as 23.98. There are no drop-frame or non-drop-frame modes in a 24 fps system because there are no conflicting monochrome versus color frames rates as there were in the original video systems developed by the NTSC. As a single frame rate is decided upon and the synchronization is fixed, a timecode system is developed to keep clock accurate time. Had the original NTSC system started with color, the timecode system developed simultaneously would have eliminated the need for more than one type of timecode.

This alteration in the frame rate from 24 fps to 23.98 fps was necessary to simplify the 24 fps to 30 fps conversion. Without

it, converting true 24 fps images and timecode to the existing 29.97 frame rate in video would be much more complex. When converting 24 fps film or HD to 30 fps video, the additional time-code numbers are added as the additional frames are added. When transferring the other way, from 30 fps to 24 fps, the additional numbers are deleted and the timecode is resequenced as the additional fields and frames are deleted.

Visual Timecode

Timecode can also be displayed as numbers over the visual images. This is achieved through the use of a character or text generator or sometimes through an internal filter in an editing system. The

Figure 17.7 Visual Timecode

timecode signal is fed into the character generator, and the character generator in turn displays a visual translation of the timecode numbers. That display is placed over the video material and can be shown on the monitor or recorded into the picture (Figure 17.7). Visual timecode is not a signal that can be read by machine, computer, or timecode reader.

NOTE In addition to video productions, timecode can also be used in sound and music production. This is especially useful for audio artists working on sound design and scoring for film and video. The timecode signal for these applications can be recorded as AES-EBU digital audio or even transported using the MIDI interface.

Video Workflows and Computer Networking

18

Traditionally television required connecting individual purpose-built devices together to build systems for creating and broadcasting content. Cameras connected to video switchers, which connected to recorders. For sound, microphones connected to mixers, which connected to the recorder as well. A show was recorded to removable media, mostly tape, and stored on a shelf. Perhaps later that tape was put on a machine that was connected to a transmitter to send the program home to its audience.

Now, of course, computer-based technology is at the center of everything media professionals do. From the biggest television networks to a single creative soul working alone, video and audio are now handled as computer files.

Large-Scale Workflows

It might be relatively easy to imagine the workflow of that creative soul working alone. That creative soul might even be you. But in order to fully understand some of the needs and possibilities of a large-scale workflow, it might be helpful to think of an imaginary

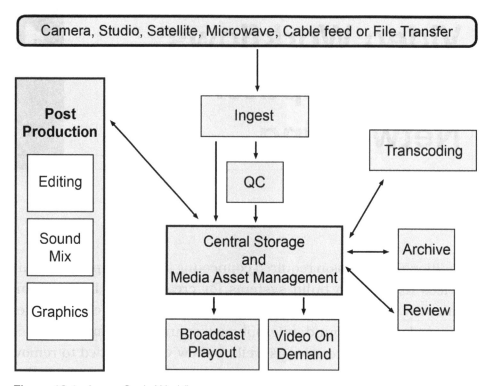

Figure 18.1 Large-Scale Workflow

television network. The diagram in Figure 18.1 shows a generic example of a large-scale workflow that can be used to examine each of the elements and see how they relate.

Central Storage

In the middle of the workflow is the place that the files are actually stored. In the diagram, this is called Central Storage. In reality, large enterprises seldom have a single repository for their material. More likely, there is a geographically diverse group of storage clusters that contain duplicates of the material. This serves to make the media files available to people in different regions. More importantly, it provides multiple locations in case a disaster takes

one of the sites offline. A broadcaster doing a large international production like the World Cup might have a storage cluster in the host country, and mirror the content to another cluster at their home base. Content creators in both countries can access local copies of the material they need. If a system failure occurred in one location, the content would still be in tact at the other.

Archive

Central Storage is used for files that are needed either in a timely fashion or on a frequent basis. The archive, however, is where files that are not currently being used, but must be saved, are located. Most often this consists of an automated tape library. When done on a large scale, this is a robotically maintained set of tapes that can be loaded and unloaded from players mechanically. Tape is both less expensive and more robust than spinning disk drives when storing large data sets. The drawback is that it cannot be accessed instantly. The tape with the requested file must be located and loaded into a player and then the file has to be copied to central storage for access.

Ingest and Quality Control

The job of actually getting material into the Central Storage system falls to Ingest operators. Feeds may come from local studios or cameras, remote feeds via microwave, satellite or fiber optic lines, or even as files uploaded by content contributors at bureaus or in the field. The Ingest operators are responsible for managing the material as it is moved into Central Storage.

Once the material has been ingested into storage, some programs and materials must be examined for quality during a Quality

Control process, sometimes referred to simply as QC. This can be done in two ways. One way is to pass the material through an automated Quality Control system. The other way is to have a Quality Control operator perform a manual inspection. However it's done, it is important that both technical standards and content standards of program material must be maintained.

Post Production

Some shows are broadcast live, such as newscasts or live sports events. But typically, a show needs to go through the post production process, where content can be manipulated and processed to prepare the show for its audience. (Post production is a huge topic outside the scope of this book.) Much of the content used by TV stations and networks is created outside the network system and brought in after it has been edited as a finished work. However, some materials may still need to be edited in association with in-house shows. Depending on the network, the post department may be modest or enormous. Something like a movie channel might have only a few seats of post production used for promotional spots or fixes, while a news or sports network might have several floors of edit rooms preparing stories, highlights, promos and other show materials.

Regardless of number, the post production editing bays all interface to Central Storage as both a source of material to work with and a place to return finished clips.

Playout and Delivery

Television networks and even local stations are not single channels. Some cable network facilities support many channels of content being made available to their audiences simultaneously. In

addition, each of the channels may have multiple feeds to different time zones. Those delayed feeds might have different commercial breaks with spots tailored to regional audiences. Folks on the West Coast may be seeing a mayonnaise commercial for Best Foods brands, while the East Coast is enjoying the same spot but for Hellmann's, which is a regional name.

Managing these details is the Playout function. Automated schedules of programs and commercials are prepared for each channel, which cue and play the material to the correct path. Playout Departments often consist of control rooms with operators using specialized equipment. Devices such as Video Servers, automation systems and scheduling software are integrated with video switchers, audio mixers and routers (Figure 18.2, Plate 24). For a traditional broadcast operation, this is where the product of all the efforts put into producing the content is finally delivered to the viewer. In a commercial station this is also where the advertising, which is how the bills get paid, is inserted.

Another way to access the Central Storage is Video on Demand (VOD). Many content channels make some of their material available to the audience as individual play outs by request. The topic of Video on Demand and Streaming Media is discussed further in Chapter 21.

Review and Screening

Throughout our made-up network, there are many people who will need to screen and review program and commercial content at different times during the production and post production process. For example, a producer may need to sign off on a news story before it airs. But it's not necessary for the producer to see the story in its

Figure 18.2 (Plate 24) Automated Playout System (XeusMedia Technology)

highest quality form. A sports writer may need to view an edited piece that used his script, but he or she is on location using a laptop. To that end there is often a link to Central Storage from the office computer network to allow people to simply view or screen files at their desks or remotely.

Transcoding

Media files come in many different forms. These have attributes that make them ideal for one purpose, but difficult to use for another. The transcoding function makes duplicates of the material in different codecs and containers that allow each area of the facility to function based on its own requirements.

For example, the high quality files used for playout are far too large to travel through an office network for review. The transcoding function could be used to make a smaller, or *proxy*, copy for review purposes. And shows that will air via the Internet would also need to be a different format than the original high quality file it originated in. (In the next chapter, you will take a closer look at transcoding, codecs, wrappers and the types of files that move through this workflow.)

Media Asset Management

In a large facility, the number of files stored and accessed can quickly become overwhelming. It is the job of Asset Management to help organize the media. Asset Management is a class of programs that catalog the stored material. The catalog function allows users to sort and search the database of clips for specific material. This works much like doing a YouTube search to filter down tens of millions of clips to find the one you're looking for.

As discussed in the previous chapter, the information about the files, or metadata, may come in part from the file itself. Workers, sometimes called Media Managers, may enter or log additional detail manually about the media assets. Later searches for material are greatly enhanced by rich detail in the metadata.

Asset management may also help process and direct the files. For example, based on a set of rules for the frequency and date of access, the program might automatically hand a file off to the archive for storage. It might also be responsible for automating the transcoding process, again based on a set of rules about what files must be available in what formats.

Computer Networking and Storage

In order to share media files among the computers used in a video operation, they must be capable of being transferred over computer networks. You've learned the components of a large-scale workflow. Let's go under the hood of this operation and learn how the computers communicate in order to make this workflow possible and also how the material is stored.

Communicating Via Internet Protocol

Let's consider an example of a simple network that has six computers connected to each other through a hub. Each computer in any network must have a unique address. Most are familiar with the Internet Protocol format, or IP address. An IP version in current use is IPv4 (Internet Protocol version 4), which uses a 32-bit number: four sets of numbers, one to three numbers in a set, each set separated by a period. One example of an IP address might be 192.16.213.254.

NOTE The total number of IP addresses that can be created using a 32-bit configuration is about 4 billion. To create more IP addresses and support the ever-growing number of Internet users and devices, a newer IP version was recently developed–IPv6. An IPv6 address uses a 128- bit number: eight sets of numbers, one to four numbers per set, with each set separated by a colon. An example of an IPv6 number would be: 2001:DB8:0:567:B3FF:0202:34:1. The various IPv6 number combinations can create many trillions of addresses.

An IP address can be set by users or system administrators. In some system designs, each computer is given a fixed address so other systems know immediately where to send data. More frequently, however, a router or server—that the computer is connected to— assigns the IP address for a certain amount of time. This technique is known as Dynamic Host Configuration Protocol, or DHCP, and is most likely how your home system is set up (Figure 18.3).

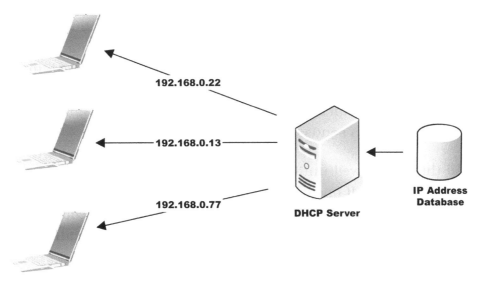

Figure 18.3 DHCP Server Flow

The DHCP Lease

In the DHCP process, the length of time one IP address is used before assigning a different IP address is known as the *lease* period. The actual lease time is variable, whether it's 24 hours or five days, and is specified on the server. A big advantage of using a DHCP server is that it renews a lease automatically, which reduces the need for a user or administrator to do it manually.

When computer number one in our example wants to send a file to computer number three, it first breaks the content into small bundles called packets. Each packet that makes up the file gets an identification number so that the receiving computer knows where it fits in the final file. The packets also get the IP address of the destination computer, number three in our case, as well as the return address of the sending computer.

The sending computer takes the first packet and sends it toward the hub. The hub then sends it out to all other computers. Each looks at the address of the packet, and ignores the data if not the intended recipient. The computer that is the intended target, in this case number three, stores the packet in the computer's memory and sends a receipt as a message back to the sender, number one. The sender then sends the next packet in from the file.

All this works well until two computers want to send a packet at the same time. If one computer is currently sending a packet and a second computer starts to transmit, the packets collide. This corrupts the data and the transmission fails. Both computers wait a random amount of time and send their packets again.

This design was built for non-real time transfer. However in our world of audio and video, a busy network with many collisions means that the receiving computer may well run out of material to play before the next packet arrives.

In this simple example, a hub was the center of our network. Hubs are an older technology, largely replaced by devices called switches and routers. These more advanced devices do not send the packets to all the other computers at the same time. Rather they have the intelligence to examine the packets and only send them to the destination computer. Additionally some of the more sophisticated of these devices will buffer incoming packets and send them out when the lines are available—greatly reducing the collisions.

Global Networking

So far our model is of a handful of computers located close to each other. This is referred to as a Local Area Network, or LAN. However, real world networks—such as the Internet and large-scale private networks like those operated by corporations—are global and connect many millions of computers. In this Wide Area Network (or WAN) environment, two computers that want to exchange files may not be connected to the same switch or router (Figure 18.4). They may not even be on the same continent.

Often packets of data are passed from router to router through many hops as they make their way from one computer to another. With large files such as audio and video over the course of the transmission, some packets may take different routes as traffic on the network changes. When this happens, packets may arrive out

of order. Most file players will buffer a number of packets before a file begins to play to help deal with this problem.

Figure 18.4 Local Area Networks Connected to a Wide Area Network

NOTE Everyone is familiar with what happens when the buffer empties before the next packet is available. A frozen picture with a rebuffering message is a frequent reminder of the difficulty of using packet networks for media streams.

In addition to traffic considerations, our networks have to be fast enough to move the amount of data contained in audio and video files. Documents do not contain really huge amounts of data. This book is less than 100 megabytes. A typical office network could move that amount of data in about eight seconds. That is great but a high quality media file compressed to that same 100 megabyte size is only about three seconds long. That means you

cannot watch that file in real time on the network without it stalling repeatedly.

The office network described here moves data at a rate of 100 megabits per second. That is an older and common standard in typical office conditions. For media applications, it is far more common to connect computers at a standard that is 10 times faster, 1,000 megabits per second, or GigE as it is called. GigE speeds are easy to achieve in a LAN-type of facility where all the computers can be connected to local switches and routers. To achieve that kind of speed in a Wide Area Network (or WAN) over long distances, special provisions must be made with network bandwidth providers at a much higher cost than a typical home or small office connection.

The next big leap in speed is to something called 10GigE. This is ten times faster than the GigE connection. This is most frequently carried on fiber optic cable, as it is difficult to move signal over normal copper wire that quickly. These types of connections are usually made between switches and routers that carry traffic around a facility. It is possible, however, to give these superfast connections to computers that need more data speed than that offered by GigE connections. A workstation that is working with large RAW type data files may need this level of connection to get to the data it is manipulating at full speed.

It is also possible to lease connections of this speed from public bandwidth providers. When broadcasters are doing large remote events like the Super Bowl or Final Four college basketball coverage, they may lease these superfast connections. Not only the program feed of the game, but also individual clips on reply servers and edit systems can then be shared between studio and event.

Data Storage

In Chapter 20 you will learn the mechanics of how data is recorded onto hard drives and disk drives, and some considerations for how to group drives together to create storage clusters. Before you take that deep dive into *how* media is recorded onto drives, let's take a broader look at the different storage devices and the ways they can connect to computers.

Direct Attached Storage

Direct attached storage is the class of devices that are connected directly to the computer that is responsible for storing files. Some forms of this are internal to the computer itself, either as a spinning hard disk or a Solid-State Storage Device (SSD). Others, such as a USB (Universal Serial Bus) or Thunderbolt hard drive, are mounted in external cases and connect to the computer through a cable.

While internal drives can easily record and play back media files, they are somewhat limited in capacity, based on the small number of them that fit in a computer case. There are several different ways these may be interfaced to the computer. Current common forms are SATA (Serial Advanced Technology Attachment) and SAS (Serial Attached SCSI). These technologies both build on older standards, PATA and SCSI, but work faster and with less complex wiring schemes. Both of these interfaces can move data at high speed, currently about 6 gigabits per second. That is enough bandwidth to handle even uncompressed high definition video files.

However, disk drives are mechanical devices using high speed spinning components, and frequently fail. And at these high bit rates, the interface to get the data to and from a hard drive can

exceed the rate that the drive itself can read and write the data. By grouping drives together, data can be duplicated on more than one disk. This type of redundancy is referred to as a *RAID* system, a Redundant Array of Independent Disks. One of the advantages of RAID systems (which are discussed in more detail in Chapter 20) is that by ganging disks together and spreading the data across the drives, performance can be greater than any individual drive.

NOTE Factors influencing drive speed include how fast the disk spins and how quickly the head can be moved over the part of the disk where the data of interest is located. This is called *seek time*.

External Drive Connectors

Externally, individual or large groups of drives may be connected to a single computer or workstation. The most familiar here may be single drives connected via a USB connector (Figure 18.5). The USB interface has seen three major speed configurations since its development in the mid 1990's. The first standard USB 1.0 was limited to about 12 megabits per second, which was only useful for compressed standard definition file transfer. The more common USB 2.0 was capable of 480 megabits per second and is still useful today for media applications. The most recent implementation, USB 3.0, has a very respectable data rate of 4 gigabits per second, approaching the speed of internal hard drives.

Figure 18.5 USB Cable and Universal USB Logo

NOTE In 1994, a group of seven companies began developing USB: Compaq, DEC, IBM, Intel, Microsoft, NEC, and Nortel. Their efforts have provided a universal and faster approach for not only connecting external drives to computers, but a multitude of devices as well.

A second common method for attaching external drives is eSATA. This is the same electrical connection used for internal drives, the only difference being the shape of the connector. This gives external drives and drive arrays the ability to transfer data as if they were inside the host computer.

Other connection methods you may be familiar with are FireWire and Thunderbolt. FireWire is an older connection method whose speed is comparable to USB 2.0. This format was developed by Apple, and has been replaced on newer computers by Thunderbolt (Figure 18.6). A Thunderbolt connection is very fast—up to 20 gigabits per second.

Storage Area Networks

One of the principal prerequisites for file-based workflows is that files need to be shared by multiple users. While it is possible to share files from direct attached systems, it is more efficient when

Figure 18.6 FireWire 800 Cable and Thunderbolt Cable

the sharing is done by technologies built for that purpose. One method of doing this is via a SAN, or Storage Area Network.

One of the chief principles of a SAN is that it is a separate network designed around file storage. Unlike the common Ethernet network that is also attached to most systems, the SAN has only one job—to deal with storage access. In addition to the hardware, a management program run on a separate computer or one of the client computers manages the files.

Shared storage systems face a problem when multiple users are accessing files. While everyone can read a file without issue, if more than one computer tries to write to a file at the same time, that file will be corrupted. It is the job of the SAN manager software to arbitrate who has permission to write to the file. This function, known as *locking*, can happen in a few different ways. The first, *volume locking*, says that the first person to connect to a drive volume can both read and write the files it contains. All other users may only read the files.

Moving down to a lower level, SAN systems may use *folder locking*, such that only the first user in a given folder has write permission, but other folders on that volume are available to be written by other users.

Volumes and Folders

In computer systems, a volume is a large unit of storage, frequently an entire disk drive. The concept of volume is however a virtual one. A single volume can also be several disk drives working together as one. Equally a single disk drive may be subdivided into several volumes.

A folder is a virtual collection of files. Often they are seen in computer operating systems as a picture of a classic file folder. Folders may contain files and other folders.

Finally, each file may be individually locked so that only one user may write to them. Each step into the hierarchy is more computationally intense as the number of things to be protected, such as volumes, folders or files, increases.

While SANs are very efficient, they require that each client computer has a specialized interface for the connection to the SAN. Each client must also run a piece of software to allow access to the SAN, and special cabling to each computer from the SAN must be installed. This makes SANs somewhat expensive and difficult to install and maintain, typically limiting their use to large organizations.

Network Attached Storage

Network attached storage devices are typically small appliances that combine one or more hard drives with a small server computer in a single box. Once plugged into a computer network, they provide external storage that is accessible to members of that network. While these appliances are a convenient way to share files, they typically are not robust enough to provide the access speeds needed for real-time playback and recording of high data rate media.

Servers

Centralized groups of hard drives, or storage systems, can be used to provide data for a variety of users simultaneously. These storage systems are called *servers*. Servers come in many forms, from simple twin hard drive units to complex groups containing hundreds of disks, and they have a variety of uses. For example, once news footage is loaded onto a server, access to that footage would be available to reporters and editors worldwide the instant it was recorded on the servers' disks. The data can be copied, changed, and

stored separately by multiple users without affecting the original data, thereby providing speed and flexibility to the users. Servers are connected to client computers, or users, by standard Ethernet networks.

Network File Servers

On a much larger scale are the file servers and data storage systems that provide the infrastructure of global data communications. It is quite possible to move and share media content over the Internet with services such as YouTube and Netflix. While this public network is fantastic for final delivery to the viewer, it is generally not robust enough for media production and management. (For more information on streaming media, see Chapter 21.)

Enterprise-scale media organizations, such as TV networks or cable companies, will often build their own data networks with leased connectivity between locations and careful internal design at their facilities (Figure 18.7). These networks are separate from the public Internet and devoted to data traffic only from their owners. When properly implemented, these networks can provide the necessary storage and bandwidth for all but the most demanding of media applications.

The Cloud

The author Arthur C. Clark said, "Any sufficiently advanced technology is indistinguishable from magic." The cloud seems to be just that. With services like Google Drive, Dropbox and many others, files may be shared among users who will have no idea where or how they are stored. Of course they reside on disk clusters in data centers somewhere near cheap power and plentiful bandwidth (Figure 18.8). While public networks do not yet provide the data speeds

Figure 18.7 Network Server Room

Figure 18.8 Cloud Network

to make these useful for real time media operations at higher qualities, that day may come soon. Perhaps it happened from the time this book was written until you picked it up.

Storing content in the cloud has some appeals and some drawbacks. The content owner may never have to consider maintenance, upgrades or backups of cloud-based assets. All that is part of the lease costs for the space that you rent.

On the other hand, data security is harder to guarantee as the assets are on the public network. And for many large organizations, those who have business models based on charging viewers for content, this is a major stumbling block. Cloud services, because they are normally geographically distant from the user, also require expensive high bandwidth connections if they must provide real time media access.

Summary

The workflow of audio and video has undergone a huge change since the turn of the century. File-based storage and management has replaced the videotape-based workflows that dominated the industry for more than half a century. Having content available as files has been driven by, and facilitated, the growth of distribution channels. Initially only available as a broadcast to be viewed in a living room, TV can now be consumed on a variety of different objects from phones, to tablets, to screens that are wrapped around the outside of buildings.

Managing Video Files

<div style="float:right">**19**</div>

Throughout this book, media is described as a continuous flow of information. When produced as digital data, this requires an enormous amount of bandwidth and storage space. A high definition signal traveling along an SDI path produces one and a half billion bits of data each second. 4K images in the same form require data paths that allow 12 billion bits to flow each second. These large data flows need to be managed as discrete sections that can be

Table 19.1 Common Data Rates

Format	Raster Size	Frames/ Sec	Scan	Approximate Data Rate*
SD Video	720 × 486	29.97	Interlace	270 mb/s
HD 720p 60	1280 × 720	59.94	Progressive	1.5 gb/s
HD 1080i	1920 × 1080	29.97	Interlace	1.5 gb/s
HD 1080p	1920 × 1080	59.94	Progressive	3 gb/s
UHD	3940 × 2160	59.94	Progressive	12 gb/s

*These data rates are common approximations for comparison and are generally a bit higher than the actual data rate. For example, 1080i video, without any audio or metadata, would actually be:

1920 × 1080 × 20 bits (@4:2:2 sampling) × 29.97 Frames per second = 1.242915 gb/s

saved and moved in the file-based structure of computers. To keep this flow of information running smoothly and efficiently within computer-based systems, it is important to prepare the files by choosing the best codec or compression scheme for the file's use as well as the most appropriate container to ensure it reaches its destination in tact.

File Containers

Media files combine audio, video and metadata. Just as you need an envelope to use the U.S. Postal Service, media files need a container or *wrapper* to encapsulate data to store and move it within computer systems. And just as physical envelopes come in different shapes, sizes and material suited to various tasks, there are a number of media containers that store and move media data (Figure 19.1).

One of the most important things a media container does is arrange and interleave the data so that the audio and video play out synchronically. If all the video data were at the start of the file, with

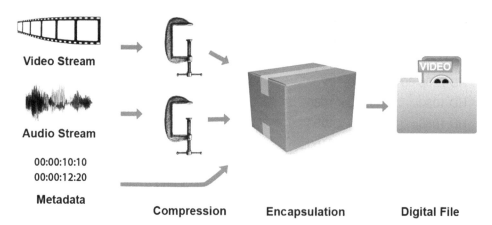

Figure 19.1 Encapsulation Process

the audio at the end, the entire file would need to be loaded into the computer memory before it could be played. Most computers don't have enough memory for this, nor does the audience have the patience to wait for this to happen. Let's take a look at different file containers.

QuickTime

One of the most familiar container formats is QuickTime, which was created by Apple. Files with the extension .MOV are QuickTime files. In addition to audio and video tracks, QuickTime files also support tracks for time code, text and some effects information.

Because QuickTime hosts a wide variety of audio and video codecs, and because Apple offers a free player for several operating systems, it is a very popular choice for web-based distribution. It is also a common format for the creation of files to be exchanged among content creators for review and approval copies.

There are several related containers that are very similar in structure to QuickTime, but were designed for special purposes. MP4 files (including .mp4, the audio only version .m4a, as well as others) are a container developed by the MPEG committee to interact specifically with MPEG-4 compression features not supported by QuickTime itself. 3GP is another format based on QuickTime, but in this case optimized for mobile delivery over cellular networks.

> **NOTE** Remember that QuickTime, MP4 and 3GP are different types of containers. They don't control or determine the type of compression they contain and carry. The compression type is determined by the codec. Codecs are described later in this chapter.

Windows Media

Files ending in .WMV and .ASF are Windows Media Files. This is a Microsoft design whose name is used to represent both a compression codec and a container format. Normally if a file has the .WMV extension, it is both a Windows media container *and* compressed with Windows media compressor. If .ASF is the extension, then the container holds a different codec.

Flash

Flash format (.flv, .f4v) is another popular container format. This is an Adobe product that was developed to contain animations built using a format called SWF. It was later extended to allow audio and video in the H.264 codec, discussed later in this chapter. This is mostly seen as files playing in a web browser via a plug-in that must be downloaded by the user. Adobe makes the browser plug-in available for free. As a result, Flash is a very popular container for web distribution of video content.

WebM

This container is a more recent development for distribution of web files in association with HTML 5 initiatives. While this supports limited codecs, it is making headway in some areas with large services like YouTube making their content available in this format (Figure 19.2). (WebM is discussed in more detail later in this chapter.)

Figure 19.2 File Container Formats

Media Exchange Format

The MXF format is perhaps the most popular in large-scale media production organizations. This format was developed from the beginning to be a SMPTE format that equipment manufacturers could use to exchange content among their products. Computerized systems used in television can require media to be wrapped in different ways. To accommodate this, the standard allows for several variations in the format. These differences are categorized as Operational Patterns, or OPs. While there are currently 10 different specs for OPs, the two most common are OP-Atom and OP-1a. The biggest difference between the two is how the audio and video are stored on disk.

OP-Atom is designed for editing systems that store the audio and video as different files. Early computer editing systems had difficulty getting all the data needed to edit from a single disk, so the audio and video were stored on different drives. While that is no longer the case, some edit systems still use separate files for each element.

OP-1a is a single file in which all the audio and video are stored in the same container. Devices such as video servers use this format.

Other Containers

There are many other containers beyond those discussed. Some are legacy formats that are fading from use. Others are brand new and have yet to build a large user base. Some are special purpose and limited to equipment and workflows.

TIP The one hint that seems pretty universal is that the file extension for a media file is the container format it is using.

Switching Containers

The process of moving media between containers is referred to as *re-wrapping*. The audio and video stay the same, still in the original codecs. The material is just reorganized in a different container better suited to the target device. For example, this process frequently happens when files are moved from the camera to an editing system.

> **NOTE** If the codec needs to be changed as well, the process then becomes one of transcoding. Transcoding can affect the quality of a file, most especially when going from a less to more compressed codec. Because re-wrapping does not change the codec of a file, it is a clean lossless process.

Codecs

As you learned in Chapter 14, data is normally compressed to reduce the amount of information with which our computers have to cope. There are many different algorithms, or *codecs*, that can be used for this job. Some are best suited for use when capturing images, while others are meant for editing. Some work well for distribution, with variants for the kind of medium that will carry them. Often codecs developed for one purpose are also used in others areas.

> **NOTE** Remember that the word codec is derived from the words <u>co</u>mpression and <u>dec</u>ompression.

There are hundreds of codecs that have been created, with newer more efficient ones replacing previous generations. Let's take a look at some of the more common codecs that are used in the

production and post production process, as well as those used to stream media.

Acquisition Codecs

Image Capture comes in many forms from the camera phone through cameras designed for digital cinema quality. Low-end cameras look for codecs that allow long captures to be stored in a small space. The goal at the high end is to capture as much detail as possible to allow the greatest flexibility in post production image processing.

At the high end are codecs such as ArriRaw and Redcode. The Arri format for the cameras they produce is not compressed at all and is, as the name implies, the raw data from the image sensor. Redcode, from the makers of the Red Camera series, is compressed, very gently, in a codec that uses JPEG 2000 wavelet compression. Sony also offers a gently compressed acquisition codec in their SR format. While the files these codecs produce are huge, they contain all the data captured by the sensor. For later post production manipulations like compositing and color grading, all the available detail gives a greater range of creative options.

NOTE These cameras, like those of the other high-end camera makers, can also be set to shoot in several other formats as well.

Adobe created CinemaDNG format as an open non-proprietary format for image capture. This is a moving image version of their Digital Negative Format (or DNG), which supports gentle lossless compression. Several camera makers support this format including Black Magic.

A somewhat more compressed image can be captured using codecs that were originally designed for editing. Avid DNxHD and Apple ProRes are two examples. Both of these formats allow for various quality captures by choosing different data rates. Originally created for editing, these codecs capture each frame as a separate element. Both have top data rates of about 200–250 Megabits per second (Mbps), or about 7:1 compression ratio. In addition to on-camera recording, these are popular choices for video servers recording studio television shows, often with data rates as low as 100 Megabits per second. An additional motivation to use these formats is that the captured material is edit-ready. No additional processing is necessary to prepare for the edit room. The clip files may simply be quickly copied to the edit system. Obviously, this is tremendously helpful for workflows that have short deadlines.

The next step down the quality ladder is to cameras that record in more heavily compressed formats such as Sony XDCam and Panasonic AVCHD. The data rate for these formats is in the 30 to 50 Megabits per second range. Both compression types are variations of the MPEG 4 Part 10, or H.264 format. Cameras in this class are often used in newsgathering and other projects that do not require heavy image compositing or color grading. Since much of the detail is compressed out of these images, they are not suited to heavy post production manipulation.

Finally at the lower end of the image capture spectrum are cameras that record in very long GOP versions of codecs like H.264. Compression for these images is very lossy, with data rates often less than 1 Mbps. While these can produce acceptable images, they are very difficult to work with in post production and often must be transcoded to a different format for editing. Camera phones and inexpensive digital video cameras sold as consumer devices fall into this group of equipment.

Codecs Used in Post Production

As mentioned earlier, there are codecs that were designed specifically for the unique requirements of editing. As examples, Avid created a group of codecs called DNxHD, while the engineers at Apple have produced several versions of their ProRes codecs (Figure 19.3). Both of these are Intraframe-based codecs, meaning they do not require information from adjacent frames to produce images.

Many codecs achieve high compression ratios by taking advantage of redundant information in adjacent frames. This does make editing a challenge. In order to make a cut at a specific frame, the computer must create that frame, along with the new one that follows, by decoding the picture from neighboring frames. While this is possible, it is somewhat taxing on the system and can produce a less than satisfactory experience for the person making the edits.

Figure 19.3 Various Codecs Using .MOV File Container Format

While there are codecs designed just for editing, most edit programs will work with many other codecs as well. Often editors will choose to work in the codec that their material was acquired in for speed and simplicity in workflow. For example, some larger networks and program producers have settled on XDCam at 50 Megabits per second as their common format. This offers an acceptable compromise between quality, speed and operability.

Contribution and Mezzanine Codecs

Frequently there is a need for compression that is an intermediate between uncompressed footage and distribution codecs. For example, let's say the cameras at a sports event are capturing the footage RAW or uncompressed. When it's time to uplink that footage or send it over a fiber optic line back to the network, the signal has to be compressed to reduce its file size. The encoder that does that is set to the largest compression ratio the channel can handle. That level of compression is referred to as *contribution quality*. Of course, when the footage gets to the network, it might be further compressed to be recorded on a server, or it might be uncompressed to be switched with other material as a live feed. Other uses of contribution quality compression include storing and playing out program content and commercials, and archiving finished work.

> **NOTE** Examples of this group are codecs such as H.264, HEVC (H.265), MPEG and JPEG 2000. When used at contribution quality levels, the codecs are adjusted to higher bit rates than when used for distribution.

Another name used for this type of compression is *mezzanine*. Much like the mezzanine is half way between floors in a building, you can think of mezzanine compression as a middle level of compression.

One common use of this type of compression is when preparing files for distribution channels such as YouTube. The finished edit in the edit codec for an hour-long show can run to many Gigabytes, far too large to easily send to the web host. A compression is made to reduce the amount of data to something easier to upload. The web host site then processes that file into several variations at different bit rates to make it publically available. The web site will offer either automatic or manual selection of the best bit rate for each user's connection. Thus, what you have sent to be re-encoded is a middle or mezzanine format.

Digital Distribution Codecs

For digital distribution such as Internet streaming, which is discussed in more detail in Chapter 21, there are certain formats that are more effective than others. One codec in particular, MPEG-4, was developed especially for streaming media on computers that have a much lower signal throughput or bandwidth than digital television or DVDs. It has heavily influenced three specific areas, which are interactive multimedia (products distributed on disks and via the web), interactive graphic applications (for example, the mobile app "Angry Birds") and digital television (DTV).

MPEG-4 Codecs

MPEG-4 is the most common digital multimedia format used to stream video and audio at much lower data rates and smaller file sizes than the previous MPEG-1 or MPEG-2 schemes. It can stream everything included in the previous MPEG schemes, but it was expanded greatly to support both video and audio objects, 3D content, subtitles and still images as well as other media types—all with a low bitrate encoding scheme. It supports a great many

devices from cell phones to satellite television distributors, such as DISHTV and DIRECTV, to broadcast digital television. MPEG-4 has many subdivisions, called profiles, that address applications ranging from surveillance cameras with low-image quality and low-resolution to more sophisticated HDTV broadcasting and Blu-ray DVDs that have a much higher quality image and greater resolution. Let's take a closer look at some MPEG-4 profiles.

H.264/AVC (Advanced Video Coding) is part of the main MPEG-4 profile. It is one of the most prevalent video codecs or video compression formats in that profile and is used for everything from Internet streaming applications to HDTV broadcast, Blu-ray DVDs and even Digital Cinema. It is nearly lossless with a 50% bit rate savings while still maintaining excellent video quality. In 2008, H.264 was approved for use in broadcast television in the United States. This was especially helpful to Digital Satellite TV, which is constrained by bandwidth issues. H.264 is less than half of the bitrate of its MPEG-2 predecessor.

High Efficiency Video Coding, also known as HEVC/H.265, is the successor to H.264/AVC. Compared to H.264, this new video compression codec doubles the data compression ratio squeezing out another 50% bitrate savings while still maintaining the same level of video quality. Alternatively, it can be used to provide vastly improved video quality at the same bit rate as H.264.

Unlike Apple's QuickTime, the wrapper or delivery container that H.265 uses is called DivX. This is the newest video compression standard, which was completed and published in 2013. It can also support 8K UHD (Ultra High Definition) televisions and resolutions up to 8192 x 4230. Still in its early stages as of the writing of this book, H.265 promises to deliver support for enhanced video formats, scalable coding and 3D video extensions.

Google's WebM Codec

Google's WebM is quite a different story. Unlike other proprietary codecs, Google's WebM is an audio-video media container format that is not only royalty free, but it is also considered to be an open-source video compression scheme for use with HTML5. This format is being developed through a community driven process that is fully documented and publicly available for viewing. WebM does not contain proprietary extensions and all users are granted a worldwide, non-exclusive, no-charge, royalty-free patent license.

One of the most important aspects of HTML5 video is that it includes various tags that allow browsers to natively play video without requiring a plug-in like Flash or Silverlight, and it does not specify a standard codec to be used.

Audio Codecs

Just as there is a variety of video codecs, there are numerous audio codecs that have been created for different purposes.

MP3 is a lossy data compression scheme for encoding digital audio. MP3 was the de facto digital audio compression scheme used to transfer and playback music on most digital audio players such as iPods. It is an audio-specific format designed by the Moving Picture Experts Group (MPEG) to greatly reduce the amount of data required to faithfully reproduce an audio recording as perceived by the human ear. The method used to produce these results is called *perceptual encoding*.

In perceptual encoding, compression algorithms are used to reduce the bandwidth of the audio data stream by dropping out the audio data that cannot be perceived by the human ear. For example, a

soft sound immediately following a loud sound would be dropped out of the audio signal saving bandwidth.

NOTE MP3 is formally known as MPEG-1 (or MPEG-2) Audio Layer III.

AAC (Advanced Audio Coding) is a lossy compression and encoding scheme for digital audio, which is replacing MP3. Using a more sophisticated compression algorithm than MP3, AAC audio has a vastly better audio quality at similar bit rates as MP3.

As part of the pervasive MPEG-2 and MPEG-4 family of standards, AAC has become the standard audio format for devices and delivery systems such as iPhone, iPod, iTunes, YouTube, Nintendo 3Ds and DSi, Wii, the PlayStation 3 and the DivX Plus Web Player (Figure 19.3). The manufacturers of in-dash car audio systems, capable of receiving Sirius XM, are also moving away from MP3 and are embracing AAC audio.

Windows Media Audio (WMA) is a proprietary lossy audio codec developed by Microsoft to compete with MP3 and the RealAudio codecs. It is used by the Windows Media Player. Variations of it are compatible with several other Windows or Linux players. This audio format and codec can be played on a Mac using the Quick-Time framework but it requires a third-party QuickTime component called Flip4Mac WMA in order to play.

Distribution Codecs

Distribution codecs are the ones that are tuned for delivering the content to the audience. Often they are more heavily compressed versions of codecs such as MPEG-2, H.264 and HEVC. Here the

selection is based on reducing bandwidth as much as possible while providing robust error recovery for less than perfect signal paths. The codec that is selected is a function of the type of delivery channel.

For Over the Air (OTA) television, MPEG-2 at just over 19 Megabits per second was chosen by the ATSC. A 2009 revision of the ATSC standard also allowed the more efficient H.264 codec to be used as well. As this book was being written, the ATSC was working to standardize the next broadcast format to include UHD, or 4K video. The codec being considered is HEVC or H.265 for what will be known as ATSC 3.

When delivered over cable and satellite to the home, the video is compressed using MPEG codecs. However when compared to OTA, cable and satellite companies often provide more highly compressed content in an effort to deliver more channels to subscribers.

Optical disks use either MPEG-2 or H.264. MPEG-2 is normally seen on DVDs, which are always standard definition. Blu-Ray disks can use several codecs—MPEG-2, H.264, or Windows Media (VC-1).

YouTube compresses content in MPEG-4. Several copies of each submitted video are made at different sizes, and the user can select the quality of the playback supported by their connection and computer. Some online services, such as Netflix, dynamically change between different compression levels based on bandwidth conditions. Other online distribution can use a broad range of codecs including Windows Media, all the MPEG variants, H.264, HEVC, and many others.

The development of compression standards, codecs and containers is an ongoing process. As mathematicians and engineers take

advantage of computer and network speed, new and better compression technologies will be developed.

> **NOTE** Due to the ever-changing nature of this technology, consider the codecs described in this chapter as a foundation for understanding how codecs evolve and how they are used in the different stages of video production, post production and distribution.

Recording and Storage Formats

<div style="float:right">**20**</div>

As discussed earlier in this book, all video images begin as a form of light, which is then converted to electrical signals. These electrical signals can then be stored to solid-state devices or converted to either magnetic or optical signals for purposes of recording on tape or disk. At the beginning of all productions, thought is given as to the specific recording format that will be used to capture the material in the shoot. At the end of the shoot, thought is again given as to how that material will be stored for use during post production or archived at the end of the project. In previous chapters, you've learned about large-scale workflows and digital distribution options. In this chapter, you will take a closer look at the different recording and storage formats available for these purposes.

Optical Media

While analog video was primarily recorded magnetically using videotape in a videotape machine, the digital video signal can be stored electronically, magnetically or optically. Optical media is a development of the digital domain. It is not used for analog recording or storage, only for recording or storing digital data. The primary difference between magnetic and optical media is that magnetic media

are volatile, meaning that the information can be lost accidentally by exposure to a strong magnetic field. Optical media, on the other hand, are non-volatile. The data, once recorded, cannot be changed or erased except through direct action by the user.

Optical Recording

All optical media use laser technology for recording, storing, and reproducing digital data. There are three primary components of a laser system: a laser, a lens, and the recording media. Let's take a look at how they work together.

Ordinary light, such as a light bulb, is referred to as *incoherent light*. Incoherent light is composed of multiple frequencies that are scattered in all directions. A laser is an optical device that generates *coherent light* in the form of a beam (Figure 20.1). Coherent light has a single, specific frequency. A laser beam is created when electrical current is used to energize or excite a chemical compound.

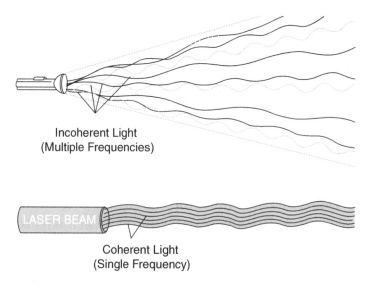

Incoherent Light
(Multiple Frequencies)

LASER BEAM

Coherent Light
(Single Frequency)

Figure 20.1 Coherent and Incoherent Light Frequencies

Specific chemicals emit specific frequencies of light. Therefore, a laser beam is a single, specific frequency of coherent light.

This light is then focused through a lens, which may be made of a variety of transparent materials. Industrial-grade rubies are often used as the lens material, accounting for the red color of common lasers. Light energy used in the creation of an image or acoustical energy used in the creation of sound is converted to electrical energy, which is then used to energize the laser.

Optical discs are made from a pure polycarbonate plastic. A reflective surface is required for the purpose of reading the data and this surface is usually a thin backing of aluminum or occasionally gold. This layer is protected by a transparent coating to which printed labels can be applied (Figure 20.2).

The intense beam of light being directed from the laser source to the storage medium changes the plastic and the data is stored as a change in the physical structure of the optical media. This change creates a small spot, or *pit*, when the laser is energized. An area where the laser is off leaves a *flat*, also called a *land* (Figure 20.2). These pits and flats are recorded in a circular track starting from the inside, or center of the disk, going outward toward the edge (Figure 20.3). On data retrieval, the changes between pits and flats are registered as ones, with no change registering as a zero.

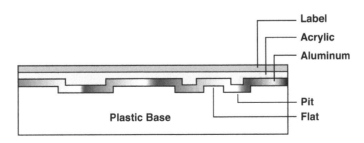

Figure 20.2 CD Cross Section

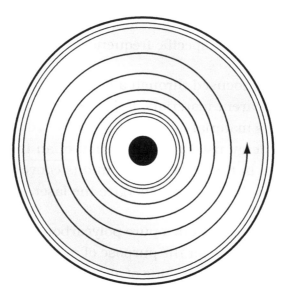

Figure 20.3 CD Directional Flow

Commercially pre-recorded optical discs are produced using a process that molds or stamps the pits into the polycarbonate before the reflective layer is applied. The pits are actual, physical indentations that change the reflectivity of this added layer when read by an optical disc player.

Consumer recordable discs have an organic dye or crystalline metal alloy data recording layer between the polycarbonate layer and the reflective metal layer, the composition of this layer being determined by the format of the disc. This layer of dye or alloy is heated by the laser and produces changes in reflectivity of the substance that mimic the changes produced by the pits.

Optical Reproduction

In order to read the pits and flats from the plastic recording media, a reflective surface is required. As mentioned earlier, aluminum, or occasionally gold, is generally used as the reflective backing against

the plastic. The aluminum backing also protects the digital data on the plastic from being damaged.

When reproducing or playing back the data, the laser beam remains on constantly. The constant light shining on the surface of the disk is reflected by the backing. The backing also protects the digital data from being damaged. The system interprets the difference in time between a reflection off a flat surface and a reflection off a pit. This difference in time allows the system to read the information as zeros or ones.

Optical Formats

The principal difference among optical formats is how much data can be stored on a single disc. While the flow of digital data is measured in bits, all digital memory is measured in bytes. A high-speed Internet connection is measured as so many *bits per second (bps)*, whereas a single-sided device such as a CD can hold between 650 and 800 MB, or megabytes, of data.

NOTE A byte normally consists of 8 bits. While there is no formal standard for this, by convention the 8-bit byte has become the de facto standard.

Hierarchy of Measurement

When working with digital files in the production and post production process, it's helpful to become familiar with the measurement of digital memory. Except for the 8-bit byte, the measurements are based on multiplications of 1000. The reference to 1000 in the metric system is derived from the Greek word, *Kilo*, which is used as

a unit prefix to define different types of measurements. A kilogram, for example, is a thousand grams. A thousand bytes is a *kilobyte*. The next measurement, *Mega*, is a thousand thousand, or 10^2. *Giga* equals a thousand megs (10^3), or a thousand million, which is a billion. *Tera* equals a thousand gigs, or a thousand billion, which is a trillion. *Peta* equals a thousand teras, which is a thousand trillion, or a quadrillion. When referring to digital memory, shortcuts are used and capitalized, such as KB for kilobytes, MB for megabytes, GB for gigabytes, PB for petabytes, and so on. Lower case shortcuts are used in reference to bits of data, such as Kb for kilobits, Mb for megabits and Gb for gigabits.

Types of Optical Media

CDs (compact discs) and DVDs (digital versatile discs or digital video discs) are the same type of optical media. The immediate difference between the formats is one of storage capacity. Storage capacity on optical media is a function of the number of tracks that can be stored or written on the surface of the media. Making the tracks on the disks narrower and placing them closer together, as in DVDs, yields a greater storage capacity. Physically, CDs and DVDs have the same dimensions, usually 120mm in diameter, although there can be minidisc formats with an 80mm diameter.

Types of CDs

CD: Primarily, CDs are used for audio recording, software and game distribution, still images, and, to a limited degree, video. Recording of images in motion is limited on CDs only because of the storage capacity of the disk. CDs are single sided and have a storage capacity of between 650 to 800 MBs.

CD-ROM (CD–Read-Only Memory): CD-ROM discs are identical in appearance to other CD discs. CD-ROMs are used for the

commercial distribution of audio CDs, computer games and other software. CD-ROMs are mass produced using a process of molding and stamping with a glass master disc. CD-ROMs have a storage capacity of between 650 to 800 MBs.

CD-R (CD–Recordable): These discs were originally known as CD Write-Once (CD-WO). An organic dye layer is employed to record the data. The laser effectively burns the dye which causes it to become opaque and reflect less light. The recording layer is changed permanently by the laser. CD-R discs can be written to once, but read many times.

CD-RW (CD–Rewritable): These discs use a crystalline metal alloy in the recording layer. The laser heats and melts this to make the appearance of the pits and lands of pre-recorded CDs. CD-RW discs can be re-recorded on up to 1,000 times, but must be blanked in between recordings. They can be read many times. Due to file systems used for re-writing the discs, storage capacity is usually less than 640 MB.

Types of DVDs

Unlike the simple single-sided CD, DVDs are available as single-sided, single-layered discs (SS SL); single-sided, double-layered discs (SS DL); double-sided, single layered discs (DS SL) and double-sided, double layered discs (DS DL). Single-layered DVDs have a storage capacity of 4.7 GB, while double-layered DVDs can store as much as 8.5 GB of data. An 8.5 GB DVD can hold up to four hours of standard definition video using MPEG-2 compression. The MPEG-2 compression process used for DVDs is generally built on a 40:1 compression ratio. DVDs, because of their greater capacity, are often used for recording images in motion, such as movies, games and interactive video.

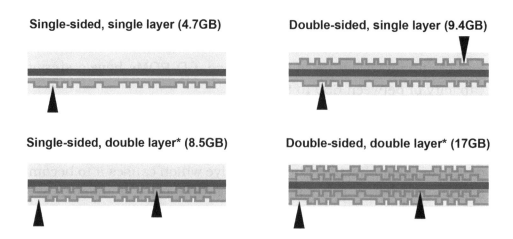

Single-sided, single layer (4.7GB)

Double-sided, single layer (9.4GB)

Single-sided, double layer* (8.5GB)

Double-sided, double layer* (17GB)

*Single laser changes focus to second layer

Figure 20.4 Types of DVD Layers

Each side of a DVD can contain two layers of data. The layer closest to the surface is burned on a transparent coating that allows the laser to change focus and read the information of the layer behind it (Figure 20.4). It is possible to have these two layers on both sides of a DVD, but it means that the DVD must be flipped over by the user. Some movies were released that had different formats of the movie on each side—16 × 9 on one side and 4 × 3 on the other.

DVD-ROM (DVD–Read-Only Memory): These discs are produced in a similar fashion to CD-ROMs. They are pressed using master discs. These discs can be single-sided and single-layer (DVD-5), single-sided and double-layer (DVD-9), or, rarely, double-sided and single-layer or double-sided and double layer.

NOTE The numbers associated with a DVD, such as DVD-5 and DVD-9, refer to a rough approximation of their capacity. In draft versions, DVD-5 actually held five gigabytes, but changes were later made that reduced the amount to 4.7.

DVD-RAM (DVD—Random Access Memory): DVD-RAM discs are rewritable and used mainly for computer data recording. They are most closely akin to a floppy or hard drive in usage. The recording layer is a crystalline metal alloy. DVD-RAM discs have a capacity between 2.58 GB and 9.4 GB and may be single or double sided.

DVD-R (DVD–Recordable): DVD-R and DVD-R DL (DVD-R Double Layer, also known as DVD-10) discs are similar to the CD-R discs. The storage capacity is 4.7 GB for the DVD-R and 8.54 for DVD-R DL. The greater storage capacity is achieved by smaller pit size and a narrower track. A laser beam with a shorter wavelength than that used for writing to CD-R discs is used. This necessitates the use of a different dye than that used for CD-R disc manufacture. DVD-R and DVD-R DL discs are made with two polycarbonate discs sandwiched together, with one disc having the reflecting layer, recording dye and track. DVD-RW discs are similar to CD-RW discs. They utilize a crystalline metal alloy in the recording level.

Blu-ray Disc (BD)

Optical media may look similar to the human eye, but CDs, DVDs, and Blu-ray Discs have important technological differences. For example, CD and DVD players and recorders use red laser beams, while Blu-ray technology employs a blue-violet laser beam, which has a much smaller wavelength. With a smaller footprint, the laser can read and record much more content on the same size disc than a laser with a bigger wavelength. CDs use an infrared 780 nm (microns) wavelength laser beam, DVDs use a 650 nm, and Blu-ray's blue-violet laser beam uses a wavelength of 405 nm (Figure 20.5, Plate 25).

Because of the higher frequency and shorter wavelength of the laser's beam, Blu-ray Disc storage capacities range from 25 GB

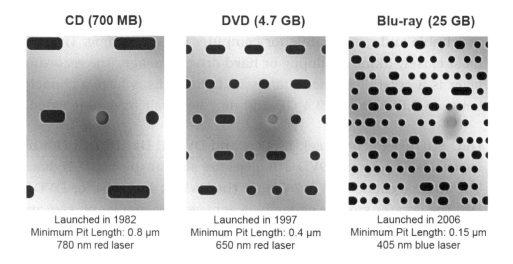

CD (700 MB)	DVD (4.7 GB)	Blu-ray (25 GB)
Launched in 1982	Launched in 1997	Launched in 2006
Minimum Pit Length: 0.8 µm	Minimum Pit Length: 0.4 µm	Minimum Pit Length: 0.15 µm
780 nm red laser	650 nm red laser	405 nm blue laser

The tighter the pattern of the pits on the disc, the more information the disc can hold. Also, a shorter laser beam can focus on the pits with greater accuracy and precision.

Figure 20.5 (Plate 25) CD, DVD, and Blu-ray Laser Beam coverage

for a single-sided disc to 50 GB for a double-sided disc. Like DVD, Blu-ray can be used to store either data files or video content. High Definition projects are most often distributed on Blu-ray due to its greater data storage capability. HD video files can be compressed using MPEG or H.264.

NOTE Blu-ray Disc variants include B-R (Blu-ray recordable) and B-RE (Blu-ray re-recordable).

Solid State Recording Formats

While some cameras used in professional settings, such as studios and remote productions, do not make recordings themselves, most common cameras have the ability to capture images to removable medium. The first of these "camcorders" worked with video tape. As other media became available, manufactures incorporated the

improved formats. Some cameras use optical media; however, the majority of systems are based on solid-state recording.

Solid-state recording media grew from the technology used by computers called EEPROM, or Electrically Erasable Programmable Read-Only Memory. Sometimes called *flash memory*, this is a form of computer memory that maintains its recoded state even when there is no power to the circuit. It can be erased and re-recorded many times. Initially this type of memory was too slow and too expensive for recording the massive amount of data in a video signal. But, as with other computer advances, the prices per byte of storage have diminished with the passing of time. Combined with on-camera data compression, this is now the predominant recording medium for cameras.

The recording media, or cards, come in many different form factors. Some, such as the Panasonic P2 cards or Sony SxS cards, are proprietary formats matched by the manufactures to the specifications of the camera (Figure 20.6). Others, such as SD (secure digital) cards,

Figure 20.6 Panasonic P2 Memory Card

are useable by a broader range of still and video cameras, audio recorders, computers and phones. Another form of flash memory is the USB memory stick.

Yet another form used by some high-end cameras is the SSD, or solid-state drive. This is essentially high capacity solid-state memory using the kind of interface found on magnetic disk drives. This is very fast memory and is used by high-end cameras to record uncompressed video. These drives are also available for laptop and desktop computers. While more expensive than "spinning" magnetic disks, they are more robust and offer much faster data access.

TIP Two important things to consider when buying media for your camera is the capacity of the cards and the speed that they can record and reproduce data. How much the camera compresses the files will determine the bandwidth and size of the data. Be sure to check the specifications for your specific camera to determine the kind of cards to obtain.

Magnetic Recording

Today, most magnetic recording takes place on computer disk drives, but the basic technology for magnetic tape recording dates back to the Second World War. Ampex Corporation first commercialized it for audio in the 1940s. In the mid 1950s, the first video tape recorders, or VTRs, were introduced for time delay programming using the Ampex VR1000. By the 1980s, the recorded signal began to transition from analog to digital. The availability of inexpensive computer disks by the late 1990s made possible the kind of file-based recording we are familiar with today.

Magnetic media is based on the physics principle that electrical signals pass through a wire and create a *magnetic field* around

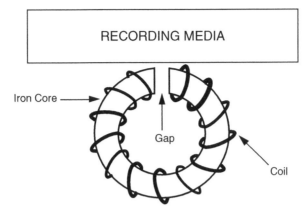

Figure 20.7 Coils of Wire Around an Iron Core

the wire. If that wire is wrapped around a soft iron core, that iron core will become an *electromagnet* (Figure 20.7). The process can be reversed. A magnetized iron core moving in a coil of wire can be used to create an electrical current in the coil of wire.

On a magnetic recording device, such as a videotape recorder, there is a record *head*, which is the part of the machine that records the signal (Figure 20.8). This record head contains a coil of wire wrapped around a soft core of iron. The video or sound signals are converted to electrical energy. When this electrical energy flows through the coil of wire in the record head, it causes the record head to become a magnet. The strength of the magnetic field varies depending on the amount of electricity that is flowing through the coil of wire around it.

The iron core is bent in the shape of a circle where the ends do not touch. Touching both ends together would complete the energy flow and the iron core could not be used to magnetize the tape or disk. Therefore, a gap or space is left between the two poles. This gap is a small opening that is visible under high magnification.

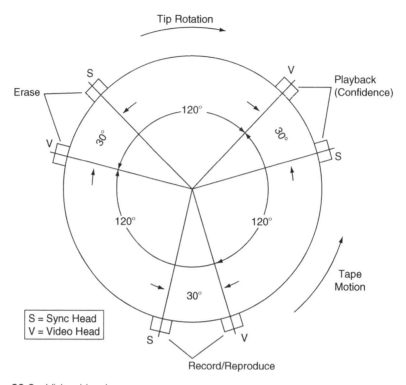

Figure 20.8 Video Heads

By leaving this gap, the flow of magnetic energy follows the path of least resistance, which is to the recording surface. The coating on the surface has greater permeability and therefore provides an easier path than trying to cross the gap between the two ends of the magnet. The magnetic energy deposits itself and is stored there.

As the tape or disk passes across the head, the varying magnetic energy levels, called *flux*, magnetize the particles on the surface. The amount of electricity, and thus the magnetic energy, varies depending on the strength of the signal. In an analog recording, the signal represents both the amplitude and frequency of the data being recorded. The levels of magnetic energy are analogous to the

variations in the signal. The particles on the tape do not move. Instead, these little particles of metal act as small magnets. As magnets, they retain their magnetic energy until they are either demagnetized through erasure or are altered by replacing the information with newly recorded material. In a digital recording, the presence or absence of a magnetic field represents the bits of data being recorded.

Playing back the recording is the reverse process. The media, which is magnetized, is passed across the playback head, that part of the machine that converts the magnetic energy back to electrical energy. The varying magnetic energy levels cause electrical current to flow in the coil of wire that is wrapped around the soft iron core in the playback head. Varying levels of electrical energy, based on the strength of the magnetic energy, are produced in the coil of wire. This electrical energy is then amplified and reproduced as the information that was originally recorded.

Lost to History

Audio and video tape are made of a thin coating of ferrous material bound to a plastic backing. Though the process is conceptually quite simple, it is not especially easy to manufacture. It took many years to develop formulations that were both robust enough not to shed the magnetic coating during use, but also not so abrasive that they wore out the metal parts they passed over. The first tapes used in the 1950s and 1960s cost hundreds of dollars for an hour-length tape. They were so expensive that they were frequently erased and reused. Unfortunately, many early television shows were erased and lost to history because of the high cost of purchasing new videotapes.

Control Track

When a video signal is recorded onto magnetic tape, a *control track* is recorded (Figure 20.9). A control track serves a similar function to perforations in film. If it were not for the perforations in film, there would be no way to place the frame in its proper position in the gate of a projector. The control track aligns the scanner in the VTR so that the playback begins at the start point and finishes at the end of the data track. The scanner or record/playback head aligns itself with the tracks one at a time as it plays them back.

NOTE How much information can be recorded on tape is a function of how fast the tape passes by the record and playback heads. Video requires a lot of information to be recorded. In order to get the speeds high enough, early tape machines mounted the heads on rotating disks and spun them across the tape at high speed in a process called scanning.

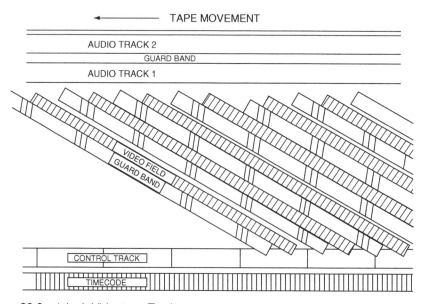

Figure 20.9 1-Inch Videotape Tracks

Magnetic disk recordings also have a structure to align and locate the position of the recorded files. In the case of disks, the surface is arranged in tracks and sectors. These are created when the disk is formatted. Hard drives also have multiple platters, or surfaces, each with its own head assembly. This both increases the capacity of the disk and makes accessing the files faster. The size and number of platters, tracks and sectors vary by disk drive model.

Hard Drives and RAID Systems

Digital data, when converted to magnetic energy, can be recorded on a *hard drive*. A hard drive is another type of magnetic disk storage device made of steel onto which the digital data is recorded. Recording occurs through a record head, similar in construction and type to a tape-based recording device. The record head consists of a soft iron core enclosed in a coil of wire. It is mounted on a movable mechanical arm that allows the head to be brought into close proximity without touching the disk surface. As the disk rotates at high speed, the record head magnetizes the disk surface on whatever part of the disk is flagged as available space. As the arm moves up and down depositing data on the disk, it emits an audible clicking noise.

Hard drives can be internal, mounted inside a computer, or portable such as in the case of USB or FireWire hard drives that attach to computers through a cable. Disk drives are mechanical devices using high-speed spinning components, and frequently fail. By grouping drives together, data can be duplicated on more than one disk. Grouping also allows for more storage than a single drive, and can be arranged to decrease the amount of time it takes to record and reproduce files. This type of redundancy is referred to as a *RAID* system, a Redundant Array of Independent Disks

Figure 20.10 RAID Array

(Figure 20.10). A RAID may consist of any number of drives, but requires at least two drives working together.

There is a variety of levels of RAID, such as RAID 0, RAID 1, RAID 5, and so on, each one employing a distinct organization or strategy in the distribution of the data across the hard drives. Each RAID level offers its own benefits, which might include increased storage capacity, superior data integrity, better fault tolerances, and faster throughput performance. The different levels achieve these benefits with varying penalties being exacted with regard to efficient use of

storage space, speed of data read/write, and varying fault tolerance performances.

The strategies of data organization utilized in RAID systems are:

Striping: The data is written across the disks in the array in stripes, each stripe consisting of the same amount of data, either at the byte-level or in blocks, and written across the disks sequentially: disk 1, disk 2, then laying the next stripe on disk 1 again, and so on. Striping decreases the access times for data, as read/write operations are performed on all hard drives in the array at once, rather than the data being accessed from one drive.

Mirroring: The data is written in blocks, with the blocks being mirrored across the disks: blocks in disk 1 being mirrored on disk 2, the blocks on disk 1 being laid out sequentially through the disk.

Duplexing: Duplexing is essentially like mirroring, only each disk (or set of disks) to be duplexed has its own hardware controller. Mirroring and duplexing are the most inefficient RAID strategies in terms of storage capacity as the effective storage is half the actual capacity of the total on the RAID hard drives. However, mirroring and duplexing provide a complete redundancy of data and provide for the fastest possible recovery of lost data in the event of a hard drive failure.

Parity: Parity in the computing world is a function that provides a check on a set of binary data, for example by notating if it has an even or odd number of ones. This parity data is stored across the RAID array. Parity protects against the loss of data in the event of hard drive failure without the high overhead of effective storage capacity loss. If a software RAID controller is being utilized, the cost of recovering data on a failed hard drive is in the need for a high performance

CPU to perform the necessary computations to rebuild the missing data.

RAID can be achieved by either hardware implementations, using a special hardware controller card, or by use of software through the normal computer drive controllers. Each implementation has its own benefits, while some RAID levels work only with hardware controllers.

RAID Levels

There are a number of RAID levels in use, each one offering its own advantages and disadvantages, and each one suitable for use in different applications. The following are the ones most commonly seen in media applications.

RAID 0 is a simple design that uses a striped array allowing for fast data access and the most economical use of hard drive storage, but provides no fault tolerance. In the event of a single drive failure, all the data in the RAID array is lost. Areas of application include video and other image production and editing, and any other application requiring high throughput.

RAID 1 utilizes mirroring or duplexing. The data is laid down sequentially within one drive, and mirrored in its pair. This provides a complete copy of all data but is inefficient with regard to disk space consumed. RAID 1 is used in applications requiring high availability such as at a financial institution.

RAID 3 uses byte-level striping and parity. The parity is recorded on a dedicated disk. This level is highly efficient in storage usage and provides high data transfer rates. RAID 3 is usually achieved by use of a hardware controller. Its applications include video production;

live streaming of video, image and video editing, which require high data throughput. Any one drive in a RAID 3 set can fail without loss of data. The bad unit can be replaced and the RAID set restored. If two or more drives fail, the entire data set is lost.

RAID 5 uses data striping at the byte level, parity being striped across the available drives. This strategy provides high performance and good fault tolerance. RAID 5 is the most popular implementation of RAID. Applications include servers, whether being used for files, databases, web, email or intranet. Like RAID 3 any single drive failure can be tolerated and the RAID restored.

RAID 6 is similar to RAID 5 only using block level striping and two parity schemes, providing greater fault tolerances. Its uses are similar to those of RAID 5. By creating a second level of parity, up to two drives may fail without the loss of data. However, this extra protection comes at the cost of reserving twice as much space as RAID levels 3 and 5 for parity data.

Other RAID formats combine the basic ideas above in combination.

RAID 0 + 1 employs RAID 0 striped arrays which are then mirrored as RAID 1 arrays. Applications for this would include a need for high performance without the need for the highest reliability.

RAID 10 uses striping and mirroring to achieve its reliability and performance. In essence it is comprised of RAID 1 arrays that are then striped as in RAID 0. The applications for this are database servers with a need for the high throughput of RAID 0 and the high fault tolerances provided by RAID 1. It is very inefficient in its use of storage, requiring a minimum of two drives for each RAID 1 segment.

RAID 30 is a combination of RAID 3 and RAID 0. While expensive, it offers extremely high levels of throughput and fault tolerance.

RAID 50 is achieved by a combination of RAID 0 striping and RAID 5 parity implementations. It is appropriate in applications that need the benefits of RAID 5 but with additional throughput.

There are several other variations of RAID combinations used to serve specific needs in data handling. Details of these combinations can be found at a number of different sources specific to its application such as libraries, hardware manufacturers and financial and educational institutions.

While there are many options to record and store video material, as you have learned throughout this book, technology is changing at a very rapid rate. But new technology typically grows out of the formats and devices that are currently in use. So by learning how technology has progressed to where we are today, and the variety of uses in today's video world, you will create an excellent foundation for understanding the technology of tomorrow.

Streaming Media 21

The delivery landscape of broadcast television has expanded from the traditional digital terrestrial, satellite and cable television methods to include streaming media. With streaming media, consumers don't have to be tied to the TVs in their living rooms or the rigid time slots dictated by broadcast television to savor their video entertainment. They are free to *time shift* or watch shows at a later time, or to *place shift* by watching from a different location, or *device shift* and watch shows on devices other than a TV such as a mobile phone, tablet, or computer. To provide this abundance of flexibility, there is *format shifting*, where media files are converted into different formats to satisfy the needs of the specific playback device or situation. Welcome to the shifting face of TV.

What is Streaming Media?

Later in this chapter, you will learn how broadcast television utilizes streaming video. But first, let's take a few steps back and look at what streaming is and how it has become such an important part of the video world.

Figure 21.1 Streaming a Movie on a Mobile Device

Streaming is the process of delivering media over the Internet as a continuous stream of data in a compressed form. As the media begins to arrive, it is displayed on a viewing device in real time, but it is not saved to the device's hard drive. To view the media, the end user needs a special piece of software called a *player* that decodes or un-compresses the data sending the video to the device's screen and audio to the device's speakers (Figure 21.1). Players can either be downloaded from a particular software maker's Web site, or they can be an integral part of a browser such as Internet Explorer, Safari, Chrome or Firefox, or part of an Internet-connected device.

NOTE The term "streaming media" does not refer to the type of media, but only to the delivery method of that media.

Streaming media has some very distinct advantages for both viewers and content deliverers. Viewers can perform customized searches for videos and create playlists. Content deliverers are able to collect data on what visitors are watching and for how long.

They can utilize bandwidth more efficiently because the viewer can begin watching the movie or media without it being fully downloaded first. The content creator also benefits because they have far greater control over their intellectual property. Once the video data is played, it is discarded by the media player and not stored on the viewer's computer.

The History of Streaming Media

In today's world, consumers take audio and video streaming for granted as access to the Internet is now pervasive. But where did streaming begin? Streaming media may have actually gotten its start as early as 1920 when Army Major General George O. Squier perfected a technology for streaming continuous music to commercial customers without the use of radio. He did this by transmitting music across electrical wires. This technology led to the development of his company, Muzak, which led to what is referred to today as *elevator music*. Since radio was also on the horizon at the same time, the General had to find other uses for his technology, such as providing background music for stores, restaurants, and elevators in office buildings, thus the reference to "piped-in" elevator music.

Fast forward to 1993, when scientists, wanting to prove their new multicasting technology worked, broadcast a performance by the band, Severe Tire Damage, over the Internet. In 1994, the Rolling Stones broadcast one of their concert tours on the Internet. The image, however, was quite small, about 1.5×1.5 inches, and could not be displayed at full speed, only about 1–10 frames per second. Other streaming events trickled out and in 1995, a new company by the name of RealNetwork Inc. (called Progressive Networks at the time) provided an Internet audio broadcast of a baseball game between the New York Yankees and the Seattle Mariners. This

became a defining moment in audio streaming history. In 1997, RealNetwork launched streaming video technology.

By the year 2000, RealNetwork became a powerhouse streaming content provider accounting for more than 85% of the Internet's streaming content. RealNetwork accomplished this feat in three short years by providing a free audio/video Real player for PCs using the Windows operating system. At the same time, Microsoft started seeing the advantage of having its own player.

Although the Real player was free, it began to lose its marketplace share to Microsoft. Consumers started objecting to the third party Real player making itself the default player for all multimedia content, as well as the multiple background processes upon installation and the message pop-ups to upgrade. It soon lost its appeal and went from being the essential player to being dropped by the consumer virtually overnight.

The Microsoft Era

From 2000 to 2007, Microsoft dominated the computer marketplace. Having the lion's share of the personal computing market vaulted the Windows Media Player to the forefront, which made it the most widely used multimedia delivery format on the Internet as well as most company's intranets. The player was non-customizable and it required a third party plug-in that enabled it to play on a Mac, which had a much smaller share of the market.

During the same time period, *HTML* (Hyper Text Markup Language)—the language of the Internet—was facing a challenge from a new language called *Flash*. The beauty of Flash was that it had greater

design flexibility and was far more interactive than HTML. Although Flash had a video component, it was not a good performer and offered poor quality video and audio with sync issues. In 2005, the inventors of Flash, Macromedia, licensed a video compression codec called VP6 from On2 Technologies. This new codec greatly improved the audio/video synchronizations of Flash allowing Macromedia to give Microsoft a run for their money.

NOTE The On2 Technologies development of the VP6 codec made such a major contribution to streaming media that Google purchased the company in 2009. Since Google's acquisition of On2, they have continued to develop the VP codec and are currently licensing it as open source technology.

The Flash Era

Shortly after Macromedia licensed the VP6 technology, its rival, Adobe, purchased Macromedia. Adobe then enabled their Flash Player to match the video quality of Microsoft's brandable player allowing for full integration into Flash-based sites. This game changer made Flash a truly cross platform delivery system that became the most prevalent streaming technology of the day.

In 2007, Microsoft tried to counter with a Flash competitor they called Silverlight, but by then most of the entertainment and broadcast sites were heavily invested in Flash. Silverlight never achieved the market penetration Microsoft had hoped for and their share in these markets decreased to single digits in 2010.

In April, 2010, while Microsoft's numbers were declining, Apple introduced the iPad, which had no support for Flash. Instead, the video playback technology on Apple's iOS devices was HTML5, a

newly updated version of the old web language. Apple changed the playing field yet again because unlike the plug-in based technologies of Flash, Windows Media or Silverlight, HTML5 uses a browser's native player to play back embedded video and audio files from websites such as YouTube.

The HTML5 Video Era

Today there are many languages used to create websites, but HTML (Hyper Text Markup Language) was the start of it all. The newest version of HTML5 has many advantages that make delivering multimedia, also called rich content, much simpler. Viewers no longer need to download a plug-in in order to watch a YouTube video or listen to streaming music.

As of October, 2014, HTML5 has been accepted by the World Wide Web Consortium (W3C) as the core language of the Internet. It bridges the gap between computers and mobile devices to provide a consistent user experience across any device. As more users move away from their desktops and embrace and rely on the mobile Web, the many benefits of HTML5 will give companies the opportunity to create new and exciting interactive online experiences using any HTML5 compatible browser.

```
<video width="320" height="240" controls>
<source src="movie.mp4" type="video/mp4">
 source src="movie.ogv" type="video/ogg">
<source src="movie.webm" type="video/webm">
```

Figure 21.2 HTML5 Media Elements in Code

Streaming Technologies

Applications such as Apple's QuickTime, Adobe's Flash and Microsoft's Windows Media and Silverlight streaming technologies have certain components in common. Each of these streaming technologies include a player to play the media on the viewer's device, a defined file format or formats that the player can play and a server component that may offer live streaming or digital rights management (DRM) features to prevent copying, which protects the content owner's intellectual property.

All of these streaming technologies use codecs, or video and audio compression schemes, to shrink the size of the files so they can be streamed and played by the user in real time. Some common video compression codecs include MPEG-4, H.264, VP6 and VP8, Windows Media Video (WMV), Google's WebM and H.265, which is the newest video codec to emerge on the market. Some common audio codecs include AAC (Advanced Audio Coding), Windows Media Audio (WMA) and MP3.

Streaming Media Types

Media streams can be either live or on demand. Live streams, or *true streaming*, does not save the file to the device's hard drive. Instead, the file is only available to be viewed while the event is in progress, such as a live sports cast.

On-demand streams are usually saved to hard drives or servers for extended periods of time to be played back from that location later. This method is referred to as *progressive streaming* or a *progressive download*. With this progressive download method, the user is

allowed access to the content before the data transfer is complete. Also since the data is saved to the user's hard drive, it will stream more smoothly and is less susceptible to interruptions. There are several types of live or on-demand streaming:

Live Streaming Video is video delivered via a streaming server or a software program that is dedicated solely to delivering streaming media through a special server. This differs from a traditional web server that delivers all forms of web content including but not limited to still images, movie files and PDFs.

Video on Demand (VOD) is an interactive TV technology subscription model whereby viewers can watch programming in real time or switch to viewing archived media from a library of prerecorded content whenever they want (Figure 21.3).

Figure 21.3 Many Sources Available through Video On Demand

Streaming Archive allows viewers or listeners to watch or hear any program material available for a fixed period of time on a provider's server.

Adaptive Streaming is really the best of both worlds, especially for lower bandwidth mobile devices or Wi-Fi. Multiple live or on-demand streams are encoded and then switched based on the device's connection speed, hence the name. When the connection is good, like on a powerful PC with a high-speed Internet connection, the viewer will receive a high-quality signal with a high data rate. But if the connection speed of the device drops, the video server detects the drop in speed and shifts gears to deliver the same file with a lower data rate. This keeps the video signal streaming at a passable quality on the slower connection, for example on a mobile phone, hopefully without interruption. Some of the adaptive streaming outlets include Apple's HTTP Live Streaming, Microsoft's Smooth Streaming and Adobe's Dynamic Streaming.

Over-The-Top Content (OTT) refers to the delivery of video and audio content over the Internet by a third party online video rental Web site or subscription service—such as Netflix, Hulu or myTV—without the need for cable or direct satellite broadcast being involved in either the control or distribution of the content. The Internet Service Provider, or ISP, is responsible for transporting only the IP packets of data to the end user's device. OTT content is accessed using apps through Internet-connected devices such as computers, tablets and smartphones or set-top boxes such as Roku, Google TV, smart TVs and a number of gaming consoles such as Nintendo's Xbox 360, the Sony PlayStation 3 and Wii.

An *Online Video Distributor* (OVD) is any distributor, for example YouTube Insight, that offers Internet-based video content provided by a person or company that is not affiliated with the OVD. There

are several services that with one click allow the content creator to spread their content across a number of video hosting services. This batch upload approach saves the content provider time and also allows them to promote their material with tags and descriptions. In some cases, it may even allow the provider to track the viewership and downloads of their videos with a simple interface.

Video and Audio Streaming Files

You have very likely viewed a program in one of the ways described above. But how does the media file itself reach its destination—you, the consumer. Let's say you visit a web page hosted on a Web server to find a file you want to see or hear. The Web server sends a message to the Streaming media server requesting the specific file. The Streaming server then streams the file to your computer bypassing the Web server. The client software on your computer decodes and plays the file. The same process applies to streaming media received through any device.

While a streaming file is small in size and efficient to transmit, it usually begins as a larger high-quality file. For example, if the file came from post production, it may have left the edit system in a mastering codec such as Apple's ProRes or Avid's DNxHD. From there it may have been compressed to an intermediate level before it went to the web server provider to be compressed in several versions for final delivery.

The process of compressing a file to make it smaller throws away information that is not needed to reproduce the video or audio. Before a file is compressed, however, its file size can be reduced without the loss of quality by either making its resolution smaller or by reducing its frame rate. Using these methods to reduce the file

size before compression means that the streaming file can be even smaller with a better video and audio quality after compression.

NOTE The small file is needed to lower the data transmission rates to the consumer taking into account their limited bandwidth to receive it.

The Evolution of Audio Streaming

The current state of streaming audio had its inauspicious beginnings in a free peer-to-peer MP3 audio file Internet download sharing service called Napster, which launched in 1999. It could be said that Napster was the first popular pirate music site. Napster's original premise was designed to make it easy for music enthusiasts to share their purchased music, older songs that were hard to find, unreleased recordings and bootleg recordings of concerts with their peers who could also upload and download their musical libraries to a central repository and trade music for free. If you could turn it into a digital file and get it on a computer, you could share it. Instead of having to buy an entire album, you could use Napster to get only the songs you wanted to have in your collection.

While this free music-sharing site was a technological innovation, it was a blatant copyright infringement against the recording artists who were not getting revenue from these shared files. In July 2000, a court order forced Napster to cease operations. Although it was determined to be illegal, Napster's new approach to sharing music was exceedingly popular and it forced the music industry to change the way consumers purchase their music.

Enter Apple. In 2001, Apple launched their media player, iTunes, which also served as a library to organize music. Shortly after,

they released their line of portable media players called iPods, and the two were a perfect match. In 2003, Apple launched the iTunes Music Store, which allowed the consumer to either purchase an entire album from an artist for a reasonable price or purchase a single song for only 99 cents. This game changer was the legal answer to Napster as the consumer was now back in control of their music and the music industry was receiving revenue.

In 2009, Apple changed the playing field again with its improved iTunes Store, which allowed users to download music, TV shows, movies, podcasts, audio books, and more to smart phone and other devices. This integrated system business model is not only a media player and library but it is also a management application for mobile devices as well. While the iTunes Music Store originally used the older MP3 audio file format, in 2004, it began to use the more efficient AAC audio compression scheme. This helped save disk space and battery life while getting an improved audio file quality overall at lower data rates than MP3.

During this time, Napster was still in the picture. It had redesigned itself as a subscription service with a healthy number of subscribers. In 2008, the electronics retailer, Best Buy, purchased Napster's library of songs. But, by 2011, Best Buy had sold Napster to Rhapsody, a company that was originally owned by RealNetwork. With this acquisition, Rhapsody became the first streaming on-demand music subscription service offering unlimited download access to a very large library of digital music for a flat monthly fee instead of the per-song or album purchase model being used by Apple's iTunes.

In the strictly streaming category—that is, ad free, or subscription supported—there is Pandora Internet Radio. Pandora took things

in a slightly different direction by upping the audio streaming game with a technological advance called the *Music Genome Project*, which is "feature recognition" technology similar to what is used for face recognition in pictures. With this approach, over 450 different musical attributes or "genes" are considered when selecting the next song—genes being characteristics of music, such as gender of lead vocalist, type of groove, and so on. Pandora learns the listener's preferences and then filters the catalog lists towards their preferences. The Pandora media player is based on an open-source app development platform called OpenLaszlo and can be accessed via any streaming media device. No downloads here!

We have now come full circle with Spotify. While Napster was responsible for shining the light on the music supply and demand disconnect, Spotify is leading the charge to legitimize music streaming and downloading. Spotify has impacted the world of audio streaming by making an ethical appeal to young people to abandon piracy and pay for their music service instead of pirating it like Napster users did years ago. Spotify's goal is to re-grow the music industry by creating Premium subscribers who will help to re-monetize the streaming audio music business with higher royalty payouts to publishers and artists through advertisers and subscribers.

> **NOTE** Young people are listening in more ways than one as over 50% of Spotify's paying subscribers in 2014 were under the age of 29.

The digital delivery of music and other audio media has been based on rapidly evolving technologies and new business models. These same technologies and business models have also paved the way for streaming video.

The New Face of Television

There has been an explosion in the amount of TV available to the consumer in the last few years as the delivery methods have expanded from the standard broadcast, cable and satellite methods to include a delivery system called Internet Protocol Television, or IPTV. Through IPTV, television services are delivered or streamed over broadband IP networks to your home or mobile device.

NOTE Broadband Internet is a high-speed Internet service that comes in four different forms: DSL (or Digital Subscriber Line), fiber-optic, cable, and satellite. The only non-broadband Internet service is the old *dial-up* connection, which is not effective for delivering streaming media. In early 2015, in an effort to ensure all Internet traffic is treated equally, the FCC passed a proposal to prohibit broadband providers from blocking, slowing down or speeding up specific websites in exchange for payment.

IPTV services are comprised of three main groups. The first group is *live television* that may or may not have social media interactivity related to the current TV show. *Time-shifted television* is the second group that contains two categories: *catch-up TV* which replays a show that was initially broadcast hours or days ago and *start-over TV* which replays the current show from its beginning. The third group is *Video on Demand* (VOD), which allows the viewer to browse a catalog of previously recorded videos that are not being broadcast at the moment.

Professional streaming video services, such as Amazon Instant Video, Netflix, Hulu Plus, Crackle and Blockbuster On Demand, fit into the time-shifted and VOD groups that offer the consumer the freedom to watch movies and TV shows when they want on a multitude of devices.

Figure 21.4 Concertgoer Shooting Event on Mobile Phone

In addition to the professionally created content available, social media sites such as YouTube, Vimeo, Facebook, and Flickr, allow consumers to share their own video content created with inexpensive webcams, digital cameras and their mobile phones (Figure 21.4). As of 2014, this consumer-driven content represented 87 percent of the total Internet traffic worldwide. This user-generated content, combined with the IPTV delivery systems, is causing younger audiences to lose interest in the old broadcasting services, which in turn is causing broadcasters to completely revise their business models to increase their audience.

Broadcast TV and Cable Goes Streaming

Cable television saw a steady growth, alongside broadcast television, over the second half of the 20th Century. When satellite TV came on the scene in the late 1970s, it became a competitive option and vied for viewership and households. But since video is now being delivered as streaming media, the goal of content providers, such as ABC, CBS, HBO, and so on, is shifting from household delivery to giving viewers access to content whenever and however

they want to see it. The media and cable executives are seeing this as a business opportunity to make more money by selling à la carte programming via streaming video directly to the consumer, bypassing the cable and satellite companies.

The television viewing demographics are also shifting. Younger audiences are less likely to subscribe to a higher cost cable or satellite package to view their favorite shows, especially with all of the programming out there on far less expensive streaming media sites such as Hulu and Netflix. To this end, HBO has announced that in 2015 they will start selling an Internet-only subscription to their movies and shows far below the price point of cable and satellite bundling fees. This way viewers who are only interested in watching specific programs, such as "Game of Thrones" or "Girls," can get the HBO shows directly via an online subscription without having to purchase dozens of unwanted channels. CBS has also announced that they will begin selling their programming online for a small monthly fee. However, CBS will withhold live events, such as pro football, from its "CBS All Access" subscription because sports are a huge ad revenue generating income stream.

Streaming Media Devices

When this book went to press, about 7.6 million households in the United States have made the shift from watching traditional broadcast, cable or satellite television to viewing their programs and movies over the streaming Internet via Wi-Fi to their TV sets. And, with the rise of streaming media services such as Hulu Plus, Netflix, Amazon Instant, Spotify and Pandora, the days of disk-based-media like DVDs and CDs are beginning to wane.

There are many types of streaming media devices available—such as streaming boxes (Roku3, Apple TV and Amazon Fire TV) for under

Figure 21.5 Streaming Media Devices

$100, sticks such as Google's Chromecast, game consoles such as Xbox360, Playstation 3 and Wii, Smart TVs, tablets, smart phones, home theater devices and Blu-ray players—all of which are capable of delivering streaming media content to the consumer (Figure 21.5). Some of these devices stream media from the web while others are also capable of displaying media from the consumer's local media collection as well.

No matter the device, they all play video at 1080p and have in common the same VOD services, the ability to play music and games, while still others can play live streaming events. Some devices such as the Amazon Fire TV, stand out with additional features like 8 GB of on-board storage space, a voice activated remote control, quad-core processors, 2 GB of memory with a dedicated GPU that is great for gaming, plus Dolby Digital surround sound and optical audio outputs.

In contrast, Google's Chromecast, referred to as a stick, looks like a small USB thumb drive but it is actually a dongle which is a small piece of hardware that contains secured software that will only run when the device is plugged in to a computer or an HDTV that has been registered with Chromecast. Chromecast is also not a standalone device, as it requires a mobile device like a smartphone, tablet, or PC in order to watch streaming video.

The rapid evolution of streaming media devices has joined with the rapid evolution in the delivery technologies to provide todays' entertainment viewer with a wide range of not just video programming options, but viewing devices. These devices can be either fixed like computers and TVs or mobile devices like smart phones and tablets, thereby dramatically increasing both the viewing options and the consumption of streaming media.

Summary

In summary, there are many delivery methods available today used to receive streaming content and many Internet-connected devices capable of displaying that content—from computers to smart phones and smart TVs, tablets, gaming consoles, set-top boxes, DVD players and everything in-between. With technological advances in computer processing power, standardization of delivery systems and players, highly improved video and audio compression codecs and the explosive growth of the Internet, the ability to stream media has become a commonplace phenomenon.

Streaming media promises to change the landscape of broadcast and cable television. So stay tuned!

Glossary

4:2:0 A chroma subsampling scheme. For every four samples of luminance taken, two are taken for each color difference signal, but only on every other scan line. (See 4:2:2.)

4:2:2 A chroma subsampling scheme. For every four samples of luminance taken, two are taken for each of the color difference signals on each scan line.

4:4:4 A chroma subsampling scheme. For every four samples of luminance taken, four are taken for each of the color difference signals on each scan line.

Active Video The portion of the video signal that contains program material.

Additive Color System The color system in which adding all colors together produces white. It is an active color system in that the object being viewed is generating the visible light as opposed to reflecting another light source. The television system is an additive color process.

AFM (Audio Frequency Modulation) A method, developed by Sony, for recording audio in the video track of a BetaSP recording. The AFM channels yield a higher quality audio signal than the standard longitudinal audio tracks. Unlike the longitudinal audio tracks, these tracks can only be recorded along with video.

Aliasing The distortion or artifact that results when the signal reconstructed from samples is different from the original continuous signal.

Amplitude Modulation (AM) A change or modulation in the height or amplitude imposed on a carrier signal. The changes in amplitude are analogous to voltage variations in the signal.

Analog In television, a signal that uses continuously varying voltage to represent the outputs from equipment for the purpose of recording, playing back, or transmitting.

Aperture The dot of electron illumination in a tube type camera that occurs where the beam intersects the face of the target. In analog video, the dot or beam aperture is the smallest size that an element of picture information can be.

Audio Over Ethernet Encoded audio signals using the standards and conventions of computer networking.

Artifacts Errors in the video, which might include chrominance smear, lag, blocking and chrominance crawl.

Aspect Ratio The mathematical relationship between the width and the height of an image. The standard NTSC, PAL, and SECAM analog aspect ratio for television is four units wide by three units high, shown as 4×3. The aspect ratio for High Definition television is 16×9.

ATSC (Advanced Television Systems Committee) The next generation of the NTSC, it is the group responsible for the creation of digital SDTV and HDTV standards in the United States.

B Frames The bi-directional frames indicated in an MPEG compression system. The data they contain is extracted from the previous and/or following frames and thus are referred to as bi-directional. These frames cannot stand alone, as they contain only portions of the video data from each frame.

Back Porch The period of time during horizontal blanking that follows the horizontal sync pulse and continues to the beginning of active video.

Bandwidth The amount of spectrum space allocated to each television channel for the transmission of television signals.

Base line Base line refers to the zero-units line of the video signal as seen on a waveform monitor.

Beam A stream of electrons, called the *beam*, comes from the back end of the tube and scans back and forth across the face of the target on the inside of the pickup tube.

Beam Splitter In a three chip camera, a beam splitter is an optical device that takes the light coming in through the lens and divides or splits it. It directs the light through filters that filter out all but one color for each of the camera chips.

Binary A system of numbers consisting only of zeros and ones. The language in which computers store and manipulate information.

Bit In digital or computer information, a zero or a one.

Bits Per Second (bps) Data communication speeds are measured as so many bits per second (bps).

Bit Rate The number of bits per second, expressed as bps, moving through a digital system.

Bit Stream An encoded compressed stream of video.

Black Burst An analog composite signal that combines the color subcarrier, horizontal sync, vertical sync, blanking, and a black video signal. It is also known as Color Black.

Black Level The measurement of the black portion of the video signal. In an analog television system, this should not go below 7.5 IRE units. In a digital video system, black may not go below 0 units.

Blu-ray Disc (BD) A type of DVD technology that employs a blue-violet laser beam with a wavelength of 405 nm.

Breezeway The part of the horizontal blanking period that goes from the end of the horizontal sync pulse to the beginning of the color burst cycle.

Burst (Color Burst) Eight to eleven cycles of pure subcarrier that appear on the back porch during horizontal blanking. The burst is used as a reference to synchronize analog color circuits in a receiver with the transmitted color signals. It is not modulated and does not have any of the other chroma information in it, such as hue and saturation.

Calibrate The process of standardizing a reference tool, such as a vectorscope or waveform monitor, so that any signal information that is displayed is measured accurately.

Cathode Ray Tube (CRT) The cathode ray tube (CRT) is a vacuum tube containing one or more electron guns, and a fluorescent screen used to view analog images.

Captioning/Closed Captioning Developed to aid the hearing impaired, the process of encoding and decoding typed text so that it may be displayed on a receiver or monitor. In the NTSC closed captioning system, the data is incorporated on line 21. Digital signals carry the data as part of the Ancillary data space.

Charge Coupled Device (CCD) A camera imaging chip consisting of multiple sites operating as capacitors that convert light energy to electrical charges.

Chroma Subsampling The sampling of the color or chroma information in an image. Chroma is sampled less often than the luminance to reduce the amount of data to be stored or transmitted.

Chrominance Pure color information without light or luminance references.

Codecs The many different algorithms used to compress video. The term was derived from the words <u>co</u>mpression and <u>de</u>compression.

Coherent Light Light that has a single, specific frequency.

Color Bars A test signal that provides the necessary elements for visual setup of video equipment. The basic display includes a

white or video-level reference, black-level reference, chroma levels, and hue information. Additional elements also may be included.

Color Black An analog composite signal that combines the color subcarrier, horizontal sync, vertical sync, blanking, and a black video signal. It is also known as Black Burst.

Color Correction The process of correcting the mix of variable colors in any scene of video, generally handled by a software program, such as DaVinci Resolve, during post production.

Color Difference Signal The calculation of the quantity of chroma information in the signal minus the luminance (Y) information (i.e., R-Y, B-Y, and G-Y).

Color Encoding Translating the color video information from its original state to a condensed form for recording and transmitting.

Color Frame The phase or direction of the subcarrier signal with respect to the lines and fields that make up the color picture. In the NTSC system, the color frame is determined by the phase of the color subcarrier at the beginning of line 10 of the first field of each frame. In the NTSC system, there are four fields to the color frame cycle. In the PAL system, there are eight fields to the color frame cycle.

Color Gamut The allowable range, minimum and maximum, of the color difference signals. Within this range, colors will be reproduced accurately on a picture monitor or receiver. Outside this range, certain colors may be either distorted or not reproduced at all.

Color Subcarrier An additional carrier for the color information that is transmitted and recorded within the main carrier of the analog video signal.

Combing When interlaced material is presented on progressive displays, it can lead to a distracting artifact called *combing*. This leaves fine lines extending from areas of fast motion similar to the teeth of a comb.

Component A format of video that has three separate elements. In component video, these elements include either Y (luminance), R-Y, and B-Y (the color difference signals), or R, G, and B (the individual color signals).

Composite A complete analog video signal that includes all sync signals, blanking signals, and active video. Active video contains luminance and chrominance information encoded into one signal. Composite sync includes horizontal and vertical sync, blanking and color burst signals

Compression The process of reducing data in a digital signal by eliminating redundant information.

Constant or Variable Bit Rate Two different ways to control the flow of bits in a compressed signal. Constant bit rates can be used to compress images in real time, whereas variable bit rates cannot.

Control Track A recorded signal on videotape that allows the VTR scanner or head to align itself with the beginning of each video track. One control track pulse occurs for each revolution of the scanner.

Cross Pulse A monitor display that shows both the horizontal and vertical blanking periods. Also known as Pulse Cross.

Decibel A logarithmic relationship between two power values. In audio it is used to measure the intensity of sound, notated as dB. There are several variations of decibel measurements. For example, a sound 10 times more powerful than 0 dB is 10 dB, and a sound 100 times more powerful than 10 dB is 20 dB.

Decoding The process of reconstituting recorded or transmitted information that has been encoded back to its original state.

Demodulate To take a modulated signal that is imposed on a carrier and recreate the information it represents in its original form.

Diamond Display A display on a vectorscope for the RGB color component signals that indicates the valid limits for the color gamut.

Dichroic The filters inside a chip camera that filter out two of the three colors.

Digital A system that uses binary bits or digits (zeros and ones) to represent sine wave or analog information.

Dolby Developed by Ray Dolby and Dolby Laboratories, it was originally a technique for audio noise reduction. It is also a standardized system for 5.1 channel surround sound called Dolby Digital AC-3.

Downconverting Converting a video signal from a scanning standard with a higher pixel count to one with a lower pixel count.

Downlink A facility for receiving signals from a satellite.

Downsampling Reducing the size of a dataset by reducing the number of samples used to represent the signal. In digital imaging this will result in lost detail.

Drop Frame A type of timecode in which the timecode generator drops, or actually skips, two frame numbers, 00 and 01, every minute except the 10th minute. Drop-frame timecode is clock accurate.

Electron Beam A stream of electrons used to convert light energy to an electrical signal, as in a camera pickup tube, or to convert electrical energy to light, as in a monitor or cathode ray tube.

Electron Gun That part of the pickup tube or receiver that produces the electron beam.

Encoding The process of conforming audio or video to the form required for a specific process or device. In digital this usually refers to compressing to a specific codec.

Equalization The boosting or attenuating of certain frequencies when a signal is recorded or played back so as to more accurately represent or purposely alter the original signals.

Equalizing Pulses Pulses that assure continued synchronization of the video signals during vertical retrace as well as proper interlace of the odd and even fields of analog video.

External Sync A synchronizing reference that is coming from an external source.

FCC (Federal Communications Commission) The commission that regulates the practices and procedures of the communications industries in the United States.

Field One half of a scanned image formed by alternating scan lines. A field can be referred to as an odd field or an even field. In the NTSC system, each field is made up of 262½ lines. There are 2 fields per frame and 60 fields per second. In the PAL and SECAM standards, there are 312½ lines per field, 2 fields per frame, and 50 fields per second.

File Wrapper A delivery container that encapsulates audio, video and metadata.

Flash Designed by Adobe, this was originally an animation container but is now also used for video.

Flash Memory A solid-state recording media using EEPROM (Electrically Erasable Programmable Read-Only Memory).

Footprint The area of the earth that a satellite signal covers.

Frame The combination of the odd and even fields of a video signal. In each frame of NTSC video, there are 525 lines of information, and there are 30 frames in a second. In the PAL and SECAM standards, there are 25 frames per second, each frame containing 625 lines.

Frequency Modulation (FM) A change in the frequency of the signal imposed on a carrier. Frequency changes reflect voltage variations from the output of the originating source. In television, it is the method used for recording analog video information on tape and for the transmission of audio signals.

Front Porch In the analog video signal, that period of time during horizontal blanking that starts at the end of active video and continues to the leading edge of the horizontal sync pulse.

Full Raster The digital image contains the full number of horizontal pixels in an image. See Thin Raster.

GOP The defined Group of Pictures used in the MPEG compression process. The GOP will contain an I frame and may contain B frames and P frames. The group may consist of as few as 1 frame or as many as 30 or more.

Graticule A lined screen in front of a CRT on a waveform or vectorscope, which is used to measure and define the specifications of a signal.

Geosynchronous When satellites are placed in orbit, they are set in motion to move at the same speed as the rotation of the earth, making them stationary above the earth. The geosynchronous orbit is about 25,000 miles above the earth.

Gigabyte (GB) A thousand megabytes, or a thousand million, which is a billion.

Harmonics The multiplication of frequencies achieved by adding the initial frequency or fundamental to itself in an arithmetic progression.

HDTV (High Definition Television) The high-resolution standard for video. HDTV includes a high pixel count, increased line count, and a wide aspect ratio (16×9).

Hertz Anything measured in "cycles per second" or the number of changes that occur within one second.

Head Individual parts of a magnetic recording device that erase, record, or play back signals on a magnetic media.

Histogram Display A graph that plots the number of pixels in an image at each possible value. Often used in digital photographic systems to measure proper exposure.

Horizontal Blanking In analog video, the period of time in which the electron beam is turned off while it is repositioned to start scanning the next line.

Horizontal Resolution The amount of detail that can be achieved horizontally across an image. This is generally measured as the number of vertical lines that can be accurately recreated horizontally across the screen. In film it is measured in the number of lines per millimeter. In video it is measured by the frequency of the signal that can still be seen as individual black and white lines.

Horizontal Synchronizing Pulses That part of the analog video signal that ensures that all of the equipment used in the creation, transmission, and reception of the video signal is synchronized on a line-by-line basis.

HTML (Hyper Text Markup Language) One of the primary computer languages used on the Internet.

Hue A specific color or pigment. In television, one of the elements that makes up the composite color signal. Hue is represented by the direction of a vector on the vectorscope.

I Frame In the MPEG compression process, the I frame, or intra-frame, contains all the image data and needs no reference to the preceding or following frames. Used as the reference frame for the creation of the B and P frames.

Image Resolution The amount of detail contained in a video image based on the number of lines in the image and the number of pixels per line.

Incoherent Light Ordinary light, such as a light bulb.

Infrared Frequencies above 100 gigahertz and below 432 trillion hertz. Infrared is above the broadcast spectrum and below the visible spectrum. Infrared can be felt as heat.

Interframe Compression A compression scheme that reduces the amount of information required to describe a sequence of images by only preserving the information about what has changed between successive frames.

Interlace Scanning The process of combining two fields of video information. One field has the odd lines of the scanned image and

the other field has the even lines. The two fields are interlaced together to form one complete image or frame of video.

Internal Sync The sync signal that is part of the composite video signal in analog video.

Intraframe Compression A compression scheme that reduces the amount of information that makes up an image without reference to any other frame before or after in time.

Intra Picture One frame that is a complete image sampled in detail so it can be used as a reference for the frames around it during the compression process. Also referred to as I frame.

IRE A measurement of units of video information on the waveform monitor graticule. One volt of video is divided into 140 IRE units. IRE is named after the Institute of Radio Engineers,

JPEG Named after the Joint Photographic Experts Group, a process of lossy image compression used for still images.

Kinescope An early process of capturing live television programs on film as a way to to archive them.

Line Frequency In the NTSC monochrome system, 15,750 lines per second, a multiple of 525 lines per frame at 30 frames per second. In the NTSC color system, approximately 15,734 lines per second, yielding 29.97 frames per second.

Linear Timecode (LTC) The original format for timecode recorded as an audio signal. It is also referred to as Longitudinal Time Code.

Logarithrms A mathematical calculation used to simplify large calculations.

Longitudinal Timecode (LTC) Timecode recorded and reproduced as an audio signal.

Lossless Compression In lossless compression, the restored image is an exact duplicate of the original with no loss of data.

Lossy Compression In lossy compression, the restored image is an approximation, not an exact duplicate, of the original.

Low Frequency Effects (LFE) The sixth channel in the 5.1 surround-sound audio system.

Low Pass A filter that allows luminance data to pass, but filters out the higher frequency color information.

Luminance The amount of white light in an image.

Macroblocks In compression, an I frame is divided into 8×8-pixel blocks and placed in groups of 16×16 pixel blocks called macroblocks.

Main Profile at Main Level (MP@ML) Main Profile means that I, B, and P frames can be used for compression, and Main Level means that the picture resolution is 720×480 in NTSC.

Media Exchange Format (MXF) A video wrapper defined by SMPTE to meet the needs of media production workflows.

Megabyte (MB) One thousand kilobytes.

Metadata Additional information that is added to the serial data stream that provides data about the picture and sound for display and other devices.

Mezzanine A moderate level of compression that is an intermediate format between uncompressed footage and highly compressed distribution codecs.

Modulated Carrier A specific frequency upon which changes have been made to carry or transmit information. There are many ways to modulate a carrier such as AM, FM, 8VSB and CODFM.

Motion Vectors During the compression process, the descriptions of distance and direction of macroblock movement within I, P or B frames are called motion vectors.

MPEG MPEG is the name of the standards group, Moving Picture Experts Group. The name is also used to describe a family of data compression schemes used in motion imaging.

MP3 (MPEG Audio Layer 3) An audio compression standard generally used to reduce the storage requirements for music.

Multicasting The transmission of more than one signal in the same spectrum space.

Non-Drop Frame A type of timecode used to label every video frame in numerically consecutive order. It is not altered to reflect the slower frame rate of color television, i.e., it is not clock accurate.

NTSC Named for the National Television System Committee, a method for creating composite analog monochrome television. Also, a method used to create color television based on color difference components modulated on one color subcarrier.

Octave In electronics, like music, a doubling of a frequency.

Oscilloscope A type of measuring tool that uses a video display to view and measure signal strength, frequency, and amplitude.

One Volt "Peak-to-Peak" The strength of a video signal measured from –40 IRE units to 100 IRE units in analog. In digital video, one volt is measured in millivolts, from –300 to 700 millivolts.

P Frames In the MPEG compression process, the P frames, or predictive frames, contain only data that is different from the I Frame. They are not complete images and cannot stand alone.

Packets In the data stream, after the data has been segmented to prepare for transmission, it is inserted in a packet. Packets are then contained in frames.

PAL Phase Alternate Line, a method for creating composite analog color video. The PAL system makes use of two color subcarriers simultaneously that are phase inverted from each other on alternate scan lines.

Pan and Scan The process of panning—or moving horizontally across an image—that can be applied during video transfer to reveal a particular portion of the widescreen image.

Parade Mode A display on a waveform monitor that simultaneously displays the luminance signal and the two color difference signals in sequential order.

Parity A function that provides a check on a set of binary data, for example by notating if it has an even or odd number of ones.

Pedestal The black level in the video signal. Also called Setup.

Persistence of Vision The period of time that the retina, or light-sensitive part of the eye, retains an image. The phenomenon that allows a sequence of individual images to be perceived as continuous motion.

Petabyte (PB) A thousand terabytes, which is a thousand trillion, or a quadrillion.

Pickup Tube The tube inside an analog camera that converts light into an electrical signal.

Pillar Box If the top and bottom of a 4 × 3 image is enlarged to touch the top and bottom of the 16 × 9 raster, an empty area will remain on the left and right of the image. This is referred to as Pillar Box.

Pixels Picture elements, the individual elements that make up a digital image.

Pixel Aspect Ratio How the width of a pixel compares to its height.

PLUGE (Picture Line Up Generating Equipment) The part of the SMPTE color bar display that may be used to correctly calibrate brightness on a picture monitor.

Primary Color In a defined color system, a color that cannot be created through a combination of any of the other primary colors.

Progressive Scan The recording and recreation of an image as a complete line-by-line frame from a single point in time.

Proxy A lower resolution substitute for large-scale video files.

PsF (Progressive Segmented Frame) A progressively scanned image that has been divided into two fields, each containing alternate lines from the frame. Unlike a true interlaced frame, both fields are from the same point in time.

Pulldown The process of duplicating video fields in order to map a 24 frame per second sequence into 30 frame per second video.

Pullup The process of removing the duplicate video fields introduced during the pulldown process that will restore a 30 frame per second video sequence to 24 frames per second.

Pulse Cross See Cross Pulse.

Quadrature Amplitude Modulation (QAM) A complex form of modulation that is capable of 64 or 256 levels rather than the 8 levels of 8VSB.

Quadrature Phase-Shift Keying (QPSK) Another form of modulation used in Satellite Broadcasting.

QuickTime A commonly used media container format created by Apple.

RAID (Redundant Array of Independent Disks) The recording of data redundantly over more than one hard drive disk to prevent catastrophic loss. There are several varieties of RAID providing various levels of protection.

Rasterizers A scope that takes an image in a vector graphics format (shapes) and converts it into a raster image (pixels or dots) for output on a video monitor.

Retrace During the scanning process, the return path of the electron beam.

Re-Wrapping The process of moving media between containers.

RF (Radio Frequency) That portion of the spectrum that lies between 3 kHz and 300 GHz.

Run-Length Encoding A type of lossless compression commonly used in graphics and computer-generated images (CGI).

Sampling Rate The rate at which analog data is read and the result converted to digital information.

SAP (Secondary Audio Program) In television recordings and transmission, a separate audio channel reserved for foreign languages or Descriptive Video Service.

Saturation The amount of color, or the ratio of luminance to chrominance information (e.g., the difference between red and pink).

Scan Lines The number of rows or lines of pixels that make up a television image. Common numbers are 480 for standard definition in the US, 720 or 1080 for High Definition, and 2160 for Ultra High Definition, or UHD (4K).

Scanner That portion of a VTR that houses the video heads. Also called the drum.

SDI (Serial Digital Interface) The SMPTE standard for the carriage of digital video signals on copper or fiber optic cable.

SDTV (Standard Definition Television) The name given to the original NTSC, PAL, and SECAM television standards.

SECAM (Sequential Colour Avec Memoire) A television standard using 625 scan lines per frame at 25 frames per second, developed by the French and used in several Eastern European countries. In the SECAM standard, there is no fixed color reference. All editing and image switching must be done as non-composite video with the synchronizing done after the fact.

Secondary Colors Those colors that are created by combining any two of the primary colors. In the NTSC system, the secondary colors are yellow, cyan, and magenta.

Server A computer-based storage device dedicated to housing and delivering data. In television systems, these devices may also decode the stored information to uncompressed audio and video signals for use by production equipment.

Setup The black level in the video signal. Also called pedestal.

Signal-to-Noise Ratio The relationship between the strength of the desired signal and the strength of the background noise or undesired information, expressed as a ratio S/N.

SMPTE The Society of Motion Picture and Television Engineers is an organization that sets the technical standards for television and motion pictures in the United States.

Spatial In digital image processing, a reference to where a pixel is on a two dimensional plane.

Spatial Density Resolution The combined pixel and line count in an image.

Spatial Redundancy The repetition of data within a frame that can be removed in the compression process.

Sprites A video object that is static and persistent.

Stereo An audio system consisting of discrete left and right channels.

Streaming Multimedia that is constantly received by an end-user over the Internet.

Sub-bands Images that are tiled into areas that are encoded separately.

Subtractive Color System The physical principle by which the eye perceives color in physical objects. In the subtractive system, an object absorbs all colors except that which the object is perceived to be. That color is reflected and stimulates the retina of the eye. In the subtractive color process, the addition of all colors will yield black, as all colors will be absorbed and none reflected. (See also Additive Color System.)

Surround Sound An audio system consisting of speakers located around the listener that creates a realistic audio environment in which the sound surrounds the listener.

Synchronizing Generator The piece of equipment that produces the synchronizing signals—such as horizontal and vertical blanking, horizontal and vertical sync, and color burst—that keeps all video equipment aligned in time.

Target The face of the pickup tube that is scanned by the electron beam.

Telecine The process that converts film to an electronic form. Telecine also refers to the machine used for the conversion.

Teletext Information that is sent along with the video signal that can be viewed separately from program material. Examples include a list of programs on a cable station or the local weather and news.

Temporal A type of compression that compares the changes between the images over time and stores the data that represents only the changes.

Temporal Resolution The frame rate, regardless of the pixel or line count, is the number of full frames scanned per second. This rate represents what is known as the temporal resolution of the image, or how fast or slow the image is scanned.

Terabyte (TB) A thousand gigabytes, or a thousand billion, which is a trillion bytes.

Test Signals Signals such as color bars, stairstep, multiburst, and cross hatch that are used in the setting up and checking of television equipment.

Thin Raster The digital image that subsamples the horizontal pixels in an image to reduce the amount of data stored and transmitted. See Full Raster.

Timecode A labeling system that is used to identify each frame of recorded video. There are several systems of time code in use worldwide.

Transcoding Converting a video signal with one encoding method into a signal with a different encoding method. In digital compression, converting from one codec to another.

Transform Coding Uses a complex conversion process to turn coded blocks of the image into a compressed image or video file for storage or transmission.

Transponders A channel of communication on a satellite.

Upconverting Converting a video signal from one scanning standard to another with a higher pixel count.

Uplink A facility for the transmission of signals to a satellite.

Ultraviolet Frequencies above 732 trillion hertz are called *ultraviolet.*

Vector A mathematical representation of a force in a particular direction. In television, it is used to measure color information where the angle represents the hue and the length represents the saturation.

Vectorscope A type of oscilloscope that is used to display the saturation and the hue of the video signal.

Vertical Blanking The period of time in which the electron beam is turned off while it moves from the bottom of the image to the top of the image to begin tracing or scanning the next field of video.

Vertical Interval That portion of the analog video signal that includes the vertical blanking, the vertical sync pulses, and the pre- and post-equalizing pulses. Also, the area where other information that is carried with the television signal—such as captioning, teletext, and satellite instructions—is inserted.

Vertical Interval Timecode A visual encoding of timecode inserted into the vertical interval of analog video signals. As the data is visual, the information may be read when the image is not moving.

Vertical Resolution The detail in an image dictated by the number of horizontal scan lines the image contains.

Vestigial A vestigial element is a part of something that has no useful value.

Video Object Plane (VOP) In compression, a video object plane consists of a sampling of the object over a number of frames.

Video Level A measurement of the luminance level of the video image. In NTSC, the analog video level should not exceed 100 IRE units nor go below 7½ IRE units. In digital images, black may be 0 millivolts and peak video may be 700 millivolts.

Voltage Voltage is measured in units and is the electric energy charge difference of electric potential energy transported between two points.

VU (Volume Units) Properly noted as dBVU, it is a measurement of the strength of an audio signal. Traditionally, 0 VU was the peak allowable transmission amplitude level of an audio signal.

WebM A video container used for the distribution of web files using HTML 5.

Windows Media A compression codec and video container designed by Microsoft.

WiFi (Wireless Fidelity) Referring to any IEEE (Institute of Electrical and Electronics Engineers) 801.11 network that is commonly used as a local area wireless network for laptop computing.

X Axis The line that goes from 0° to 180° is referred to as the X axis.

Y Axis The vertical up and down line that goes from 90° to 270°.

Index